D1112750

Hanging Man

Hanging Man

THE ARREST OF

AI WEIWEI

Barnaby Martin

ff

Faber and Faber, Inc.

An affiliate of Farrar, Straus and Giroux

New York

Faber and Faber, Inc.
An affiliate of Farrar, Straus and Giroux
18 West 18th Street, New York 10011

The photographs of Mang Ke at home in Tongzhou, the aftermath of the 2008 Sichuan earthquake, and the artist's demolished studio are from the author's collection. All the rest are reproduced courtesy of Ai Weiwei.

Library of Congress Cataloging-in-Publication Data
Martin, Barnaby, 1972–
Hanging man : the arrest of Ai Weiwei / Barnaby Martin. — First American edition.
 pages cm
 ISBN 978-0-374-16775-2 (hardback) — ISBN 978-0-374-70843-6 (e-book)
 1. Ai, Weiwei. 2. Ai, Weiwei—Political and social views. 3. Dissenters, Artistic—China—Social conditions—21st century. 4. China—Politics and government—2002– 5. China—Social conditions—2000– I. Title.

N7349.A5 M37 2013
709.2—dc23
[B]

 2013015010

Faber and Faber, Inc., books may be purchased for educational, business, or promotional use. For information on bulk purchases, please contact the Macmillan Corporate and Premium Sales Department at 1-800-221-7945, extension 5442, or write to specialmarkets@macmillan.com.

www.fsgbooks.com
www.twitter.com/fsgbooks • www.facebook.com/fsgbooks

1 3 5 7 9 10 8 6 4 2

Amongst the refugees in the village there was a worker from Berlin with her two little daughters . . . She told us almost at once that her husband had spent a long time in prison for being a communist and, if he was even still alive, was now God knows where in a punishment battalion. And she herself, she proudly reported, had also been locked up for a year, and would still be there today but for the fact that the prisons were overcrowded and that they needed her as a worker.

'Why were you in prison?' I asked. 'Well, 'cos of certain expressions {*wejen Ausdrücken*} . . .' (She had insulted the Führer along with the symbols and institutions of the Third Reich.) For me this was the revelation. It was . . . the why and the wherefore of my setting to work . . . less out of conceit, I hope, than 'cos of certain expressions.

—Viktor Klemperer
The Language of the Third Reich: LTI, Lingua Tertii Imperii
(translated by Martin Brady)

Part 1

I

It was July 2011 and Ai Weiwei was under house arrest in Beijing. He had just been released from detention and he was forbidden from talking to journalists or fellow dissidents, he was obliged to report all his proposed movements to his minders and when he did leave his house he was tailed and shadowed by undercover police. It wasn't exactly the 'freedom' he'd been hoping for but as I was about to find out, it was immeasurably better than his experience inside.

Like thousands of other people round the world I had watched the footage of China's most famous artist being unceremoniously dumped back on his doorstep by the police, clutching the top of his beltless trousers. He had looked cowed and he appeared to be in shock, and as he'd shuffled through the steel door into the courtyard of his home all he'd managed to mutter to the cameras was that he was not allowed to talk to the press and that he hoped people would understand. For all the Chinese Communist Party's efforts to portray the country as a modern, upstanding member of the international community it was still unable to tolerate dissent and its attempts to improve its image abroad were, as Weiwei had said of the Beijing Olympics, nothing more than 'a fake smile'. If you crossed the invisible line that demarcated what

could and could not be said you would still get arrested, no matter how famous or important you were. For many people in China and abroad who looked up to Ai Weiwei as one of the few people who dared to publicly criticise the Chinese government, it was an exceptionally demoralising and frightening moment.

A few years ago, the general public in the west knew next to nothing about this strange, bearlike man who sported a sage's beard and chuckled frequently and made inexplicable pieces of art. As a package he was almost *sui generis*. Even to people within the art world he was a strange commodity. At first glance he could easily be mistaken for a latter-day Chinese Dadaist but if he was a Dadaist, he was a Dadaist who was operating in a country that appeared to be some sort of cross between Aldous Huxley's *Brave New World* and George Orwell's *1984*. He also appeared to be a political activist and blogger, but in a society where political activism and blogging is more often than not a fatal career move.

His *Sunflower Seeds* show in the Turbine Hall of Tate Modern in London in 2010 propelled him to global fame and prompted more people to take a closer look at his work. Those who did found a succession of strange objects and bizarre installations. He appeared to specialise in altering and tinkering with the banal, background furniture of life: chairs and stools colliding with each other (*Grapes*); chairs made of marble; marble doors; a one-man shoe; a marble CCTV camera; hundreds of coal hives lined up on the floor; bicycles stacked upon bicycles, arranged in a circle; hundreds of Neolithic pots, immersed in industrial paint. Then there were

4

the larger-scale pieces: *Fairytale*, for example – the work he created for Documenta 12 in 2007, in which 1001 Chinese people wandered the streets of Kassel in Germany for a week. Or *Remembering*, the haunting fresco he created for the facade of the Haus der Kunst in Munich as part of his *So Sorry* retrospective in 2009. It was made from nine thousand children's backpacks and it spelt out the tragic words 'She lived happily on this earth for seven years'. This was a quote from one of the mothers who had lost a child during the 2008 Sichuan earthquake. Thousands of children had perished in the disaster when their shoddily built school buildings had collapsed on their heads.

His art was serious and yet at other times it was irreverent; it was inventive and yet ordinary. Normal things were transformed by his touch so that they appeared in a new and uncanny light. It seemed that over the course of three decades he had succeeded in erecting a half-recognisable netherworld that had the effect of forcing people to look again at reality and see it through fresh eyes.

But it wasn't Ai Weiwei's tinkering with the realia of existence that first got him into trouble with the Chinese government. His problems really began when his art merged with his vociferous campaigning for transparency and accountability in government and for freedom of expression. It is hard to overemphasise just how extensive Ai Weiwei's non-art activities were before his arrest. At times he had more than fifteen hundred people on his payroll; his art was just one of the many manifestations of his energy and personality. Art, architecture, blogging, book writing, campaigning were all natural

by-products. First and foremost he was an irrepressible demi-urge with a deeply radical agenda. Until his arrest, Weiwei's real drive and power often went unrecognised, perhaps due to the fact that because of his wit and intelligence he has been regarded in the past as something of a puckish character, a sort of Duchampian clown. But there was something far darker lurking beneath the surface. Weiwei was on a self-imposed mission: his stated ambition is to change China and, like one of the Furies of Greek myth, he is both the child and the nemesis of the current order.

*

A few days after his release I phoned various contacts in Beijing. No one I knew had yet spoken to him. He was refusing all interviews because he was worried that if he did speak to anyone he would be rearrested for breaching the terms of his bail and above all else he didn't want to be detained again. There was only one thing left to do: I picked up the phone and rang his old mobile number. I assumed that the police would have confiscated it or turned it off, but to my surprise Weiwei answered. My first thought was that he sounded much older than when we had last spoken, a month or so before his arrest – much older and much slower. And my second thought was: 'They've broken him.' But when I asked him what it had been like inside, his characteristic openness and alacrity suddenly returned: 'Come and visit and we can talk about everything.' I agreed, but because his phone and email were tapped I refrained from telling him precisely when I would come.

During the first six months of 2011 the atmosphere among the dissident community in Beijing, and among the broader community of people who dared to criticise the Chinese government, went from excitement to stifling fear and paranoia. The Arab Spring was in full swing and all across the Middle East authoritarian regimes were fighting desperate rearguard actions. With the overthrow of the Egyptian and Yemeni governments in February 2011, the revolutionaries appeared to have the wind in their sails and to the leadership of the Chinese Communist Party these events must have been worryingly reminiscent of the atmosphere in April 1989, when events in Poland brought Lech Wałęsa's Solidarity Party a step closer to power and precipitated the domino-like collapse of the Eastern Bloc. In 1989 the Chinese students in Tiananmen Square had held up banners expressing their solidarity with their brothers and sisters abroad in the Soviet Union; Wu'er Kaixi, perhaps the most charismatic of the student leaders in 1989, even went so far as to boast that he was 'better than Lech Wałęsa'.

In February 2011 the Chinese government decided to act: scores of human rights activists and dissidents were detained by the police. They suffered beatings, torture and repeated interrogation and they were forced to make videotaped confessions. Some of these people were held for a few days, others were sent to re-education camps and still others simply vanished. At the time of writing their relatives still do not know where they are. They were often hooded when they were arrested; they were often watched round the clock. Relatives of those arrested who have dared to talk to the *Guardian*

newspaper said that when the detainees returned home, they suffered disturbed sleep, memory loss and trauma.

For the Chinese government, the round-up was a pre-emptive strike. The Tiananmen Square showdown and the eventual massacre on 4 June 1989 have coloured the thoughts and actions of the leadership ever since. The 1989 demonstrations began peacefully enough as a spontaneous mourning vigil for the well-loved aspirant reformer Hu Yaobang, who had died on 11 April that year. But very quickly things had escalated. First the students called for a continuation of reform and then, emboldened by the inaction of the leadership and the support of the people and workers of Beijing, they began to denounce the Politburo members by name. Student leaders like Wu'er Kaixi, Wang Dan and Chai Lin were allowed to use Tiananmen Square as a platform from which they addressed China and the world. Zhao Ziyang, the General Secretary of the Party, had urged restraint, counselling that the students were only expressing their patriotism; Li Peng, the leader of the conservative faction, had advised force. The ultimate decision lay with the paramount leader, Deng Xiaoping, a man who had been an active participant in almost all the great events of China's tumultuous post-imperial history.

Deng was born in 1904. He had seen countless friends and colleagues die horribly in the conflicts with the Nationalists and the Japanese. He had been on the Long March with Mao Zedong in 1934–5, the seminal event in the story of the Chinese Communist Party, a year-long military retreat in which only some eight thousand survived of the eighty thousand who had set out. He had seen military service at first hand

and at a high level; he was political secretary for the Second Field Army during one of the biggest conventional military battles in human history, the Huaihai campaign in 1948–9, the Chinese Stalingrad: a battle of such gigantic proportions that it is alleged to have left more than five hundred thousand Nationalist soldiers dead. He had witnessed the disaster of the Great Leap Forward and the ensuing catastrophic famine that killed at least thirty million people and possibly as many as forty-five million. He had been purged from the leadership three times by Mao but he was always recalled to the top table of Chinese politics. His whole life had been lived against a backdrop of violence and war that had culminated in the cannibalistic frenzy of the Cultural Revolution, during which his own son was thrown out of the window of his student dormitory, leaving him confined to a wheelchair for the rest of his life. The complete anarchy of the first years of the Cultural Revolution had only been brought to a close by the sending in of the People's Liberation Army, but it smouldered on pretty much until the death of Mao and Zhou Enlai, the arrest and trial of the Gang of Four by Hua Guofeng, Mao's chosen successor, and the ascension of Deng himself to the position of paramount leader. In short, Deng had seen everything: the horrors, the pain and the hard-won success. On 4 June 1989, he wasn't going to allow a bunch of students to push the country back into the chaos of the past. Today, Deng's decision to send in the army and his justification for that decision still provide the rationale behind the terms of the contract between the Party and the people. As Deng said at the time:

Of course we want to build socialist democracy, but we can't possibly do it in a hurry and still less do we want that western-style stuff. If our one billion people jumped into multi-party elections we'd get chaos like the all-out civil war we saw during the Cultural Revolution. Democracy is our goal but you'll never get there without national stability.

*

But why had Ai Weiwei been arrested? To the outside observer, particularly someone who lives in the west and only knows him as a conceptual artist, his detention was shocking, verging on the bizarre. The sudden wave of arrests of human rights activists and lawyers was depressing but predictable. Such people are always the targets of repressive regimes. But a conceptual artist who had just deposited one hundred million hand-painted sunflower seeds on the floor of Tate Modern, why was he feeling the heat? Could it be that the Chinese Communist Party had an extremely sophisticated view of the origins of dissent? Did they understand the deeply subversive nature of his Dada-style art and recognise that throughout history, aesthetic revolution has always been a harbinger of social revolution; that changes in the way artists portray reality lead inevitably to the changes in the way the common people think and behave? Or maybe it was more straightforward than that. Ai Weiwei was a tireless critic of the government, and he had a vast following on Twitter and Chinese social media platforms. It was not a

combination that the Chinese government approved of. But whatever the ultimate reasons for his arrest I felt that Ai Weiwei's experience at the hands of the Chinese secret police could throw a unique light on the psychological state of the Chinese Communist Party itself.

But just after his release Ai Weiwei was isolated. In addition to his initial, self-imposed purdah, some foreign journalists in Beijing were not seeking him out for the simple reason that if they did so they risked having their press visas revoked or not renewed at the end of the year. Others did approach him but initially at least he declined to do interviews, afraid that he might be rearrested for breaching the terms of his bail. The first detailed accounts of his experience only began to appear in the foreign press in September. As for local journalists, they certainly weren't going to get involved. Foreign art dealers, similarly, were nervous about associating with a man who was still very much a pariah. If you are a professional and you've ploughed much of your life into becoming an expert on some aspect of China or Chinese culture, it certainly wasn't worth jeopardising what you had built up. This is not to say that many people in the art community were not working to support Ai Weiwei and to further the cause of artistic freedom – the very opposite was the case – but they had to be very careful, and to make their contributions in more subtle ways. If you live in China, outright and vocal support of a jailed dissident can be dangerous. It is all too easy to get detained.

So why did I decide to visit him? Firstly, my career as a writer is not dependent on me being able to visit China, so I

am less afraid of penalties from the Chinese state. Secondly, because I knew that other people were obliged to give Wei-wei a wide berth, I thought I should check to see if he was all right. I could interview him and if necessary advertise his plight by writing an article for a newspaper, while other people couldn't afford to do this. Thirdly, I was interested to hear his story because for some time I had been toying with the idea of writing a book about modern China that would use an account of Ai Weiwei's life as its backbone. His life and that of his father, Ai Qing, one of China's most famous twentieth-century poets, are so intertwined with the great people and events of modern Chinese history that any biographical account would necessarily touch on the main historical events of the post-imperial epoch. Furthermore, Ai Weiwei is that rare bird, a Chinese person that many people elsewhere in the world have heard of and for the most part are interested in and even sympathetic towards. Ask someone to name three living Chinese people and Ai Weiwei will most likely appear on their list. When writing about China there are few living Chinese citizens who command anything like this kind of name recognition. For most non-Chinese people, unless they have been fortunate enough to study Chinese at university or to have lived in the country or one of its satellites, knowledge of China is very limited indeed. So my original thought had been that by stepping through the door into Ai Weiwei's compound I would learn a great deal more about China itself.

*

Very early one morning at the beginning of July 2011, I walked through customs at Beijing airport. I had been informed that there was a police car stationed outside Ai Weiwei's house twenty-four hours a day and I knew from past experience that there was a CCTV camera pointing directly at his doorbell. The plan that I had formulated on the plane was simple enough. I hoped to be able to make my way into his house and then, while everything was still fresh in his mind, talk to him in detail about the time he had just spent languishing in the Chinese penal system. The main problem with this plan was that despite Weiwei's assertion to me on the phone that he was fine and that he would 'tell me everything', I had no idea at all if he would be willing or able to follow through on his promise. It was already becoming clear that some of the people who had been taken in around the same time as him had been tortured, and some, including one member of Weiwei's staff, had failed to recover from their ordeal inside. I had no experience at all of interviewing people under such circumstances and as I made my way through the vast airport, the dark side to Weiwei's strange treatment at the hands of the Chinese Communist Party began to preoccupy me.

Immediately following Weiwei's detention the whole world had demanded to know why he had been arrested. Overnight, he was transformed into a martyr. This was not all that surprising in itself. Regimes that persecute artists always look particularly bad. It was very easy to hagiographise Weiwei; little effort was needed to see him in a romantic light, as the reincarnation of that classic type of avant-

garde rebel artist who had once been common in the west.

Now he was free again surely it also made sense to ask why he had been released? If it transpired that despite his ordeal he was sound in mind and body then what did that mean? If he had not been tortured, then why not? Was he being protected by someone? Had he done a deal, or was he simply a pawn being moved around by a higher power? People like Ai Weiwei can become like counters in a board game: their liberty or their lack of it, their status as a free citizen, is a by-product of the power struggles and horse-trading that take place far above their heads. They become a weather vane for the direction a regime is moving in. Weiwei's arrest, just like the arrest of Bo Xilai, the populist, self-promoting mayor of Chongqing, in April 2012, tells you nothing about either man's guilt or innocence. What it can do is throw some small light on which faction is gaining the upper hand in Beijing. Weiwei had just spent eighty-one days being interrogated by the foot soldiers of his political enemies. It was reasonable to suspect that the orders for both his arrest and his release must have come right from the top, from the level of the Politburo. Perhaps, then, he had learnt something about his captors during the process of his interrogation. It might well be that he had insights into the state of mind of the leaders of the world's most populous nation.

It was quite obvious from my very brief phone conversation with him, and from watching the footage of him evading the journalists on that first night when he had returned home, that he too was a changed man and that whatever they had done to him inside had deeply traumatised him. My plan was

to begin with physical and mental details. We could for example start with the moment when the black sack had been slipped over his head at Beijing airport, just as he was about to board a flight to Hong Kong on 10 April. Once the conversation began to flow I hoped it would then open up, and we could advance onto more interesting but possibly more ginger territory. I wanted to know about his father, Ai Qing, who had at one time been a personal friend of Chairman Mao's. As the more cynical of my Hong Kong Cantonese friends never ceased to remind me, this made Ai Weiwei part of the 'red aristocracy', whether he liked it or not. Today the upper echelons of the Chinese government and Chinese society are filled with the scions of this aristocracy, the so-called princelings. These are the sons, and occasionally the daughters, of the People's Republic of China's first generation of top generals and politicians. As the years go by, these princelings' lives become further and further removed from those of ordinary Chinese people. Many of them are only concerned with converting their inherited political capital into more tangible financial capital and are not remotely interested in their fathers' and grandfathers' lofty ideological goals. In a way, Ai Weiwei was a sort of cultural princeling. Perhaps his peculiar treatment at the hands of the authorities had something to do with this.

Ai Weiwei once told me in great detail about his early years, how he was born in 1957 in the heart of the hutongs – the remnants of the lanes and alleyways that still surround the Forbidden City in Beijing. For the first year of his life Weiwei's family lived in a courtyard house on the old east side of

the hutongs until his father fell out of favour with Mao and the family was banished to the Gobi desert.

Ai Qing, who Weiwei readily acknowledges has been the major influence in his life, was born in 1910 in a village in Zhejiang province, just one year before the start of the Xinhai Revolution, the uprising against the Qing Dynasty that led to the downfall of the last emperor and the end of dynastic China. For decades the Qing dynasty had been weakening; there was a growing peasant underclass dissatisfied with its lot; there was the increasing realisation among sections of the intellectual elite that a complete break with the Confucian heritage was needed; and there was humiliation at the hands of foreigners, culminating in the defeat at the hands of the British that resulted in the Treaty of Nanjing (1842). There had been revolutions within the empire too, of which the Taiping Rebellion in 1850–64 was the largest, with over six million dead. Britain ruled Hong Kong and central Shanghai; the French had concessions in Yunnan, and all across the empire foreigners were exempt from local laws. In 1895 further humiliation was piled on when Japan, China's traditional rival and inferior, defeated the Qing navy and took control of Taiwan. All around the fringes of the empire, foreign powers were nibbling.

The final collapse of the Qing dynasty came very suddenly. An armed uprising in 1911 in Wuchang, a city in central China, blossomed into a full-blown rebellion that the Qing forces were unable to suppress. Other garrisons around the country rose up against the Qing overlords, bolstered by support from the gentry and rising middle classes. The Qing were

not Han Chinese; they were members of the Manchurian Aisin Goro clan, part of an ethnically and linguistically distinct Jurchen people, whose homeland was in the far northeast of China. Since the foundation of the Qing dynasty in 1644 they had adopted Han Chinese customs, dress and language but at the same time they had kept themselves separate: intermarriage with the Han Chinese population was forbidden. Support for the Manchurian overlords had been draining away for decades and there had been several previous attempted uprisings prior to the one in Wuchang. Many of these attempts had been organised by the revolutionary league of Sun Yat-sen, who is now regarded as the founding father of modern China, even by the Communists.

Sun was one of many educated people who had given up hope that the Qing would ever be able to reform and modernise. By 1900, tens of thousands of Chinese had been abroad to study or work and their experiences in Japan, in Europe and in America opened their eyes to the truth about China's waning powers. Sun Yat-sen himself was in America when he first heard the news about the successful uprising in Wuchang. The Wuchang uprising turned into the nationwide Xinhai Revolution; the boy emperor Puyi abdicated and the Republic of China was born. Sun was made its first president, though within a matter of weeks he was pushed aside by Yuan Shiukai, a former Qing strong-man and author of key military reforms of the late dynasty. China's first and last democratic elections were held in 1912 and Sun's newly reconstituted Revolutionary League, now called the Guomindang, or Nationalist Party, won a majority in elections to the National Assembly in 1913. Within

17

a year, the National Assembly was disbanded as Yuan attempted to gain total control of the country at the expense of his erstwhile allies, the anti-monarchists, the pro-Republican warlords and Sun's Guomindang. But Yuan died in 1916, and China slid into the era of the warlords, which was to last until 1928. There was no national government; foreign powers played off the rival warlords one against another, and China's new era of democracy and freedom seemed to have vanished almost as quickly as it had appeared.

Such was the background to Ai Qing's early years and even in rural Zhejiang province the changes wrought by the tumultuous events of 1911 and its aftermath were profound. The world of the fixed Confucian hierarchies was disappearing. New ways of thinking were entering China and new publications that articulated these changes were springing up every day. Relationships between young and old, between rulers and ruled, between men and women, would never be the same again.

At birth, Ai Qing wasn't called Ai Qing. His name was in fact Jiang Haicheng. Like Mao himself, he was the scion of a relatively well-off landowning family; it was only as a young man that he changed his name. As was the custom in those days, directly after his birth his parents consulted an astrologer. They were told that their newborn son would bring ruin to their household. The only hope they had was to give him away. Terrified by the astrologer's prophecy, Ai Qing's parents handed the baby over to one of the poorest women in the village, a peasant who already had too many children of her own to feed. In order to make room at the table for the infant Ai

Qing, this woman drowned one of her own children in the paddy fields.

On his ninth birthday, Ai Qing's parents relented and allowed their young son back into the ancestral home but only on the strict condition that he refer to them as his uncle and aunt. This was 1919, the year of the 4 May demonstration – a red-letter date in modern Chinese history and a sort of Chinese equivalent of the storming of the Bastille or the Boston Tea Party. Beijing students had torched the house of Cao Ruilin, the minister of communications in the government of the Republic of China and an alleged collaborator with the Japanese, to protest at the latest humiliation at the hands of the foreigners. News had just reached Beijing of the nature of the settlement reached in the Treaty of Versailles. The British and the French had 'given' the pre–First World War German colonies on Chinese territory to Japan. Far from being treated as an equal and an ally (China had sent more than a hundred thousand men to France to work as labourers during the war), China's status as second-class power was reaffirmed.

The years either side of 4 May 1919 are sometimes referred to as the 4 May era and the proponents of change are often referred to as belonging to a notional '4 May movement' or 'new culture movement'. These people wanted to bring science and democracy to a moribund China. Many of them saw Confucianism, which had been the bulwark of Chinese society for more than two millennia, as the main obstacle to China joining the modern world. They saw too the success that Japan had garnered following the Meiji Restoration in 1868, when its leading oligarchs had restored imperial rule

and set about modernising Japan by reforming the army, introducing compulsory schooling, rewriting the constitution, industrialising the country and generally importing the latest technology and innovations. They looked abroad for inspiration but they were nationalists all the same; they wanted to take the best of the foreign thinking and bring it home to China and thereby restore her to her rightful place at the head of the top table of nations. Even today, 4 May 1919 is used as a touchstone and rallying cry all across the political spectrum: the Nationalists claimed to be the heirs of the 4 May movement, so too did the Communists, so too the students in Tiananmen in 1989. Ai Weiwei himself has said that what he is pushing for today in China is merely the natural conclusion of the work that first began in the days of the 4 May movement.

But the noble dreams of 4 May 1919 failed to materialise. The Xinhai Revolution and the democratic elections to the National Assembly had been a false dawn and China had descended into warlordism. It was against this background of political frustration that the Chinese Communist Party (CCP) first emerged. The CCP was founded in 1921 by Chen Duxiu, the head of the Faculty of Humanities at what was then known as Peking University, and Li Dazhao, the chief librarian, and it was the product of the second major stream of foreign cultural influence on Chinese intellectual life. If Sun Yat-sen and thousands of other Chinese people had been inspired by the democracies of Europe and America, men like Chen and Li turned instead to the thoughts of the anarchist Kropotkin and of Marx and Engels. After the suc-

cess of the Russian Revolution in 1917 and the ensuing defeat of the Whites in the Russian Civil War, communism and specifically Marxism suddenly looked like a viable and attractive alternative: not only was it successful but it was in its essence fundamentally anti-imperialist. Chen and Li soon gathered around them a growing band of young radicals, including a certain strong-willed young man from Hunan province who worked in the Peking University library alongside Li Dazhao: Mao Zedong.

But in the early twenties the Chinese Communist Party did not look like a force to be reckoned with. It could still only muster a few hundred members, most of whom were either associated with or on the fringes of Peking University. The Nationalists, on the other hand, were the face of party politics in China. Although they too were ill-disciplined as a political force until they later received an injection of funding and training from Soviet Russia, they could at least claim to have overthrown the Qing dynasty. In 1911, the Communist Party had not even existed. Furthermore, the Communist Party might well never have become the force it did had it not been for the help of Sun Yat-sen and the Nationalists. In 1923, Sun met representatives from the Comintern who were keen to sow the seeds of revolution abroad. After the betrayal at Versailles, Sun was prepared to deal with Lenin and a man called Joffe, who was one of Lenin's senior agents in China. The Comintern agreed that Moscow would assist the Nationalists, but they insisted that the Nationalists allow the Communists into their ranks in exchange for funds from Moscow. For a time, this deal benefited all three parties. The

United Front, as it was known, worked well and together the Communists and Nationalists staged the Northern Expedition, a military campaign that began in 1926, with the objective of defeating the warlords and unifying all of China. But Sun's death in 1925 led to the accession of Chiang Kai-shek, who was less keen on tolerating the Communists in the Nationalist Party's midst. In 1927, after the Northern Expedition had captured Shanghai, he made a decision to break away. Working with the Shanghai criminal underworld, who weren't particularly sympathetic to the Communists themselves, Chiang ordered the massacre of thousands of Communist Party members and brought to an end the uneasy alliance. Mao, at this time stationed in Hunan province, watched from afar the disaster that befell the Communists in Shanghai and continued to develop his own theory of radical, rural communist revolution. In time, the Nationalists turned their attention to the Communist 'bandits' still at large in Jiangxi, and in 1934 Mao and the rest of the Jiangxi Communists were forced to evacuate their base and embark on what has become known as the Long March, the perilous anabasis from which Mao eventually emerged as leader of a newly forged CCP.

Throughout the mid-twenties, Ai Qing studied at Hangzhou Art College. In 1928, one year after the outbreak of hostilities between the Communists and the Nationalists, he went abroad to live in Paris to further his studies. He was eighteen years old and he was immersed in the cauldron of the revolutionary art and literature of western modernism. By the time he returned in 1932, China had descended into an all-

out civil war. Though he was not yet a member of the Communist Party he was already a revolutionary poet and almost immediately after he landed in Shanghai, he joined a left-wing writers' group. In July 1932 he was arrested by the Nationalists and jailed in Shanghai. Unable to paint, he turned to poetry and many of his poems were successfully smuggled out of prison and published to great acclaim, some even becoming bestsellers. To this day, Communists of the generation of Wen Jiabao and Hu Jintao still frequently recite Ai Qing's poems from memory when they make public speeches. In 1937, the war of resistance against Japan began and hostilities between the Communists and Nationalists were suspended so they could concentrate on defeating their mutual enemy. At one point Japanese soldiers passed through Ai Qing's ancestral village, which was not far from Shanghai. When they discovered the now famous poet's ancestral mansion they burned it to the ground and so, as Weiwei points out, the astrologer's dark prophecy was fulfilled.

In 1941 Chairman Mao befriended Ai Qing, seeking to draw the famous and highly respected poet into his circle. Ai Qing travelled to Yan'an, the Communist base in Shaanxi province, and officially joined the Party. For a while the two men were very close. Mao solicited Ai Qing's advice on culture and Ai Qing was given jobs on the Party committees that oversaw the arts. But as Mao's own ideas continued to evolve, it became clear that in the future China there would be no room for any kind of thought other than Chairman Mao Thought.

With the eventual defeat of the Japanese in 1947, hostili-

ties between the Communists and Nationalists were resumed. The civil war continued until 1949, when Chiang Kai-shek was finally forced to flee to Taiwan with over two million Nationalist followers. Mao and the Communist Party had won.

By 1949, Ai Qing was one of the most famous living poets in China and his verse was practically compulsory reading for every member of the Communist Party. But as the 1950s progressed he grew disillusioned with Mao. This disillusionment came to a head in 1956 when Mao initiated the Hundred Flowers Movement. People were urged to speak up and criticise the Party: 'Let a hundred flowers bloom and let a hundred schools of thought contend,' announced Mao. But this period of liberty was short-lived. Ordering the crackdown to begin, Mao remarked that he had 'enticed the snakes out of their caves'. Ai Qing, once a close confidant of Mao, went the same way as so many others who allowed themselves to get too close to the sun king: he was sent down to Dongbei in the north of the country, near the Korean border, along with his wife and young son Weiwei.

This was 1958, the tail end of the great anti-intellectualist purge. With Mao's encouragement the literary elite turned on itself; former friends and literary rivals rushed to point the finger at each other. Many people were executed and over three hundred thousand intellectuals were rusticated. Ai Qing was branded a 'triple criminal' – the very worst kind. It meant he was against the Party, the state and the country. Following the revolutionary tradition the family were billeted with a woodcutter, to be tutored in the ways of righteousness. Later, they were moved to Xinjiang in the far west, the

Chinese Siberia, to a Soviet-style concrete block. Later they were moved again, to temporary housing in a dormitory in an army camp. Finally their travels came to an ignominious end and they were deposited in an earthen pit, a hole in the ground covered in brushwood, in a village on the edge of the Gobi desert.

Ai Qing was a pariah. He was forced to clean the public toilets. He came home exhausted every night, covered in shit; he lost his sight in one eye and on several occasions he tried to commit suicide. Once, when I talked to Weiwei about how his father survived that period, he said: 'Every day my father put all his life into his job as a toilet cleaner. The only way out for me was to turn the urinals into a work of art.' Weiwei described how he would sometimes follow his father to work and watch him applying all his strength and intelligence to the demeaning task, meticulously laying the sand and cleaning the holes, and by the end everything would be immaculate, all the sand was in place. Weiwei still says that this was the greatest gift his father gave him: the example that if one is always clear and precise in thought, always sincere, then even the most humble task, even a task you have been given to grind you down and humiliate you entirely, can be dignified and redeemed in the end.

Often Weiwei would be left alone with his father for weeks on end while his mother went to Beijing to petition the Party cadres for forgiveness, to beg them to let her family return to the capital. At a very young age, Weiwei was forced by necessity to learn how to make everything, from stoves to furniture, to bricks, to clothes. He mended leather shoes, he

threshed corn and went out into the fields when it was still dark to harvest opium from mature *Papaver somniferum*. During the height of the Cultural Revolution, Weiwei's formal education was, like everyone else's, limited to the rote-learning of quotations from Chairman Mao's Little Red Book. Yet in the evening his father would sit him down in their hovel and, finding it too painful to talk about China, he would speak instead for hours about classical antiquity, about the life of Julius Caesar, or Caligula, who made his own horse a consul, or about the final dark days of the Roman Republic when Octavian Augustus was made 'first among equals' and all the noble ideals of the golden age were abandoned and tyranny and hypocrisy swept the land. Stories of political intrigue and betrayal from millennia ago, from the other side of the world; to a young boy they could hardly have made sense as history let alone as allegory. This was Ai Weiwei's mother-lode: a hole in the ground where he watched the snuffing out of his father's spirit and his mother's ever-deepening despair.

And yet, extraordinary as the Ai family saga is, such experiences were very common. Of course, Ai Qing was a great poet, and few people in China ever found themselves on close terms with Mao, but the travails of the family, the internal migrations suffered on the whim of the Party, the *Dr Zhivago*-like family separations, the humiliations, the falls from grace – all set against the backdrop of the civil war, the Great Leap Forward, the great famine and the Cultural Revolution – these experiences were ubiquitous, particularly among people whose families came from the educated classes, the gentry, the civil servants.

To take but one example: today's presumptive leader in waiting, Xi Jinping. Xi's own father, Xi Zhongxun, was one of the first generation of Communist leaders. Like Ai Qing, Xi Zhongxun was the son of a landowner. Like Ai Qing, Xi Zhongxun moved too close to the centre of power, only to be purged, in his case in 1962. And Xi Jinping, just like Ai Weiwei, was sent down to the countryside during the Cultural Revolution. China's future leader mucked out pigs in Shaanxi. He is on record as saying that the ideals of the Cultural Revolution were never realised, that they proved, ultimately, to be illusory.

The longer one spends in China and the more one learns of the fates that befell so many of its citizens over the last hundred years, it begins to seem as though this is a society that has yet to come to terms with the horrors of its very recent past. 'Revolution is a bitter thing,' wrote Lu Xun, perhaps China's most famous twentieth-century writer. He was referring to the Xinhai Revolution of 1911–12. 'Before the revolution I was a slave. After the revolution I was a slave of slaves.' He died in 1936. Had he lived to see the horrors of the end of the civil war and the Great Leap Forward and the famine and the Cultural Revolution, his assessment would most probably have been even more bleak.

2

But when I first met Ai Weiwei I was oblivious to his dark family history. Our first meeting took place in 2010 in the extremely prosaic surroundings of a gloomy hotel lobby in west London. His *Sunflower Seeds* exhibition at Tate Modern was just about to open and although neither of us knew it at the time, he was on the brink of worldwide fame.

I arrived at the hotel very early in the morning only to find him already in the lobby, finishing an interview with a journalist. There was a cameraman and a host of hangers-on. I sat patiently and listened as he answered every question that was put to him in neat, quiet, heavily aspirated English. The cameraman bobbed and weaved like a boxer, the skinny interviewer swayed like a cobra. Ai Weiwei sat perfectly still and talked. I leaned back into my chair and waited my turn and looked down at my feet. It occurred to me that the trousers, the shoes, the socks, the underwear, the jacket, the shirt on my back, the umbrella I was carrying, the camera, all of it was made in China, along with the phone in my pocket, the computers at the hotel's reception desk, the lights above our heads, half the stuff of our lives. If suddenly the spell was broken, and all these magical goods from the east vanished simultaneously, we would be sent right back to the Stone

Age. Naked, we would wander our dark and empty streets. In vain we would search for pots and pans, trousers, tin openers, torches, cars, hairdryers, mobile phones, coffins, fish tanks, light bulbs, toys.

Before I met Weiwei, I knew of only a handful of his works. One in particular had always caught my eye, *Hanging Man*, a piece Weiwei made in 1985, when he was living in New York. At the time he had had no money to buy materials and so he had twisted a coat hanger into the shape of Marcel Duchamp's profile and hooked it onto his bathroom mirror in his basement apartment on the Lower East Side. The first time I saw a photo of Weiwei's *Hanging Man* piece, I was completely bewitched. It struck me immediately as a sort of archetypal symbol in the making, like the ace of spades, or the rose, or the cross. And the name *Hanging Man* was itself intriguing. Was Ai Weiwei making an intentional reference to the Tarot card of that name, itself a reference to a much larger, older concept of human mind or soul, suspended upside down in the cosmos, tested by the ordeal of conscious life? Duchamp was an initiate into such ancient esoteric teachings and would have found the title pleasing – he was quite explicit in his formulas and intentions – but was this true of Ai Weiwei?

In preparation for our meeting I had been learning more about Ai Weiwei's work and very quickly I became fascinated. Here was a Chinese artist from the first wave of post-Mao artists, who had gone to America and immersed himself in the traditions of western art. He left China in 1981 when it was still very difficult to get hold of any books on western art and where the single most ubiquitous image was the sacred

portrait of Chairman Mao that adorned every public building and every bank note, and he had moved to a New York where Jasper Johns and Warhol were in their prime. As I read about Weiwei, I imagined the shock, the release he must have felt when he first saw Warhol's iconoclastic portrait of Mao. I imagined him travelling to Philadelphia to see Duchamp's *Large Glass* or venturing to a small gallery on the Lower East Side to see Jeff Koons's *Total Equilibrium* series, the iconic basketballs suspended in a vitrine, on sale back then for just a few thousand dollars.

At the time, Ai Weiwei had no money. He worked as a gardener, a housekeeper, a picture framer, a builder. He studied; he produced his first American works, the early Dadaist creations like *Hanging Man* and *One Man Shoe*, two black lace-up brogues stitched together at the heel. With these works we see the beginning of what becomes a recurring alchemical theme in Weiwei's art: the transformation of base matter, of unpromising circumstances, into art. You can practise it anywhere, in the most cramped hovel, in the most subterranean flat in New York. The principle is simple: all force, all energy can be transformed and redirected. With a simple sidestep or a fractional change of perspective even tragedy can be turned into art.

*

In the hotel in London, the other interview finally came to an end. It was my turn to talk to Ai Weiwei. The cameras were switched off and he relaxed. He offered me some tea, I thanked

him for taking the time to see me and we fell into conversation about his upcoming show. I noticed the scar on his skull, and I asked him how his head was (it was only ten months earlier that he had suffered a brain haemorrhage as the result of a police beating). He touched the scar gingerly, laughed and shrugged. 'It is OK,' he said. I asked him how the Chinese police were treating him now and he told me a story about something that happened to him back in 2007 when he was living at his mother's place in the hutongs on Beijing's old East Side.

'There was a loud knock on the door,' said Weiwei. 'Outside were two policemen. They invited themselves in and informed me that I was under arrest and that I should accompany them immediately to the police station. I agreed but under one condition: "First, you must show me your police IDs. After all, police protocol requires it." The policemen began to look very uncomfortable. They had left their badges back at the station. For a moment no one knew what to do, then I had an idea. I picked up the phone and called the police: "There are two impostors in my living room, posing as police officers. Come quickly and arrest these men."

'Five minutes later there was another knock on the door. It was the policemen's superior. He was very angry. He said that he could vouch for his colleagues and that it was time for me to come to jail. Again, I agreed but on one condition: "I will come. But first, I must see your ID." The superior officer turned red and muttered something about having left his badge in his office. I chucked them all out onto the street and I never heard from them again.'

A typical Ai Weiwei story: the dark comedy of Daniil

Kharms crossed with Terry Gilliam's *Brazil*. And typical also because the story manages to capture so many aspects of his outlook. He is a lover of paradox, he is prepared to turn any situation into a 'ready-made', that is to say he has taken Duchamp's concept of the ready-made (such as the toilet bowl that Duchamp signed 'R. Mutt' and put in the art gallery) and he has extended it across the whole of his life. Real life, real experience, becomes the ready-made. Weiwei has said that he intends to use the whole of China as a ready-made in his art; he will somehow make the predicament of China's place in the world, and his own predicament as an artist trying to practise freely in China, into a work of art.

Ai Weiwei has always said that Duchamp is his master but Duchamp is part of a tradition that has its own deep roots in China. Hui-neng, the illiterate firewood vendor from Guangdong province who rose from total obscurity to almost single-handedly found Zen Buddhism, is someone else Ai Weiwei has always admired. Hui-neng was one of the most colourful figures of the Zen school and although he is not as famous as Chuang Tzu ('Am I Chuang Tzu dreaming that I am a butterfly or a butterfly dreaming that I am Chuang Tzu?'), he is very well known. Hui-neng was of the Monty Python, smack-you-in-the-face-with-a-dead-fish school of Zen. He believed it was possible to bypass the slow path to enlightenment via multiple reincarnations – instead enlightenment could be had in the here and now, in a single instant. He would definitely have approved of dumping a hundred million sunflower seeds on the floor of the Turbine Hall in Tate Modern or calling the police to arrest the police.

I asked Weiwei about the difference between Chinese and western theories of the unconscious. He scratched his head and remarked that the day after he had stayed up late into the night sketching out the design for one of his most famous porcelain pieces, *The Wave*, in 1994 – an incredible recreation in porcelain of Hokusai's famous curling, froth-tinged waves, as seen from the bluff at Yokohama – the Asian tsunami hit. We discussed how Duchamp's *The Bride Stripped Bare by her Bachelors, Even* is the work of an initiate into the western occult tradition. The bachelors are the planets, the bride is the sun, and that is only the beginning. As we spoke Weiwei was writing out three Chinese characters. 'What does that say?' I asked. '*Lian jin shu,*' he answered, searching for the right English word: 'Man from old days who turns shit into gold.'

Finally, the conversation turned to what was meant to be the real subject matter of our meeting: the early avant-garde movement in Beijing; the days when Weiwei and his colleagues began to discuss the powerful ideas that were then only just seeping in from the west: the ideas of Dada and Picasso, of the cubists and the Fauvists, and Cézanne.

For some time I had been conducting some research into the first generation of post-Mao artists and writers, the people who had appeared out of obscurity in the wake of the Cultural Revolution and flourished during the decade prior to the dreadful events of 4 June 1989. Many of them were of the Red Guard generation and spent the Cultural Revolution years in the countryside, sharing forbidden books of translated literature. I had a vague plan to organise a show that would bring together what I could find of this early Chinese

contemporary art. I had had a very tentative discussion with someone at the Ashmolean Museum in Oxford who had expressed even more tentative interest, and I intended to go to Hong Kong and track down Johnson Chan, the famous collector and gallerist who had known many of these artists. I hoped to be able to contact some of the artists themselves and borrow what was left of their work. There had already been retrospective shows in Hong Kong in 1989, in Tokyo in 2000 and even in China in 2007. But their work and their achievements, while not actually forgotten, have been somewhat relegated to the second division. Today, when people talk of contemporary Chinese art they are normally referring to the tradition that begins with people of the generation of Zhang Xiaogang, the older Liu Wei, Zeng Fanzhi, Geng Jianyi and Zhang Peili. But in truth these artists, whose work now sells for fortunes in the auction houses in Hong Kong and the west, were the second or even the third wave of Chinese contemporary artists and it was the pioneers of the first wave who fascinated me: the artists who had emerged from the darkness of the purges, the Great Leap Forward and the ensuing famine, and the Cultural Revolution.

The 1957 anti-rightist purge that had seen Ai Qing, along with hundreds of thousands of others, sent down to the countryside was followed very quickly in 1958 by Mao's attempt to drag rural China into the industrial age and simultaneously collectivise all agricultural production: the so-called Great Leap Forward. Agriculture had always been the basis of the Chinese state and unlike in Russia, where the urban proletariat formed the backbone of the Party, Mao had made the

rural membership the cornerstone of CCP. Even before 1949, in the Communist-controlled areas Mao had enacted land reforms that stripped the gentry and large landowners of their estates and redistributed their farmland to the peasants, but from 1955 onwards he began to move in an even more radical direction. The goal was to make rural China properly communist and that meant collectivising farms and abolishing private ownership of farmland altogether. Mao sanctioned and encouraged the murder by public execution of rich landlords and peasants. Millions of people died in the reforms. Vast People's Communes were created, consisting of hundreds of farms, sometimes even thousands – Henan commune was made up of 9369 households – and peasants no longer worked their own land. Some of the greatest works of propaganda art are concerned with the Great Leap Forward. There was, for a time, at the beginning, a sense of boundless optimism about the whole enterprise: pictures of peasants toiling happily in the fields of Great Northern Farm Number One, bringing in the sorghum harvest, or men and women hammering rivets into every part of China's new steel infrastructure.

Mao also ordered mass rural industrialisation: his now famous 'backyard smelters' were introduced throughout China and in 1959 the Great Leap Forward officially began. Every peasant was a Stakhanovite and every production target was surpassed. At least that was how it appeared from the official statistics, but the official statistics became more and more divorced from reality with every month that passed.

Frank Dikköter in his comprehensive English-language

study *Mao's Great Famine* and Yang Jisheng in his equally thorough study *Tombstone* both describe how farming practices changed from the days of the efficient, self-sufficient, almost capitalist smallholdings of the early years of the PRC to the large collective farms and finally to the giant, inefficient People's Communes. When the famine came there were no reserves, there was nothing for people to fall back on at all. Both accounts of the famine draw on previously unseen Chinese government primary sources and their accounts are harrowing in the extreme. Over forty million deaths by starvation is a conservative figure. It was the end of Mao's agrarian revolution. By 1962 the Politburo had instructed the full unwinding of the disastrous policies of mass collectivisation and by the mid-sixties food production had recovered to its pre-Great Leap levels.

Mao meanwhile had stepped down from one of his top jobs and he had even contemplated retiring from the front line of politics altogether. But this never happened. For some reason – perhaps because his revolutionary zeal remained undimmed, perhaps because he feared being isolated – he remained as chairman of the Party. Nevertheless, he was no longer at the centre of power and his role was becoming increasingly non-executive, something that he was neither used to nor enjoyed. He became suspicious that Deng Xiaoping and Liu Shaoqi were building their own power bases with a view to challenging his leadership, and in order to reassert his pre-eminent control he turned to Lin Biao, field marshal of the People's Liberation Army, and Chen Boda, both trusted Mao loyalists. Together they put together the now famous

Little Red Book, properly titled *Quotations from Chairman Mao Zedong*. Mao had a natural, earthy, aphoristic turn of phrase, though it is his more extreme quotations that are remembered today, such as: 'Dog shit is better than dogma. At least you can spread dog shit on the fields.' The Little Red Book became China's Bible. Almost a billion copies were distributed and it marked the beginning of Mao's comeback propaganda campaign.

Divisions began to appear in the CCP. At one extreme were Deng Xiaoping and Liu Shaoqi, who were accused by Mao's allies of being 'rightists', and at the other extreme were Lin Biao and the Gang of Four, which comprised Mao's wife Jiang Qing (a former movie actress from Shanghai) and three men, fanatical Mao loyalists who had originally worked together in Shanghai: Zhang Chunqiao, Wang Hongwen and Yao Wenyuan. In between these two camps were the Group of Five, the so-called moderates.

In May 1966 Mao set up the Central Cultural Revolution Group. The Gang of Four was put in effective control. It was through the CCRG that Mao controlled the ensuing horror of the revolution itself. Mao announced to the Communist Party that 'representatives of the bourgeoisie have sneaked into the party, the government, the army and various spheres of culture and are a bunch of counter-revolutionary revisionists. Once the conditions are ripe, they will seize power.' Lin Biao organised students to agitate on university campuses and to criticise the education system for being counter-revolutionary, and the most enthusiastic students began to attack their teachers. Deng and Liu attempted to

contain the trouble. Zhou, as ever, tried to mediate between the factions.

It was at this moment that Mao returned to the public stage. He was seventy-two years old but in July 1966, in front of the cameras and reporters of all of China's media, he swam across the Yangtze River at Wuchang (the town where the 1911 Xinhai rebellion had begun). The whole of China marvelled at this audacious and hugely symbolic act. The Great Helmsman was back. The following month Mao addressed a rally in Tiananmen Square of over one million delirious people, many of them students, waving their Little Red Books and screaming in adulation: 'Chairman Mao will live for ten thousand years.' No one else could come close to this cult status. Mao had returned to the top of Chinese politics and the Great Proletarian Cultural Revolution was underway.

The Great Proletarian Cultural Revolution had as its incredible aim the total destruction of the old Chinese society and its replacement with something new. There was, as there often is with revolutions that seek to iron out the inequities of the social order once and for all, something sublime about its madness. The old hierarchies of dynastic China were proving almost impossible to dismantle. Confucian modes of thought persisted despite the best efforts of the Communists, and superstition and religion were still the norm in the countryside. To the infuriation of the ardent communists, it appeared that the people wanted to live in servitude forever. Furthermore, there was growing resentment at the bureaucratisation of the revolution and also at the widespread perception that the Party was hatching its own aristocracy. All these factors help

to explain the particularly explosive nature of the violence that followed, but they only go part of the way.

On 5 August 1966 Mao made his own big-character poster, encouraging people to 'bombard the headquarters'. The same day he wrote an editorial piece in the *People's Daily*. Young students' energies were directed towards attacking the 'four olds': old ideas, old culture, old customs, old habits. Chaos, Mao proclaimed, was preferable to the order of a Party infiltrated by the bourgeoisie. Anything that smacked of tradition or deference, anything western or capitalist, should be destroyed. Students and high-school pupils formed gangs – the infamous Red Guards – and set about terrorising their teachers and passers-by in the street, or indeed anyone who had the faintest whiff of pretension or the slightest trace of foreign influence. The victims were paraded in the 'jetplane' position: their arms were stretched out behind their backs, whilst their chests were thrust downwards towards the ground. They would be tormented and denounced and forced into day-long sessions of self-criticism. There were arbitrary beatings and many people were murdered during these sessions. Many others later committed suicide. The police were culpable, helping the Red Guards find targets among the five proscribed categories: the landlords, the rich peasants, the reactionaries, the bad elements and the counter-revolutionaries. It didn't stop there. The energies of the Red Guards were also directed towards China's ancient heritage. Books, buildings, paintings, temples, tombs: all were targets. Many were vandalised. This two-year-long Walpurgis night was the most destructive phase of the Cultural Revolution and during this dark time

nothing was sacred. Even high-ranking Party cadres, people who had been in positions of authority since the days of the civil war or the Long March, were not spared. Instead they faced the Stalinist nightmare of suddenly being transformed from the accuser to the accused.

Finally, with the economy suffering from the nationwide terror, Mao began the process of calling off the Red Guards. He instigated the 'Up to the mountains and down to the villages' campaign, whereby the young were urged to travel to the countryside and learn from the peasants. This had the effect of dispersing the gangs of young people from the cities. Secondly, he ordered the People's Liberation Army to take over the job of seeking out 'counter-revolutionaries'. The campaign 'to cleanse the class ranks' continued the horrors of the Red Guards and if anything the army was even more thorough. Though the exact figures are still the subject of intense debate, it is probably fair to say that over the course of the next few years, tens of thousands of people died and hundreds of thousands were arrested.

By 1971 even the most fervent Mao loyalists were beginning to question the direction of the Cultural Revolution. And it was in 1971, in an atmosphere of growing but unarticulated scepticism, that Lin Biao, one of the architects of Mao's comeback campaign, was accused of plotting to take control. It is impossible to know whether this was in fact the case or whether the accusation was made merely so that Mao could move against him. Whatever the truth, it is widely believed that Lin Biao decided he was in such grave danger that all he could do was get to Mao before Mao got to him. To

this end, he planned to assassinate Mao. This alleged plot was supposed to have been uncovered when Lin Biao's daughter leaked the details to Zhou Enlai. Lin was then left with no other option but to flee. On 13 September he boarded a plane for Russia but mysteriously it crashed in Mongolia. Was it engine failure or lack of petrol, was it brought down by a bomb or was it shot down? Mao is said to have denied any involvement.

Lin Biao had been Mao's anointed successor but now he was dead. Zhou Enlai persuaded Mao to rehabilitate Deng. From June 1974 onwards Deng was given oversight of the Politburo, the Military Affairs Commission and the State Council. Deng and Zhou were both in favour of ending the Cultural Revolution altogether and they succeeded in diluting the influence of their rivals, the Gang of Four, whose zeal remained undimmed. Gradually, the Great Proletarian Cultural Revolution was drawing to a close.

In 1976 three historic events occurred that changed the political and social landscape of China forever. First, on 8 January, Zhou Enlai died. Then, on 9 September, Mao died, and finally, several weeks later, the Gang of Four were arrested on the orders of Hua Guofeng by an elite unit of the People's Liberation Army. A period of purges ensued, during which many of the ultra-leftists who had risen to position during the turmoil of the Cultural Revolution were denounced as 'vicious anti-Party conspirators' or 'residual dregs of the Gang of Four' and then placed under arrest. Many were sentenced to life imprisonment. Some were executed.

An unprecedented renaissance occurred in almost all walks

of life, including in the fine arts. The people were allowed to taste a little of the oxygen of freedom and this included the freedom to criticise the mistakes of the past, in particular the dreadful excesses of the Cultural Revolution. Deng, who following Zhou's death had been purged by the Gang of Four, was reinstated by Hua but in gratitude for this gesture, Deng then proceeded to outmanoeuvre Hua and become de facto leader. (Deng did at least set one new precedent: instead of purging Hua and sending him down or worse, he allowed him to retain his position on the People's Committee and disappear quietly into the woodwork.)

With the Gang of Four under arrest, Deng wanted to put some clear water between himself and Mao's legacy. He calculated correctly that this would shore up the support of the people and help him defeat his remaining political enemies who regarded themselves as Mao's heirs. A profound sense of relief swept over the nation. People felt that now, after years of fear, they could finally express themselves. This brief flowering of relative liberty in 1978 is traditionally referred to as the Beijing Spring. The danger for Deng was that this new-found sense of freedom might get taken too far.

*

Ai Weiwei had been in Beijing during the late 1970s. He knew many of the people involved in the arts and had even been one of the twelve founding members of the Stars group of artists. To my mind, three of the most important cultural events in modern Chinese history are the founding of the

Stars group in 1979, the groundbreaking Robert Rauschenberg exhibition in Beijing in 1985 and the seminal *China Avant-Garde* show held in the China Art Gallery in February 1989. Those who believe that Ai Weiwei has come very late to political dissidence should note his membership of Stars from the beginning.

The Stars group was founded by two factory workers, Ma Desheng and Huang Rui – but to say that it was 'founded' over-formalises its initial inception. It began as a small group of friends and acquaintances discussing the strange ideas that they held so dear, among them the possibility that there were better ways to gain access to reality than through revolutionary realism.

The story of the Stars group is an essential episode in the history of contemporary Chinese art. Although many of the Stars participants are still alive and can easily be tracked down and interviewed, and although many of the poets and writers who were part of the same extended social milieu are also happy to share their thoughts, it is nevertheless very difficult to piece together any kind of objective, reliable historical account of those early days. Over the intervening years many of the people involved have fallen out, some have travelled to the other end of the political spectrum and they all remember the key events very differently.

However, it is definitely uncontentious to claim that Ma Desheng was the *primum mobile* of the Stars group. Ma Desheng walked with crutches as a result of childhood illness, but he had by all accounts an incredible energy and vitality. He was passionate about his factory work, he was passionate

about his art, he was passionate about everything. In 1979 he was twenty-seven years old. He had grown up under Mao and witnessed the barbarity of the Cultural Revolution. Ever since he could remember he had wanted to be an artist but he was refused entry into art school because of his disability and so he ended up with no formal artistic training at all. He was sent to work as an industrial draftsman and a designer of woodblock prints.

Huang Rui was Ma Desheng's chief associate. Huang began life as a farmer in Mongolia. He also lacked any formal art training other than a short course at the Workers' Association of East Beijing. Born in 1949, three years older than Ma Desheng, Huang moved to Beijing in 1975 and worked in a leather factory until 1979 when, like most of the other Stars members, he found his way into unemployment and freedom. 'We were like hooligans,' Yang Lian, a poet who knew both men well, once said to me. 'Many of us had been sent down to the country in the early seventies during the anti-intellectualist purge, to work on farms and co-operatives, and after 1978 and the Beijing Spring, we were finally able to come home and the pressure was let off – just a little bit but it was enough.'

As well as producing his own art, Huang Rui also designed the covers for one of the most important magazines in post-Mao China, *Jintian* ('Today'), first published in December 1979 by the poet-artist Mang Ke and the poet Bai Dao. They were friends of Ai Weiwei and of Weiwei's brother Ai Dan. In 1979 the literary-artistic-democratic-revolutionary circles were very small indeed.

Ai Weiwei, then just twenty-two years old and a student at Beijing Film School, joined the Stars as one of the twelve founding members. (Whenever I ask Ai Weiwei to discuss the Stars he says he rarely went to the meetings and that he played a very minor role, partly because he was much younger than the rest of the group. Nevertheless, he signed his name as a founder and he showed his work alongside theirs, putting himself in the firing line.) The group took their name from one of the concepts that regularly came up in their meetings, *ziwo*, which can be roughly translated into English as 'ego', 'self' or 'I-ness'. Their ambition was to bring *ziwo* back into art after decades spent following the depersonalising rules of revolutionary realism. They believed above all else in the inalienable right of human beings to express themselves as they pleased. As Ma Desheng said: 'Every artist is a star . . . We called our group "Stars" in order to emphasise our individuality. This was directed against the drab uniformity of the Cultural Revolution.'

Together, they would meet and discuss their illegal counter-revolutionary ideas: their belief in the necessity of cultivating an individual outlook, of subjectivity and freedom of expression. It is hard to fully understand the risks that Ai Weiwei and this small, tight-knit group of people took without understanding something about the history of art in modern China.

At the beginning of the twentieth century, many young educated Chinese people felt that they were living in the last days of a hopelessly moribund culture that had failed to keep pace with developments around the globe. The defeat of the

Qing dynasty during the Opium Wars and the consequent opening up of the treaty ports, followed by defeat in the Sino-Japanese war in 1895, meant that foreign ideas and technology were easier to come by in the big cities and that the widening gap between the 'classical' culture of dynastic China and the modern culture of the west was becoming more and more obvious. Although the epoch between 1911 and 1949 is often seen as one of turmoil and chaos, it was also something of a golden age for modern China. During this period, right up until the Communist hegemony, Chinese people fully engaged with the outside world: borders were opened, trade was extensive, ideas, people and capital travelled back and forth. China was on course to become a player on the global economic stage, and it was in the process of assimilating the best of western culture into its own much older and equally rich tradition.

The 4 May movement articulated this general sense of urgency combined with dissatisfaction and its progressive thinkers demanded change and transformation. They questioned both the time-honoured belief in the innate superiority of Chinese civilisation and the accompanying idea that China had nothing to learn from the rest of the world. Increasingly they believed that China had been allowed to fall decisively behind the scientific, materialistic, individualistic culture of the west. It was time, they argued, for radical change. In the realm of art, change meant the adoption of the western tradition of realist painting. Ironically, the west itself was in the process of turning its back on realism in favour of modernism in its many guises, but to the intellectual elite in

China, realist painting was seen as the most characteristic and significant of all the western traditions.

The move towards realism was given further impetus by the talks that Chairman Mao gave at Yan'an in 1942 on the future of art and literature. Yan'an is a small town in Shaanxi province, near to where the Long March finally came to an end. It became the headquarters of the Communists and there, in the caves nearby, Mao explained what art and literature must become after the revolution. Translations of the talks are available online today, and hundreds of thousands of such translations were printed during the Cultural Revolution for would-be Maoists abroad.

The Maoist model for the future of art in China combined Soviet-style realism with Chinese folk art and the new hybrid was known as 'revolutionary realism' (in literature it was often referred to as 'revolutionary realism combined with revolutionary romanticism'). Revolutionary realism became the orthodoxy in art for the next thirty years and it wasn't until the Stars and their contemporaries articulated an alternative at the end of the seventies that artists began to realise they were in exactly the same position in relation to the rest of the world as they had been in 1919. The only difference was that now realism was the moribund tradition. Once again China had been left behind and the rest of the world had moved on.

After Yan'an, revolutionary realism was the only permissible form in art or literature. And just as in the Soviet Union, a hand-picked group of artists and writers were put in charge of spreading the word and keeping a watchful eye over the activities of their colleagues.

The apogee of government-controlled socialist realist art in Soviet Russia can be seen in the propaganda posters produced during the 1930s, with their images of muscular, square-jawed workers and peasants striking heroic poses. In China, the propaganda posters produced during the Mao years are perhaps the most memorable legacy of the revolutionary realist art movement with its instantly recognisable style that blends Soviet socialist realism with Chinese folk art.

In the literary sphere, one of the exemplary pieces of socialist realist writing in the Soviet Union was *The White Sea Canal*, commissioned by the government as a purportedly realistic account of the building of the 180-mile canal joining the White Sea to the Baltic Sea. Maxim Gorky was made chairman of a committee tasked with writing *The White Sea Canal*, though he never once travelled north to see the canal being built, where hundreds of thousands of political prisoners were hacking through marshy, mosquito-ridden forests and dragging lumps of granite. This was fantasy and propaganda masquerading as realism. If you read *The White Sea Canal* today you could easily be forgiven for thinking that the canal was one of the few noble monuments to the Soviet era and not simply yet another giant tombstone. Many years later, Solzhenitsyn paid a visit to the White Sea Canal and he had this to say:

In 1966, I spent eight hours by the canal. During this time there was one self-propelled barge which passed from Povenets to Soroka, and one, identical type, which passed from Soroka to Povenets. Their numbers were

different, and it was only by their numbers that I could tell them apart and be sure that it was not the same one as before on its way back. Because they were loaded altogether identically, with the very same pine logs which had been lying exposed for a long time and were useless for anything except firewood. And cancelling the one load against the other we get zero. And a quarter of a million corpses to be remembered.

And it was the same in China. In the 1960s there were two particular *grands projets* which occur again and again in propaganda posters and in literature. One was the new bridge over the Yangtze River at Nanjing, and the other was the new 125,000-kilowatt Shanghai steam turbine. The periodical *Chinese Literature* published two essays allegedly written by workers, describing their glorious experiences of working on these mammoth projects.

So Yan'an marks a turning point in Chinese culture. At Yan'an Mao ushered in his own narrow aesthetic that allowed only one permissible vision of reality and insisted that this version must be commemorated in state-sanctioned art. Anyone who deviated from this reality would be silenced. It was not long before the corpses began to pile up just as they had done on the banks of the White Sea Canal.

Across the country, in university art departments and academies, revolutionary realism was the only thing on the syllabus. To be accepted into an art department, a student had to spend many years at high school mastering the techniques of realist painting. A university undergraduate art course con-

sisted of drawing busts of Mao or Lenin or Marx, going on field trips to villages and factories and sketching workers and peasants. Even the traditional forms of Chinese ink painting were commandeered, adapted to the tenets of revolutionary realism. Even now, in fine art departments in China, the emphasis is still on realist painting. Perhaps it is hardly surprising then that the generation of Chinese artists that came after the Stars were particularly attracted to surrealism and *pittura metafisica* and pop art, as the natural way to put their finely honed painting and drawing skills to more subversive use.

From 1949 onwards, no other kind of art was permitted to be taught or practised anywhere in China. To make matters worse, thanks to the isolation of the Mao years, an isolation that in its effects was very much akin to the isolation of the Qing years, normal contact with artistic developments in the rest of the world was drastically impaired. (At least the Qing showed moments of enthusiasm for foreign culture: for example the imitation Versailles that they built to the northwest of Beijing, or the series of paintings in which the Yongzheng emperor was depicted in European dress.) Once again, the Chinese intelligentsia was plunged into darkness, ordered to conform to a single worldview and become part of a single system, hermetically sealed from the rest of the world, self-reinforcing at every turn. The final isolationist stroke was the closure of the universities and academies by Mao during the Cultural Revolution and the expulsion of many artists and writers to the countryside for re-education. Any kind of non-Party art practice after that point ceased altogether or had to be carried on in total obscurity.

After Mao's death in 1976, when the shadow of the Great Proletarian Cultural Revolution was finally lifted under Deng Xiaoping, the universities and fine art academies began to reopen on a large scale and students were once again allowed to nourish themselves on the thin gruel of revolutionary realism. But then in 1978 the Beijing Spring began and something incredible happened at the old hundred-metre-long grey brick wall at Xidan junction on Chang'an Avenue which had been used for years by Beijingers as a community notice board. Encouraged by the atmosphere of truth and reconciliation that Deng was attempting to foster in order to distance himself from Mao's legacy, the wall became a meeting place for people from all over China who had come to Beijing to express their grievances about what had happened during the Cultural Revolution. Very soon the 'Democracy Wall' was covered in poems and one-page magazines and big-character posters that were a jumble of obituaries, memories, hymns to liberty, prayers. It also became a sort of Speaker's Corner, where new ideas were discussed openly and where people went to meet and to read each other's work. It is worth emphasising again just how few these early pioneers were. They all knew each other, they all met at the Democracy Wall and went to continue their discussions in restaurants and nearby parks, or at each other's homes.

Deng used the young people of Beijing, just as Mao had done. Once the Gang of Four had gone, he no longer needed them. The Wall was closed down and moved to Ritan Park, and Wei Jingsheng, an associate of the Stars who had posted his now famous demand for a 'Fifth Modernisation' there,

was arrested. The slogan or goal of 'Four Modernisations' was first used by Zhou Enlai in the sixties. China was to modernise its agriculture, its industry, its science and its military. Deng had continued to push the idea of the Four Modernisations when he became paramount leader. The Fifth Modernisation that Wei Jingsheng called for was, of course, democracy.

Today it can be hard to appreciate quite what a 'year zero' 1977–8 was for poets and artists in China. Three thousand years of cultural history had been wiped off the board by Maoism but nothing of substance had been put in its place, not even the obvious alternative of the western tradition of modernity. These post-Revolution poets and artists emerged into a wasteland, shattered remnants of the past lying scattered around them. The umbilical cord to the millennia-old classical Chinese traditions had been almost completely severed by events of the twentieth century: by the 4 May movement, by Maoism and by the recent years of totalitarian control of the arts.

So much had been lost. The elements of Chinese classical civilisation did not lend themselves to being used in a piece-meal fashion. To overemphasise the point – but not by much – language, philosophy, art, food, medicine all functioned as parts of a whole and were aspects of a single worldview. It was an interlocking and self-ramifying system that was not designed to be cherry-picked or to have its constituent parts used in isolation. To cling on to classical styles in painting or poetry when so much of the classical worldview had been fragmented or demolished was a forlorn enterprise. There was

another reason why the classical Chinese traditions had become so remote to the generation of artists and writers emerging after Mao. Since the early twentieth century thousands of new words had been coming into the Chinese language from the west, often via Japan: words for time, mind, space, science, political concepts, philosophical concepts. The number of imported words – and thereby imported concepts – increased after the revolution and today much of the Chinese language used in everyday discourse by an educated Chinese speaker is of comparatively recent foreign origin. Chinese indigenous cultural traditions had been assailed by many forces – political, aesthetic, semiotic, scientific – and they had not been able to withstand the assault.

Everything had been blasted open and the artists and writers were standing in the ruins, or at least that is how they saw it. They had the shattered remnants of Chinese cultural history and the ruinous legacy of Maoism behind them. They had a few books and ideas from the aesthetic traditions by now venerable in the west – such as modernism, relativism, individualism – which Mao and the Party had attempted to suppress. (In oral histories of the Cultural Revolution there are quite a lot of testimonies from people who say that they secretly read banned translated material that had been looted by the Red Guards.) But even if they had been fortunate enough to have access to prohibited material, for decades they had been deprived of the right to speak in their own voice. Is it any surprise that they of all people were most keenly aware of the need for individual freedom of expression, for democracy?

On 27 September 1979 the Stars group organised an impromptu show of their own works in Beijing, hanging their canvases on the park railings outside the China Art Gallery. It was a truly revolutionary act. Today some people argue that these artists and writers were merely attempting to do in their own fields of endeavour what Deng was demanding of the country at large: modernisation. They were patriotic reformers acting in the field of art. But this doesn't do them justice at all.

On 28 September, a day after the triumphant opening of the Stars al fresco show, the police arrived and ordered the paintings to be taken down. On the 29th, the show was declared to be illegal. To an observer today much of the work in the show can seem naïve, or derivative of the work of Picasso or the Fauvists or the Impressionists. Such derivativeness was perhaps inevitable. Yet there are some works that are charged with an explosiveness and energy which is utterly unique and quite breathtaking. These works are intriguingly reminiscent of some of the art that was produced in Soweto during the last decade of apartheid. Long-suppressed energies, individual artistic vision, so much that was buried for so long, finally surging to the surface. Furthermore, the originality of the work was only half the point; simply to be painting in styles other than that of revolutionary realism was a major act of rebellion. The statement was plain, and deeply renegade, even post-Mao: there are other ways of seeing reality.

On 1 October 1979, the thirtieth anniversary of the foundation of the People's Republic, the Stars group organised a march. They wanted to protest at the total absence of human

rights in China. Under a banner that read 'We demand democracy and artistic freedom', the group held its unprecedented march from the Xidan Democracy Wall to the headquarters of the Beijing Municipal Party Committee. Finally, the Stars were granted a small exhibition in Huafeng Studio in Beihai Park. The exhibition lasted for only ten days at the end of November but it was a huge victory for artistic freedom in China.

The following year, 1980, the Stars organised themselves into the Stars Painters Society. The twelve listed founding members were Ma Desheng, Huang Rui, Wang Keping, Yang Li, Yang Yiping, Qu Leilei, Mao Lizi, Bo Yun, Zhong Acheng, Shao Fei, Li Shuang and Ai Weiwei. The head of the Artists' Association, Jiang Feng, grudgingly allowed them to hold a second exhibition in the China Art Gallery itself, the inner sanctum of Communist art orthodoxy. Jiang was an apparatchik with unimpeachable Party credentials and he calculated that the exhibition would be a disaster because the public would not be able to make any sense of the Stars' bizarre new art.

Jiang was quite wrong. What the public made of the exhibits is hard to guess, given that no one in China had had any exposure to anything other than revolutionary realism for the last thirty years, but the show had hundreds of thousands of visitors in two weeks. After the show, there was 170 yuan left over from ticket sales (official shows always had a small entry fee) and a huge party of the exhibitors and organisers, with other members of associated art groups, had a meal at Moscow, one of Beijing's only foreign restaurants at that time.

They blew the whole lot on Russian food and vodka and beer, and Ma Desheng stood up and gave a speech in a foreign language of his own invention, which Huang Rui translated as best he could. Things finally seemed to be going in the right direction.

But after the success of the show, the Stars faced growing criticism. It appears that the authorities began to wake up to the dangers of an aesthetic that promoted an individualistic view of the world. It was made quite plain to the Stars that they would never show their work again in China. They were obliged to disband the group and gradually, one by one, they either gave up art forever or drifted into exile. Ai Weiwei left for America in 1981, utterly disillusioned by his experience and convinced that the only route to artistic freedom was to go abroad. He was followed by almost all the other original Stars members. Wang Keping went to Paris, Ma Desheng to Switzerland, then also to Paris; three more of the group moved to America: Zhong Acheng, Shao Fei and Yang Li.

During the early 1980s, there were a few other unofficial or quasi-official art shows, including the first Xi'an exhibition of modern art. In June 1981, the Chinese publication *Art Monthly* sponsored a national conference that questioned received ideas about art in China. Several curators and editors of official art magazines also had a profound impact on the rebirth of Chinese art by encouraging the new generation of artists and disseminating their work. Li Xianting in particular stands out. He was on the inside – a state employee – yet he was constantly finding ways to propagate the new art. He was the editor of *Art Monthly*, for which he wrote conten-

tious pieces under a pseudonym until in 1983 he published a series of essays that discussed abstract art and was finally removed from his post.

By the mid-eighties a new generation of artists had begun to emerge. The Stars group was, if not forgotten, then at least banished to the sidelines. This new wave of artists were less interested in the west's early modernism, Impressionism and abstract expressionism than the Stars had been, and more interested in America's post-1960s art. Robert Rauschenberg's Beijing show in 1985 had a catalytic effect on art in China and the late eighties was a carnival of experimentation in every conceivable western genre.

However, this carnival came to an abrupt end in 1989 and it was after that turning point that the great crop of artists emerged who are now most associated with the label of contemporary Chinese art. The mood of the post-1989 years contributed to the rise of 'cynical realism', a mood of hopelessness, of ambivalence and coolness towards reality. It is only more recently, since 1995, that Chinese art has really managed to dissociate itself from its Chinese roots and like a tributary, join the great river that is the tradition of global contemporary art.

The 1989 *Avant-Garde* show has often been talked of as the Chinese *Freeze*, although this is a little unfair as Hirst and co. seem rather trivial in their concerns by comparison. But in its self-awareness and determination to incite a reaction, it was similar. Once again, Li Xianting was involved, this time as exhibition designer. The venue was the National China Art Gallery. It was the first time modern art had been allowed

into the hallowed exhibition space. The genesis for the exhibition had come a few years earlier when there was a gathering of artists (not yet contemporary but modern) from all over China at Huangshan in Anhui province. Someone proposed that the work should be brought together in a national show and on 5 February 1989 the doors of the National Art Gallery opened.

Li Xianting had maximised the show's effect by placing installation and pop art in the first room. And though performance art was strictly forbidden, many of the most memorable works were performance pieces, put on without the requisite permissions. People had never seen anything like it before. One artist, Wu Shanzhuan, was selling prawns and another, Li Shan, was washing his feet, but it was a woman artist called Xiao Lu who really commanded the attention of the authorities. Two hours after the exhibition opened, Xiao Lu fired a live round from a revolver into her exhibit on the first floor. The authorities panicked and within an hour the entire show was closed. Xiao Lu's artistic statement has since been called the first shot of the Tiananmen Square massacre. The exhibition did open again, but it was closed for a second time due to a bomb scare, which also turned out to be a work of conceptual art. It was opened for a third time and finally closed on 19 February. It was more than ten years before contemporary Chinese art was next allowed to grace the most important exhibition space in Beijing.

Could the 1989 show have happened without the Stars? Perhaps something like it would have taken place sooner or later. The explosion of art groups and associations in the early

eighties and the very long list of shows that took place give the impression of an unstoppable momentum. But had the Stars failed completely things might have been very different. Many of this new generation of artists mention the crucial influence of books, monographs and periodicals that arrived from abroad in the years following the Beijing spring and prior to Deng's crackdown. Yet it was the Stars who first lit up the darkness of Chinese art after the Cultural Revolution and it was the Stars who took the first major risks and broke new ground. It was the Stars who insisted on the radical links between democracy, freedom of expression and art, and it was the Stars who paid the price. Li Xianting was quite clear about the influence of Stars: he criticised the 1989 show for lacking a true avant-garde spirit and for not building on the achievements of the Stars.

*

The meeting in the west London hotel was a success. I had learned an enormous amount about the early days of post-Mao art. Ai Weiwei was, after all, living art history. I kept in touch with him, and when I was next in Beijing I took the opportunity to pay him a visit. As I remember, he was in high spirits. He had just got back from somewhere – Seoul, I think – where he had been opening a new show, and before that he had been in London, at Tate Modern, where his *Sunflower Seeds* had had a triumphant reception. I can't remember why now, but when I saw Weiwei that time in Beijing, we got talking about his decade in New York and his wife dug out an old

album of black-and-white photographs from the 1980s, when Weiwei was a young man – gaunt, handsome, still very much the penniless artist. The photos were fascinating. Pictures of Weiwei and friends in his grim, tiny, dark apartment; an old racing bike stored on the kitchen table, shoes kept under the sink. He shared the tiny apartment with two other Chinese guys. There is a photo of their three narrow mattresses lined up on the floor, and the three of them lying head to toe, posing for the camera.

'Who are those guys?' I asked.

'Them? Oh, that's Chen Kaige and Tan Dun.'

I was astonished. 'You mean *the* Chen Kaige – the movie director, the director of *Farewell My Concubine*? And *the* Tan Dun?'

'Yes. We lived together for years. Before any of us had a break.'

Serendipity, Weiwei claimed. The young Chinese expat community in NYC was very tight in those days. I turned over the page: a photograph of a skinny Chinese kid, Tan Dun again, standing next to the fridge tuning his violin. I asked Weiwei to translate the scrawled caption. He scrunched up his eyes to read the spidery text: 'Tan Dun practises before going out busking.'

I imagined all those hurried commuters in Manhattan, years ago, streaming out of the subway to their offices, passing a Chinese kid with a violin – little knowing that they were being serenaded by one of the greatest violinists of the twentieth century . . .

The following day I returned to Weiwei's studio. I was on

my way to the airport and I wanted to say goodbye; Wei-wei's house is a couple of hundred yards from the airport expressway. But this time things were very different. The atmosphere had changed entirely. Weiwei was still sitting at his round table in the garden, where he conducts all his interviews, but now he was in conversation with two men dressed in civilian clothes. There were no smiles. There was a terrible air of tension. Who were these men? The secret police? Weiwei seemed to be paralysed by their presence. I was afraid to interrupt. Gao Dan, the doorman, didn't know who they were. He looked very concerned. I decided to leave. On the way out I glanced at Weiwei. If one word could be used to describe his method in art and life it might be 'leeway'. He often says he has no idea where his work will go next. Like the direction of a cat's next step, he says, he is powerless to predict such things and what is more, he does not want to. He is free and he makes a virtue out of uncertainty. But now he was hunched up in a ball and he looked frightened, like a trapped animal.

3

Beijing is hot in July, even in the middle of the night. As I stroll jet-lagged through the fabulous futuristic Arrivals Hall of Beijing International Airport, a building that looks more like part of a spaceport than an airport, I am beginning to feel very anxious about what might happen when I approach Weiwei's door.

Months later, when I look back at my diary entry from this day, my state of heightened anxiety seems unrecognisable – in fact it almost seems melodramatic. After all, by early September, normal service had been resumed: people were trooping in and out of Weiwei's house and his office had come to resemble a doctor's waiting room during an epidemic as it filled up with assorted journalists, curators, art dealers, dissidents, fans, people bringing gifts, people wanting him to sign works of art and assorted other random visitors whose motives weren't always immediately identifiable. But this was not the case at all in the days just after his return home. The atmosphere was very bad, most people were giving him a wide berth, and in order to faithfully report the effects of Ai Weiwei's arrest on the wider community it is important to try to convey the sense of fear and paranoia that hung in the air, those first few days after his release.

During Weiwei's spell in detention I had tried to seek out other artists in Beijing who knew him, to ask what they made of his arrest. It was an uncomfortable time for many people and several refused to meet or speak at all – and who could blame them? At the Hong Kong Art Fair in May 2011, which one might have thought was far enough away from the all-seeing eye of Beijing, people would glance over their shoulders and moderate their voices to a whisper. The arbitrary arrests were hugely intimidating and the atmosphere of fear that came to prevail in Beijing was almost enough to discourage me from going back once Weiwei was released.

Some people in the west defend China's record on the suppression of free speech, claiming that it is a short-term necessity. China, they say, is attempting to turn itself into a giant Singapore and we must sympathise with any regime that dares to take it upon itself to drag this vast and until very recently almost entirely rural economy into the twenty-first century. And among Chinese citizens, even educated liberal-minded Chinese citizens, it is surprising quite how often one hears versions of the Deng-style mantra: that change can only come slowly and from the top and that people shouldn't rock the boat. And if you disagree with this way of thinking, people quickly move on to the attack with arguments that make the defender of freedom of expression sound dangerously naïve. Surely, they say, the Chinese Communist Party should be given the benefit of the doubt. Is it not better that a few honest men and women languish in jail than a country descend into anarchy?

The Chinese Communist Party is like God: you cannot see

it but it's all-powerful and it is everywhere. It is a parallel government, following the model prescribed by Lenin according to which the Party ensures that its agents infiltrate the state at every level and hold every key post. Far from being an open, egalitarian mass movement, the Party that Lenin envisaged was narrow, secretive and elitist: the people are ruled by a select few who make decisions behind closed doors and periodically draw fresh blood into their ranks from below.

The Chinese Communist Party has no legal status under Chinese law, other than a one-line reference at the beginning of the Chinese Constitution. And by law, every other organisation of any kind has to register with the Party; the Party alone exists beyond and above the law. It has no website, no published membership list; its committees meet in secret and decide upon everything long before there is any kind of public debate. Every government post, every editor of every newspaper, every CEO of every big state company is appointed by the Party. Before the big board meetings of China Oil or Chinese telecoms companies, the Party members will meet to decide upon the outcome of the impending board meeting. Before the newspaper editor decides how to handle a story, the Party will tell him or her what to say. There is no free press, censorship is the norm and the orders on what to report and how to report it come straight from the top of the Party.

The Party is an invisible political machine that controls all aspects of Chinese life, including the Communist government itself, and this is the aspect most foreign to outsiders. The Communist government has a president and when the president travels abroad he is styled 'President of the PRC',

but the president is also the secretary of the Party and the Party role is senior. All government jobs are held by people who are also of high rank in the Party, and in every case it is the Party hierarchy that takes precedence. Richard McGregor, in his excellent book *The Party*, illustrates this point very well with the example of Shanghai car number plates. The secretary of the Shanghai Communist Party's plate is 0001; the mayor of Shanghai's plate (mayor being the top government job in the city) is 0002.

So, from the outside, China might resemble any other country; its institutions and methods of government are recognisable. It has the familiar organs of state: a foreign ministry, a ministry of finance, a police force; it has law courts, prisons, universities, think tanks and an army. But this resemblance is deceptive. The reality is that the Party Organisation Department (a sort of cross between a human resources department and the thought police) is responsible for deciding who gets all the key jobs and who gets what promotion, no matter whether the job in question is in the Ministry of Finance or in the law courts. Similarly, if a Party member is found guilty of corruption, then the Party investigates the case first and only when it has made its own decision does it instruct the formal offices of government to do their work.

The only occasions when one sees the naked power of the Party are when it is threatened. In 1999 the peaceful spiritual sect Falun Gong ('Cultivation of the Wheel of the Law'), whose activities are focused on the practice of qigong, traditional Chinese physical, mental and spiritual exercises, dared to organise a sit-in outside the Party's Beijing headquarters

in Zhongnanhai. More than ten thousand Falun Gong practitioners gathered for a whole day's peaceful, silent protest. It was the largest public demonstration since the Tiananmen protests of 1989. Falun Gong had survived for many years and although there had been moments of tension with the authorities, nothing could have prepared them for what happened next. As soon as Jiang Zemin, the then president, learned about the sit-in he sent out the order to exterminate Falun Gong in China. The niceties of proper arrest procedures, fair trials and prison sentences were dispensed with and the power of the Party was briefly exposed, as it has been during the detention of Ai Weiwei. What followed was a wave of mass abductions of Falun Gong practitioners. 'Abductions', 'kidnappings' and 'disappearances' are the only words that accurately describe what happened. People were not formally arrested or charged or put on trial, they just vanished, and since Jiang announced the crackdown it is estimated that those who have been either murdered or sent to work camps or lunatic asylums number in the tens of thousands. A minority were criminally charged and sentenced to terms of imprisonment; in the majority of cases there was no formal criminal charge or sentencing. As of August 2004 the overseas-based Falun Gong rights movement published a report that claimed that more than a thousand detained practitioners had died as a result of torture or maltreatment.

More recent Chinese politics furnishes us with another example. Bo Xilai, the former mayor of Chongqing and one of the accused in the Neil Heywood homicide case, will not be charged and tried in a court of law, nor will any of his associ-

ates who have also been rounded up – or if they are tried, the trial will offer nothing more than the membrane-thin veneer of a legal process that will obscure more than it reveals. Their fates will first be decided behind closed doors. The notion that the Party would allow its dirty laundry to be displayed in public is unlikely to say the least. It is indisputable: China does not have the rule of law in the sense that that phrase is applied to the systems of democratic nations.

It is important to note at this point that many people take a less pessimistic view of the political situation in China, including many foreigners who live full-time in the country. Some Beijing friends, who have lived in the city for twenty years or more, find the perspective presented in this book too negative, too lacking in objectivity. While being anything but sympathetic towards the regime's treatment of Ai Weiwei, they point out that there have been significant advances in individual freedoms over the past twenty years that should not be overlooked, and that today Ai Weiwei has resumed his online posting and this has in part legitimised the widespread use of social media to reveal corruption and other social ills. Furthermore, although it is true that the authorities are dealing with him in the time-honoured tradition of China (to quote Nicholas Bequelin, senior Asia researcher at Human Rights Watch, they are making him 'wear small shoes', as the Chinese saying goes – that is, they are forcing him to suffer a never-ending series of petty bureaucratic demands and administrative vexations in order to wear him down), nevertheless he is no longer in jail and he is once again able to communicate with the outside world.

The present work is in part an attempt to capture a moment in time; to record for posterity one man's account of his eighty-one days of interrogation at the hands of the Chinese state at the start of the second decade of the twenty-first century. In doing so it is necessary to provide background information for the non-specialist reader and the choice of background information is coloured by this author's own experiences: of living in China, of living in Hong Kong, of interviewing Ai Weiwei. One cannot sit in a room, for hours on end, watching someone's evident suffering, without a growing sense of sympathy – and anger. Nevertheless, I have tried to report facts that do not support the conclusions that I hold and I have tried to be honest in my observations so as to allow readers the space to form their own judgements from the material that is presented. And inevitably, when one is dealing with a subject as emotive as contemporary China, even one's choice of facts to present becomes controversial, and statements that one might assume are relatively uncontentious turn out to be nothing of the sort.

To take one example: whatever one's view of the Chinese Communist Party, whether you think it is a benevolent oligarchy, or a wicked self-perpetuating power nexus, or something in between – a collection of pragmatic career politicians who are attempting to steer the world's most populous country through the troubled waters of the twenty-first century – I think it is undeniable that the round-up of lawyers and dissidents and activists that took place in April 2010 was a step beyond mere pre-emptive detention; it was characteristic of the behaviour of a totalitarian regime as defined

by George Orwell, or more recently by the British sociologist Anthony Giddens, for example. Yet many other people would disagree.

*

It is still dark when the taxi drops me on the edge of Cao-changdi village. Suburban Beijing is comprised of 'villages', though there is no longer any way of knowing when you leave one village and enter the next. Urbanisation has blurred all the old boundaries and the farmers' fields are long gone. As Weiwei likes to point out, the positive characteristics of village life – community, self-sufficiency – have vanished. You could quite easily starve to death before you found either a helpful stranger or a shop. All around lies the detritus of the modernis-ing world that is familiar to anyone who has travelled: un-finished trenches, presumably dug for utility pipes of some kind but now lying empty, untarmacked lanes littered with rubbish and inexplicably large boulders. Cats, dogs, the sound of a rooster. Brand new three-storey buildings stand next to des-perate hovels. Not a star is to be seen in the night sky. This is one of the effects of Beijing's dense pollution: even on the rare occasions when the daytime sky is strikingly clear and blue, there are still no stars at night – just the dull orangey blackness. I turn onto Weiwei's street and I see that it is empty except for one stationary police car, parked right outside his front door.

I try to walk at my usual pace, to look as if I'm not antici-pating being apprehended. Nervously, I approach the police car, expecting the door to open and a stern official to appear.

Nothing happens. As I walk past the window of the car I glance inside. I can see two policemen, just boys really, their seats tipped right back, fast asleep. The bathos is almost funny. I knock quickly on the big steel door to Weiwei's compound and after a wait of about a minute the door is opened by an unsmiling man: Gao Dan, one of the most stalwart members of Weiwei's staff.

The courtyard is unchanged from my last visit. It was designed by Weiwei himself, as were the brick buildings that surround it: the living quarters, the studio, the offices and the storerooms for his work. Weiwei designed the entire compound in an afternoon and it was built in sixty days. I remember him once describing how during his crucial sojourn in America in his twenties he discovered Bernard Leitner's book *The Wittgenstein House*, a collection of photos and text about the house that Ludwig Wittgenstein designed for his sister in Vienna. Wittgenstein designed everything, from the dimensions of the rooms to the door handles, window frames and stair rails. At the time Weiwei already admired Wittgenstein's philosophical ideas, but to discover that the philosopher was also an equally rigorous self-taught architect was inspiring, though it was fifteen years before Weiwei could embark on a similar project. A decade and a half later Weiwei rented some empty fields in Caochangdi. Two months later the compound was finished. It was quickly recognised as a masterpiece and before too long it was appearing in architectural magazines around the world. And so, almost by accident, Weiwei's architectural practice, FAKE Design, was born.

But Ai Weiwei has gone further than Wittgenstein. Today

he is known internationally for the Bird's Nest stadium he designed with Jacques Herzog and Pierre de Meuron for the Beijing Olympics. However, in the square mile or so around his compound in Caochangdi there are dozens of other large complexes of buildings that Weiwei designed and built from scratch in a period of about two months in 2008, all in his own idiosyncratic style. To date he has undertaken over seventy architectural projects, more than most architects achieve in a lifetime.

The courtyard in Weiwei's compound is the size of a tennis court. There is a lawn in the middle and some ten-foot-high bamboo plants to the left. In front of the entrance is a large table on which Weiwei has arranged two dozen of what appear to be fist-sized stones. They are prehistoric flints – axe heads or cutting tools of some kind. Weiwei is also a keen and knowledgeable collector of Chinese antiques. To the right of the lawn a cobblestone path runs down the side of a one-storey brick building, connecting the entrance to the cobbled area where people sit outside in fine weather. Last summer, when he operated in very different circumstances, Weiwei could be found here most mornings, routinely giving interviews to international journalists. There is a great slab of knee-high stone that acts as a bench, and a round table and a selection of chairs. On the right is a doorway that leads to the offices and on the left the doorway to the home that Weiwei shares with his wife, Lu Qing, who is also an artist. Weiwei is a very early riser. He prefers to work in the morning, starting long before dawn.

Gao Dan leads me to the main office, a large white room

off the courtyard, and turns on the light. There is a collection of sofas and wicker chairs, a good coffee machine and further desks, chairs and computers for the six or seven staff who come in every day. Gao Dan gestures for me to sit down, then he disappears back into the darkness of the courtyard to find Ai Weiwei.

When I was last here, back in November 2010, this room was filled with staff. There must have been thirty people crammed in together, all working on computers or making phone calls, and this didn't even include the staff who help Weiwei with research, with exhibitions or with the planning and execution of works of art (many of his big pieces, such as *Sunflower Seeds*, require enormous amounts of logistical planning). Now many of these members of staff have been scattered to the four winds: some were arrested, the rest have fled. Only a few people have dared to show their faces again in Beijing.

The door from the courtyard opens and I recognise Weiwei's burly frame. The effect is rather cinematic. He steps out of the darkness and I suddenly find myself unsure how to begin. Asking him how he is feeling now seems more than a little absurd; like asking someone who's just been run over by a bus if they're all right. We shake hands.

'How are you feeling?' I ask foolishly, unable to stop myself. Weiwei shrugs, unsmiling.

'I'm OK. Not so bad.'

I note that he's much thinner but he doesn't look OK at all. We chat and I'm pleased to notice that at least he sounds like his usual self. His voice is soft and relaxed and not as strained

as it was when we spoke on the phone. Despite his diminished girth he is still a commanding presence.

There is something very solid about the person of Ai Wei-wei. He is not tall but he usually looks robust and strong. This can be seen particularly in his shoulders and his neck, which have the contours of a wrestler or a weightlifter. Now he is wearing a loose and well-worn dark blue tailless linen shirt and a pair of linen trousers, equally worn. Perhaps he senses my anxiety about his physical and mental health. Anyway, he reassures me that he is fine, that he is just relieved to be out, and then he motions towards the sofa.

We sit down and immediately begin to talk. After five minutes Weiwei still hasn't smiled. This is unprecedented in my experience of talking to him and it compounds the underlying atmosphere of claustrophobia and tension. But something else occurs to me as well: in his current state I don't think he has the presence of mind to dress up his thoughts. Often in regular interviews, he repeats verbatim long phrases that he has said before or if he doesn't want to answer a question, he rambles gnomically. But now he is vulnerable, completely lacking his normal confidence and poise. Finally, he sighs:

'You know I've spoken to no one about this – apart from my wife and a few friends. It's still so fresh. Maybe we should make a record of it. I think it could be a very important record because it will show the general condition of this state, of this judicial system, of this kind of mentality and behaviour.'

He looks down at the floor. After a pause he continues:

'Every second seemed so long when I was in there. It was

endless and it was terrifying because everything was so distorted. It's torture to put a human being in such a hopeless condition. You feel you are dropped into a hole and you will never be discovered again. You have no rights. You cannot contact anybody and you are totally cut off from reality, even from the faintest traces of any connection to reality. And also you have no access to a lawyer, which is terrifying, because of course they are accusing you of so many things. And every day it goes on and on: the psychological brainwashing, the harassment, the torture...'

His voice trails off again. He bows his head, perhaps wondering how to explain it at all. I can hear my clothes rustling as I shift in my seat. I wonder what he is thinking about, what torments and humiliations. Then the light returns to his eyes and he is back in the room again, and as he does so often in conversation, he takes a step back, metaphorically speaking, and with the lightest of touches he adds a pigment or two of irony to his sketch:

'...But solitary confinement has its advantages. You see: I lost weight. I'm more healthy now. It even cured my diabetes...'

He gets up out of his chair and asks me if I want a cup of coffee. He makes me a double espresso and tells me to wait a minute while he pads back across the courtyard to his house to fetch his tea glass. While I wait for Ai Weiwei to return, I try to compose my thoughts. The empty office, the diminished number of desks, Weiwei padding across his silent courtyard – there is a terrible melancholy to the whole scene. His compound, normally alive with activity, is now

reminiscent of a derelict theatre, or an abandoned military operations room. An unexpected and malevolent force has been encountered; a crushing defeat has been inflicted, from which recovery is impossible. All that remains are shattered dreams – and the general, the impressario, the all powerful sorcerer, has been shrunk back to human proportions. Or is it just my imagination?

Weiwei comes back in from the courtyard, carrying his lidded tea glass. The tea is the colour of whisky and the tea leaves are floating in the water like seaweed. As soon as I see his solid reassuring presence such treacherous thoughts vanish. In an hour the compound will probably be filled with people; it is just too early for them yet, I tell myself.

'I think we should go next door,' says Weiwei.

He leads me back across the silent courtyard and into his house. The sky has already turned a deep, dark blue; dawn is on the way. The main room in Weiwei's house is large, about ten metres in length with a six-metre-high ceiling. Like all the buildings that he has constructed in the neighbourhood it is made of bricks laid in the English bond, and it has an incredibly peaceful atmosphere. At one end is a huge French window, and beyond, the garden. Outside, abandoned among the bamboo stalks, is *Marble Arm*, a single arm extended with the hand and fingers making the internationally understood gesture for 'Fuck off'. A giant table extends almost the whole length of the room and around the table are beautiful Qing dynasty chairs. On the wall, next to the window, I notice a tiny wire model that Weiwei made for his magnificent piece *Descending Light* – a monumental red and gold chandelier,

lying on its side on the floor, still illuminated. The model looks very like the arc of hoops that joins the Bachelors to the Chocolate Grinder in Duchamp's *Large Glass*. Incongruous among this elegance, on the floor in the corner is a pile of dog shit that thankfully, for some reason, doesn't seem to smell.

'Our dog is so old,' says Weiwei as a brown-and-white floppy-eared dog totters out from under the table. He kneels down and pats the ancient creature and mutters some soothing words.

Standing there, in the still quiet of his reception room, while Weiwei plays with his dog on the floor, I find myself wondering again how a relatively quiet, seemingly unassuming human being can be the focus of so much activity. And yet he always seems so self-contained, so centred. He sits and sips his tea, or wanders in to inspect his workshop, or taps out a few thousand characters on the internet, or chats with some of the many strangers who, before the arrest, dropped by every day to pay their respects. The overall scheme that connects all this activity is visible only to him. His various companies have generated large sums of money over the last few years, though prior to that, as recently as a few years ago, he was not well off and had to earn his living by dealing in Chinese antiquities. He reinvests a lot of what he earns, in building his team of researchers and investigators, in expanding his art infrastructure and attempting ever more ambitious projects. The *Sunflower Seeds* exhibit at Tate Modern took more than three years to produce, with sixteen hundred artisans individually painting each ceramic seed. The idea was that visitors to the Turbine Hall should walk across the giant car-

pet of seeds and bend down and scoop them up by the handful and examine them and then toss them away – perhaps as Mao tossed away millions of people's lives. Indeed, Weiwei had foreseen that people would slip the seeds into their pockets and handbags and carry them home. He had planned for this eventuality by supplying the gallery with eight million extra seeds so that the vast pile could be topped up every night. This would be a work of art that was as bottomless in its generosity as the magic porridge pot in the children's story; a work of art that everyone could own. It was also a marvellous branding exercise: everyone who visited the exhibition could take a few seeds and then give them to their friends. Soon they would be scattered across the land. Regrettably, due to alleged 'health and safety' issues, the work was sectioned off and people were never able to experience the artwork in the way that Ai Weiwei intended. Even so it had a profound allusive force – each sunflower seed was handmade, as each human personality is unique, and yet the seeds were dumped into a great pile, depersonalised as oppressive regimes seek to depersonalise the individual, so you have to make a concerted effort to differentiate one seed from another. The costs of this project were enormous.

Today, it would be accurate to describe Weiwei as rich. If he makes a work of art, he will have a queue of collectors waiting to snap it up. But he lives frugally: there are no sports cars or expensive clothes (and no fancy holidays, obviously). And he pours a lot of the money he makes back into a sort of aesthetic-political-revolutionary movement that is determined to change the way people view reality and, by so doing,

to change China. Later in the day Weiwei shows me the collection of belongings that he took from his cell in a plastic bag when he was released: he plans to use the towels and toothpaste tubes he brought home with him to make a piece of sculpture or an installation. So, with a small shift in perspective, his eighty-one days of imprisonment may be transformed into a ready-made, a work of art.

The large room is quiet. We begin.

'So, can we go back to the week before your arrest?' I say.

'Shall I start right from the beginning?'

'Yes. Why don't you just talk, and we'll see where it goes.'

Weiwei doesn't need to pause to compose his thoughts. It is very useful that he is a natural raconteur with a colourful turn of phrase, even in English. He would have made a great demagogic public speaker.

'It was the end of April 2011,' he begins. 'I was going through Hong Kong to Taipei because at the end of the year I was supposed to have a show there. My first show in . . . well, not in China but in Chinese society because up till now I have been forbidden to show my work in Beijing. One show was planned for March in the Ullens Centre in Beijing but at the last minute it was cancelled, they suddenly told me that it was not allowed. So clearly I realised that maybe this one in Taipei wouldn't happen either, but still you work on it. You always hope that maybe there is a chance that you can show your work. On this occasion I was planning to meet with the gallery in Taipei to see their site but the week before I was due to go I began to see signs of a lot of strange behaviour. The police came to the studio and asked me for fire certificates,

to check safety, or they came and checked people's identities. It was quite obvious they were planning something but of course you can never know precisely what they are going to do. Also they checked my wife's studio, which is not far from here, and the house of my girlfriend, with whom I have a baby boy. They checked also there and both of them mentioned it to me and told me that the police were there, pretending to ask something, sniffing around. I didn't pay much attention because for a long time I know that normally they wouldn't touch me. And if they change, if suddenly they decide to get me, it must be a big, big decision. And then I cannot avoid it anyway, it will be so severe that nobody can help me.'

'These were Beijing police? Not army or the Public Security Bureau?'

'Yes. They were Beijing police. You realise this is a kind of force you cannot avoid. It is like a shadow falling. There is nothing you can do. So you forget about it and you try not to pay it any attention. But gradually I began to realise that something was happening as so many people were being arrested all around me.'

'Were these people you knew?' I ask.

'People I know, people I don't know, people I know from the internet. From Twitter I am familiar with their activities. But they are much less active than me. They are either writers or lawyers. They are professionals. They have to do their work so they have been arrested and nobody knows where they are. Or rather I should say they have been disappeared because nobody sees the legal papers, nobody gets any answers as to where they are.'

'Even now?'

'Yes. Some are still inside. Some are released. So, I get a sense of danger, of urgency, and I start to do some exercise in February, to walk an hour in a park regularly. I think that if it happens, if I get sent down, then I will need a stronger body condition. And actually, this really helped. Meanwhile, the local people who work for the government began to secretly pass messages to my neighbours, saying, "You know that Ai Weiwei? You tell him he's in big trouble now. And tell him to stop doing all those things that make foreign people happy, those things that make the Chinese government lose so much face." They passed on these warnings and I said, "What? I'm just an artist!" And another person who also worked with the officials was driving past my assistant and they stopped and rolled down the window and said, "Listen: this village has eighteen people just watching Ai Weiwei and monitoring his activities. So you tell him, he's in big trouble now." So, I know all these things are going on but what can I do? On the internet I give opinions about whatever comes to my mind, to whatever event has happened. People ask me what's my opinion of this and that and I answer. This kind of thing happens almost every day or week because, you know, I spend so much time on the internet. Once we take nude photos and put them on the internet; it's a joke, it's a kind of art or action. Another day I put my photographs online – you know, the *Study of Perspective*. It's just for fun, it's a way to express your hopeless intentions, or your attitude towards the situation. And so that day, 3 April, Jennifer, my assistant, and I decided to go to Taipei. We were at the airport, we were queuing up – there

were two lines – and I see that Jennifer is being approached by officials but she doesn't even notice. I realise the trouble has finally come and when they pick up my passport they announce, "You are not allowed to leave because your travel may damage the state security."'

'Were those their exact words?' I say.

Weiwei thinks for a moment. The criminal charge of choice in China has gone from 'being counter-revolutionary' to the blander but equally grave 'damaging state security'.

'Yes. "Your travelling may cause damage to state security." Those are the standard words they use to stop anybody who wants to travel. They stopped me once before. I was going to travel to Liu Xiaobo's Nobel ceremony in Oslo. They stopped me and used the exact same sentence. So of course there is no argument. You cannot say "Why?" or "What?" – it's just said as a fact. So then a group of undercover agents came in and said, "We have to find a place to talk." They were very serious and well prepared. That was maybe eight thirty in the morning. So I followed them through some secret passages going down to the airport street level. We had been on the top level. Then this big van is there with many undercover agents waiting. So I had to get in the van. On each side the police were holding me and then they covered me with this big hood and then I thought, oh no, this is the end. Then the car started to drive and nobody said a word. Nobody said anything.'

'What was your emotion at this point?'

'I felt quite hopeless. Because this is an act by the state at the highest level.'

'But you had prepared for this?'

'Yes – but you can never really prepare yourself. You can prepare in case someone comes to talk to you but this is like you only see in the movies, when people capture hostages. On the way they were very rude, no explanation, nothing.'

'So it must have been terrifying.'

'Yes. Very terrifying. But more than terrifying. Everything has been designed like a programme so you just become part of this long journey. So I sit there quietly but then I find that I am starting to suffocate because the hood is made of very thick material. It gets so bad that the soldiers even try to use a key to puncture a few holes in it. But it's not possible, the fabric is just too strong.'

'Black?'

'Black, heavy, strong material. Then after an hour and a half – but later I find it wasn't that long – it just felt like it was – we arrived somewhere and they carried me into a room . . .'

'Carried you?'

'They have to hold me under the arms because I can't see anything and then I have to sit in a chair. After a while they ask me to stand up and take off the hood. I see I'm in a room in front of a very strong, well-built person. You only see such a person in early Russian movies. I mean when Hollywood movies picture a Russian bodyguard. This kind of person.'

'Was he wearing a uniform?'

'No. Plain clothes. But the room is completely sealed.'

'What colour was the room?'

'A shabby hotel. A bad hotel room. You can only see that this is the case because everything has been moved; there are images left on the wall; there was a sign, there was a picture,

there were two beds, you can see because it left some kind of traces on the wall. So they push you against the wall and search you. But of course there is nothing to be searched. They just take off your belt and ask you to take a seat. You have to follow the instructions. You have to sit like this.'

Weiwei sits with his back straight in his chair and his palms flat on his knees.

'How old was the man who gave the orders?'

'Thirty-five, forty.'

'Did you get any human feeling from him?'

'No. It's so dramatic. It makes you feel totally cut off from normal sensibilities.'

'Is that deliberate?'

'Yes. Of course. I think so. Even to a ridiculous degree.'

'But when you enter this world it is their reality. It's not that it's theatre for them, at all.'

'No. You're right. But for you? You feel: what? Why? It's so crazy. If I'm a terrorist I would understand. It's so much like performance. And yet, yes, it's so real. You can see from their eyes, from their movements, they are top professionals. But I've been lucky. I had done interviews with people who were under the black hood and they were thrown from the mountain or beaten, severe physical punishment. I did a lot of interviews. I did a study. Also I made a movie about it. A documentary movie. So I heard many people telling me the same story, repeatedly. Of course, even when people tell me their story and I know it's a hundred per cent true I still can't believe it, not completely, it's not possible.'

'Did you talk at all at the very beginning?'

'No. You cannot talk. You are not allowed to talk. You are just sitting here, in this pose: two hands on your lap, facing forward. And there are two guys sitting right close to you, one in your position and another one also like this, and they stare at you and will never move their eyes, will never blink even. And no emotion, absolutely silent. The first day I'm sitting like this all day, from arrival in the morning until ten in the evening and my hands are cuffed to the chair. Then later on the guy comes and starts to question me . . .'

This method of guarding the prisoner, with two policemen or soldiers sitting only inches away, twenty-four hours a day, is a common practice during such interrogations in China. The prisoner is not allowed to look at the guards but the guards never take their eyes off the prisoner, not even when they are lying in bed, trying to sleep. Not even when they go to the toilet. For the prisoner it is exhausting, alienating, demoralising, terrifying. It is, of course, a form of torture.

'You had no water or food?' I say.

'You can ask for water. You will have food when they have food. They bring you a small box, bread, but at the time you have no sense to want to eat anything. And of course you need water, then you say, "I need water," and they pour you water. But they are very careful. They wait for it to become cold, because it's always hot, boiled water from an urn. Then when they are sure it is cold, they let you drink it. Then you give the cup to them and they put it back.'

'The two guards arrived after the first man had left. And there was a table?'

'They arrived at the same time. There was an interrogation table.'

'Eight hours with no one speaking?'

'Not a word. And they are sitting right next to you, staring you in the face. No emotion. You glance at them and they stare back. You look away and glance at them and they are still staring at you. Like stone. Like rock.'

'Where do these people come from?'

'They are police. Highly trained for this matter.'

'And so, during those first eight hours, what happens to your thoughts?'

'You know this is definitely not a joke. You realise this is going to be a long, long journey. You look to see how big the room is, what kind of dress this person has, you look at the details, the rug, the wallpaper.'

'What were the men wearing?'

'They're just undercover police, dressed just like normal people: shirt, jeans.'

'Could you have told they were undercover police had you seen them elsewhere?'

'No. They look just like normal people. Except they have crew cuts and they are very strong, very good build . . .'

'Could you imagine what these people were thinking? What do they know about you?'

'They know nothing about me. They don't even know my name. They are just another unit who has to watch me or, how you say? Give me some humiliation. But they are not interested in me. This is their daily work. Every day it's someone else.'

'So to them you're just yet another faceless prisoner?'

'Yes. There are just many, many rooms. Later I found out many of my friends and colleagues have had this experience. They described their rooms. Exactly the same details.'

'At ten p.m. someone came?'

'Someone came.'

'Old? Young?'

'A man. About forty, well dressed. A sports jacket. I remember it's coffee-coloured, a little bit reddish. He looks a bit professorish. He threw a big bunch of papers on the table. And then the interrogation began.'

'So if you saw him in the street, you wouldn't look twice...'

'Yes. I saw so many people in there that looked just like my neighbours. You could never imagine that's the kind of work they're doing. You think they're like us. And then he starts to ask me, "Who are you?" "What is your profession?" This made me desperate. "But you must know who I am," I said. "You took my passport. You arrested me." He said, "Yes. But this is procedure." Another one is doing the typing.'

'So there were two?'

'Yes. One was always typing the transcript.'

'A man or woman?'

'Both men of course.'

'So when this man came in to speak to you – did he smile?'

'He's quite contented . . . But he's a little bit of a nervous type. He threw his material on the table. He's kind of short, not very tall. He said, "You may be quite well known but I don't know you at all, trust me. I went on the internet to check about you." He points at papers that he's just thrown

on his desk. On the internet there's a lot of information about me, a lot. I looked at his papers and I was very confused. This must be a well-planned operation from the highest level but this guy who starts the interrogation knows absolutely nothing about me. He just personally did a check, even though it's not officially required . . . I begin to feel I am getting into the hands of people who are not professional and that makes me very worried indeed.'

'Someone higher up has deliberately put you into a machine?'

'Yes, into an old machine. A machine that just processes people until the end. And one of the first questions was, "What is your profession?" In Chinese, "artist" is *yi shu jia. Jia* means "specialist". I say I am *yi shu jia* and he says, "*Yi shu jia*? How can you call yourself *yi shu jia*? You are so arrogant." So I say, "What else do I call myself?"'

'But why did he object?'

'Because he is proper Party member, old style. He said the most you can call yourself is "art worker", one who works in the art field. If you call yourself an artist you are so arrogant. In the old category in China, during the Cultural Revolution, people were never called artist. They were called art workers. Everyone was a kind of worker. Chairman Mao, even, was a worker. Everybody is a worker. A farmer, a soldier, a cultural worker. He would not accept that I call myself an artist. So from the very start I realised, oh God, this is quite an old book, quite an old reality, quite an old system. And these people who are going to be with me, they will never understand my art, my thinking . . .'

Weiwei falls silent. Sometimes, as he is talking, recalling the events, his larynx tightens and his voice changes. As I watch him I find I am wondering – worrying – about his emotional and mental state. What damage has been done? And what will be the long-term effects of his detention? The day Weiwei was released he was driven up to his door and unceremoniously dumped on the pavement. In the online footage he appears to be completely disoriented, to have been thoroughly institutionalised. And now his current situation is far from the ideal conditions for recuperation. I hope that at least my interviewing him may be therapeutic in some way. He has urged his colleagues who were detained at the same time to write down their own experiences as well, and for the same reason.

Perhaps because of his own psychological make-up Weiwei will fare better than other people. His life at every step has been characterised by confrontation, by adversity and state interference in his life and the life of his family. His material and professional success has come only very recently. But then again, who knows for certain, when many of the effects of his confinement may be buried well within, and may never surface or only after many years?

Eventually, Weiwei begins again:

'During the whole interrogation, they accused me of five crimes. At the very beginning the first thing they accused me of was "inciting the subversion of state power". But of course, they didn't give me any proof. They just said, "You always attack the government, the Communist Party, their policies. You are so brutally, ruthlessly doing that, all the time, and

88

now you have to pay for your crime. We will let people know you are a pornographer, your lifestyle is rotten and you are a liar on your taxes and people will understand what a bad person you are. We will ruin your reputation." So from the beginning, they just openly told me that.'

'Was this during the very first interview?'

'Yes. The very first day. I said, "What are your allegations?" He said: firstly, the subversion of state power. Secondly, economic crimes. I said, "What economic crimes?" He said, "You are lying to the public. Your art and the making of your art doesn't cost that much but you sell it so high." I said, "Wait a minute – we need some basic communication here. You don't understand." But then I stop myself and I think, should I answer these questions? I can remain silent instead if I want but maybe I will face violence like all the stories I have heard from other people who have been taken away? Maybe they will become really mad? Or I can try to reason with them, I can try to explain. So I choose the second. To explain, to make them understand about art. "First, the price of artwork is not decided by me, it's decided by the market and by the galleries who take my work. I don't make so much work and lots of people want to buy it from the galleries who represent me. I think it's absolutely too high, also I'm very much ashamed but this is not in my control. I am not involved at all. And also, like all artists, for a long time no one wanted to buy it. I gave my work away." But the interrogator doesn't give a damn shit. He says, "You lie to the public, you copy other people's work, and you just lie to the public all the time. All you're trying to do is get money and all you do is criticise the government to

get attention for your work." Those arguments are very shallow but it's very easy to understand why they make them, they want to have a reason to get me. They need a justification and so they want to convince people that my criticisms of the government are just to further my own causes. This way they can avoid the criticism itself.'

'But do you think they believe the arguments that they make?'

'I don't know if they believe them or not. Of course, you might attack the government in order to raise your profile – any artist can do that. But I am successful anyway, without doing that. So why would I risk my life by attacking the government, if I was only interested in self-promotion? I am really risking a lot. For what? Fame? Money? I don't think so.'

'What did they say to that response?'

'They say nothing. They will never argue anything. They don't want answers. Everything is so ridiculous. Everything is so real but at the same time so ironic. I want to say, "Come on, this is not real! This is not a professional way to handle this. It doesn't leave you with any dignity. There are no valuable arguments here."'

'But isn't that all the more frightening? That the whole thing is so ludicrous?'

'Yes. The accusations are ridiculous and it is much more frightening because you've been thrown into the hands of people who will never understand what you are trying to say. I cannot explain to them about what I do. And on the other side, they are also very frustrated. They don't know anything about art and they have never even touched political crimes

before. I said, "Please, get on the internet to see how people discuss my art.'"

'But you said this man had researched you on the internet?'

'Yes, but only through the Chinese internet, the domestic internet. Which means a lot of criticism but no balanced view. But they think all opinions from outside China is all political people against China, people who want to make China look bad. So, they only read the domestic internet, which is very negative about me, just government attacks.'

It is the lot of any original artist to have to try to convince other people that his or her distinctive way of seeing the world is worth something. The default position of most cultural establishments is to reject real novelty of perception when it first emerges, and many artists who are now revered, from Duchamp to Warhol to Ai Weiwei, were initially ridiculed or ignored by influential critics or gallerists. However, convincing gallerists and critics of the validity of one's artistic vision is one thing; convincing two secret policemen while being detained in a shabby room in Beijing, with the threat of life imprisonment or worse hanging over your head, is quite another.

Today in the west plenty of people don't like conceptual art and find it bogus or difficult to understand, but China very much lags behind the west. When it comes to taste in art the vast majority of people in China are conservative in at least one respect: they still expect works of art to take the form of sculptures or paintings, or perhaps buildings. (I am not talking here about the highly sophisticated players in the Chinese art world but rather the average Chinese person whose educa-

tion and exposure to more avant-garde forms of art is less than that of their equivalents in the west.) Yet China does have a history of extending the accepted categories of art, a history that precedes the west's. It could also quite easily be argued that many of the west's most modern forms – abstractionism, minimalism, expressionism – have their equivalents and their precursors in the indigenous art of China. Minimalism in the west was quite consciously influenced by the Japanese Zen tradition – however, it is often forgotten that Zen found its first flowering in China – and many of the ceramics from the Song tradition outdo the minimalism of artists like Donald Judd and equally, some of the greatest ink painters used their ponytails as brushes or flicked ink over their shoulders, hundreds of years before Jackson Pollock was born. But conceptual art, in the modern, western sense, is not something most Chinese people are familiar with at all. Weiwei's interrogators, poorly paid Beijing policemen, were being asked to question him about things that made no sense to them at all. They had diligently looked up Weiwei's work online and to their complete bewilderment they discovered that his alleged 'art' consisted of a giant heap of hand-painted sunflower seeds, or the *Fairytale* event of 2007 in which Weiwei inexplicably paid for 1001 Chinese citizens and 1001 Qing dynasty chairs to be flown to Germany. The chairs were arranged around the exhibition space and the Chinese 'visitors' were given spending money and housed in dormitory-style accommodation. They wore clothes that he had designed; they roamed the city for three months; then they went home again. The artwork was about what happened to these people's spirits, their

personalities, during the three-month period. It was their experience, their changing consciousness that Ai Weiwei was interested in. That must have made about as much sense to the secret police interrogators as *Fountain*, the urinal that Marcel Duchamp presented as a work of art, made to the average American when it was unveiled in 1917.

'But did they discuss your journalism surrounding the Sichuan earthquake for example?'

'No, they would not discuss the Sichuan earthquake.'

In May 2008, an earthquake measuring 8 on the Richter scale devastated Sichuan province, killing almost seventy thousand people. Among the dead were a disproportionate number of schoolchildren. The government was slow to investigate why so many schools were reduced to rubble while adjacent buildings remained intact. Over the ensuing months, pressure on the government from the parents of the dead children began to grow. Thanks to China's one child policy, in many cases parents had lost their only child in the ruins of what became known colloquially as the 'tofu-dregs schoolhouses'. Ai Weiwei went down to Chengdu and became involved in the investigation to discover the reasons for the collapse of school buildings. It became clear that bribery, corruption, and backhanders from construction companies to local politicians had allowed the builders to cut corners and ignore the normal rules on building safety. He tried to compile a list of the names of all the dead children, something that the government had neglected to do as it simply tried to sweep the whole matter under the carpet. Without detracting for a moment from the courageous actions of the

bereaved parents and other Chinese political activists, it is fair to say that Ai Weiwei's research played a significant part in forcing the government to undertake a proper investigation. Because of his activities, Ai Weiwei fell foul of the Chengdu police and at one point he was beaten very badly. After his return to Beijing he complained frequently of headaches. A few months later, he was in Germany preparing for an exhibition when he complained of a severe headache and was rushed to hospital. He was found to be suffering from a cerebral haemorrhage, caused by the beating he endured. He underwent emergency surgery, the scars of which are still clearly visible on his head.

'For the Sichuan earthquake I did a lot of things and many things were caused by that. For example we made a demonstration on Tiananmen Square. We walked down Chang'an Avenue. This was very, very severe.' Chang'an Avenue is the Pall Mall or Champs-Elysées of Beijing. For the Communist Party it is a raw nerve that runs directly into Tiananmen Square, for it was up Chang'an that the students marched during the democracy protests in 1989, and it was up Chang'an that the tanks rolled on the fateful evening of 4 June. To organise a demonstration, to march up Chang'an today is an astonishingly brave thing to do, verging on the suicidal.

'But they didn't mention any of that at all?'

'No. No.'

'Why not?'

'Because they disguise their true intentions. They try to persecute me, to frighten me. They say I am in a double marriage and so on. They are threats.'

Ai Weiwei has a young son by his girlfriend. This is unusual but hardly qualifies him as a bigamist, even under Chinese law. But as he pointed out on several occasions during our talks, under the severe conditions of his interrogation and while deprived of any legal counsel, all threats, no matter how preposterous, take on a previously unimagined reality.

'You know, also in Shanghai, my studio was torn down,' says Weiwei. 'That was a very big thing in China but they refused to talk about that either.'

'But did you actively bring up any of those subjects?'

'Yes. I kept telling them what my attitude was, why I wrote the things I wrote, but they tried not to talk about any of it. The whole idea was not to argue with me but to put me under some kind of pressure, to accuse me with different crimes. But at the same time the interrogators were not sure those are real crimes . . . so the whole situation was absurd. Later, they accused me of tax problems. I felt sorry for them. They couldn't find anything solid. They knew that if it came to a real court it would collapse.'

'But did you specifically say to the police, "Why are you not accusing me of X or Y . . . ?" I mean you said at the beginning they accused you of subversion . . .'

At this point Weiwei sighs and falls silent. It is clear that he has spent hundreds of hours trying to understand the behaviour of those who ordered his arrest. The decision to arrest him and then to release him suggests there is an ongoing disagreement among those in the Chinese regime who can decide his fate. Weiwei's treatment, it must be said, has been exceptional and the fact that he wasn't simply thrown into an

oubliette has, perhaps, something to do with his huge profile in the west. The sympathy that his case aroused around the world, and the subsequent pressure that was put on the Chinese government by western leaders, presumably had some impact on his specific case, though on few others. The Nobel laureate Liu Xiaobo has not had the same good fortune, despite widespread international condemnation of his internment by the Chinese authorities. Also around the same time that Weiwei was arrested, some fifty-five other artists, writers and activists were rounded up and many of them have so far not been heard of again. Ai Weiwei falls into a very exclusive category of people who have been 'disappeared' and then released without suffering any serious physical maltreatment. It would hardly be a surprise if this led to a sense of survivor guilt, or if this sense of guilt actually propelled him towards a second confrontation with the authorities.

'They chain-smoked so badly,' says Weiwei, after a lengthy pause. 'I said, "Look! There're already eight butts there. Before you sentence me I will be dead if you keep smoking like this." The interrogator said, "Oh, you don't smoke? That's your liberty. It's my liberty to smoke. I have to work." Which is true. Those people make no money, maybe three hundred dollars a month. They work twenty-four hours a day. Their phone has to be on all the time. They have to pay the phone bill themselves and they receive calls twenty-four hours a day. They complained to me, "Is this fair?" It's not fair, but what can we do?'

'So these people were at times friendly, or conciliatory in some way?'

'They started to say, "Weiwei, I have to question you in a professional way, a very, very harsh way but you don't have to answer me, you can just say, 'I don't remember.'"'

'Why did they do that, do you think?'

'They want to question someone who has really committed a crime, not someone the Party has told them to pin a crime on for political reasons. The authorities had chosen the wrong people. These guys weren't comfortable and they didn't like accusing me. They had integrity, they didn't want to do it.'

'You'd have thought it would be easy for the Party to find people who would, if you will forgive the phrase, hate you?'

'That's what I thought but no. Completely not. These people are very innocent. They said this is the first time they did a political crime.'

'They normally do murders and so on?'

'Yes. One of them was so frank. He told me that he went to one person's trial to see how it works. So now I know why whenever they have an open trial in China they don't even allow the family to go in. It's because they already have twenty people in the room and they tell you that all the seats are occupied. Now I understand. Those people inside taking up the seats are just like him. They go to the trials to try to understand how these cases work. He said he went to one person's trial. It was Hu Jia's trial.' Hu Jia is an award-winning activist who campaigned for human rights, freedom of speech and the plight of AIDS victims in China. 'Hu Jia was released recently after three and a half years in jail. And it was so interesting because this interrogator told me about his case. I asked

97

why they sentenced Hu to three and a half years. I wanted to know the answer because I thought my case was comparable to his. And they told me he had been very stubborn. He had already been taken in and let out three times already but he was still very troublesome so they had to do it. You see how the pattern goes. When Hu Jia went in he and his wife had a two-month-old baby – just a new baby but now he's almost four years old. Hu Jia is very strong spiritually but of course mentally he had some damage . . . Long-term damage. Once they even told me, "Weiwei, two years in jail and you are finished. Nobody can handle that. You are totally finished." You know they are very honest to tell me that.'

'You think that's true? If you look at the other people you know?'

'Yes. I think Chinese jails, more or less, do very strong damage to you. Of course, for political prisoners, because they have belief, that makes them stronger but it is too hard. No one can come out undamaged.'

'Were they telling you this as a threat?'

'No. Later they became sympathetic to me. They would come in but they didn't want to question me. I am talking about the first two people. And we started to discuss other things: how to make a noodle, a really good noodle, a Beijing-style cooked noodle. And we all discussed what to put in first. You know: the proportions and the cooking time. He said, "I just cannot question you." They are very discouraged. They felt very bad. They are professional and at the same time they don't believe in this. They think it's ridiculous.'

Weiwei is suddenly looking very tired and depressed. I

stand up and suggest I get some more hot water from the kitchen. Weiwei nods, still lost in his thoughts about his conversation with the interrogator. I pick up our tea glasses and walk through into the small room at the end. I fill the kettle with water and turn it on. I notice that I feel hugely relieved now that I am no longer in the room and this makes me feel ashamed. But just listening to Weiwei's account is intensely stressful and quite exhausting.

4

As I wait for the kettle to boil, I study Weiwei through the doorway. It is actually a very peaceful scene. The large, airy room, the sunlight now streaming in through the floor-to-ceiling windows, the man and his faithful hound. Again, I register how strange it is to see him without hordes of followers and colleagues.

Weiwei has said that it was in New York that he first read *The Philosophy of Andy Warhol*. It was, he claims, like a lightning bolt striking him between the eyes. After Warhol there was no turning back: he got into Jasper Johns, an artist whose work he had seen in books in China but had rejected because at the time it made no sense. Then he moved on to Duchamp, whom to this day he still refers to as his 'master'. Finally his travels led him all the way back to Dada and surrealism. He might not have had any money for materials but at least he now had an apprenticeship. He turned to everyday objects that he found at the foot of his bed in his cramped apartment. He made *Violin* in 1985 out of a violin and the handle of a shovel, *Hanging Man* in 1985 and *One Man Shoe* in 1987. And in 1985 he said goodbye to painting with three portraits of Mao: *Mao 1–3*.

In 1988 he had his first and only show in the US: *Old*

Shoes, Safe Sex. It took place at Ethan Cohen's gallery. Cohen, nowadays a highly respected New York gallerist, was back then a young man of verve and prescience. The 'Safe Sex' of the show title referred to a knee-length rubber raincoat that had a condom conveniently attached at crotch height – AIDS was just then becoming a mainstream fear. This early work is charged with strangeness and raw energy. It is unsettling and disquieting but with hindsight it can be understood as the birth pangs, the first coughing and spluttering as he found his way towards fluency. Later, Weiwei's alchemical method would encompass objects made from mother of pearl, ancient temple wood, fine ceramic, paint, plastic, crystal, Palaeolithic relics. Nothing is sacred, everything can be transmuted into something else.

The show received a few notices and the work was compared to Dada – not unfavourably – but critics seemed to regard it as too much of a homage to be worthy of particular note. In the context of late 1980s art, no one was suddenly going to go crazy about an obscure Chinese artist's seeming preoccupation with the past. But perhaps this assessment was too shallow. Ai Weiwei was attempting to do more than merely reprise the western avant-garde tradition. Partha Mitter, the scholar of Indian modern art, has made this point in the analogous context of Indian artists' use of the avant-garde: that when non-western artists attempted 'modernism' they were considered 'Picasso manqué', whereas when Picasso raided African tribal art, he incorporated it into his own tradition with his integrity intact. Western art is parthenogenic; Asian art is not.

A violin with a shovel handle means one thing when it is made by a European artist in the 1910s and something very different when it is made by a Chinese artist who has just stepped out of the cauldron of the Cultural Revolution. Owning a violin in 1966 in China might have been enough of a badge of someone's bourgeois leanings to result in them getting kicked to death in the streets, or at the very least forced to do some proper work. And the same can be said of works like *Chopsticks*.

And there are other reasons why the craftsmanship of *One Man Shoe* is not simply a throwback to Dada. Weiwei made shoes when he was growing up in the Gobi – and China as the workshop of the world, as the horn of plenty that has somehow gone wrong, is one of his perennial themes. *One Man Shoe* is a more efficient shoe; a single shoe that works for both feet. It is the insane but logical conclusion of the inhuman aspect of the manufacturing ingenuity of China. The hundred million hand-painted ceramic sunflower seeds that were exhibited in the Tate in 2010 are perhaps the apogee of this career-long rumination. Sunflower seeds were the staple snack during the Cultural Revolution (they are a ubiquitous snack across China today). Each seed an individual human being, nourished by the sun king Mao; now scattered in a vast pile to be trampled under foot, now picked up and weighed in hand, now tossed to one side again, to be lost forever in the undifferentiated heap.

An analogy to philosophical anthropology can be illuminating. The concept of a human being, of a person, of mind and body, of belief and memory and imagination, of feelings

and emotions and good and evil, are not normally considered to be theoretical concepts. They are not concepts we can abandon after the manner of the luminous ether, or phlogiston. They are used all the time, in our lives, atheoretically. The availability of these concepts gives shape to our subjective experience. Through using them, we are able to form articulate expression. The concepts we choose to regard as atheoretical make us what we are.

Weiwei takes the atheoretical objects of our physical reality – the equivalent of these most basic philosophical concepts – and he does things to them that disturb us at a profound level. He says that although we think these objects are atheoretical, they are not. The reality we have created for ourselves is contingent – it does not have to be this way. It is arbitrary. There is no inevitability to human society and culture. It is, at one level, absurd. The ordinary things that we fill our lives with – the shoes, the chairs, the tables – are the incarnations of a particular way of thinking and seeing, a way of thinking that just happens, for the time being, to be in the ascendant. Marcel Duchamp caused people to ask 'What is art?' Ai Weiwei causes people to ask 'What is reality?' And just as with his blogs, where for eight hours a day he would add his words to the endless stream of the internet, so too with his art he heaves his strange new creations into the ever broadening river of reality, hoping that by doing so he will alter its course and change its volume and depth.

It should be noted that there are plenty of people who would regard even this lightweight critique as overly favourable: that his work is derivative; that it is not sufficiently

consistent to justify all the praise. However, for most people, the successes, when they do come, far outweigh the failures.

After his only New York show in 1988, his work dried up. He moved many times and every time he moved he dumped what little work he had produced. But he didn't stop thinking of himself as an artist. The abiding lesson he took from Duchamp was that being an artist was about living as an artist, rather than producing some product, some work of art for a gallery, or even for oneself.

After thirteen years in America, Ai Weiwei returned to China, to an art scene that seemed to him to be well off the speed. Many Chinese artists asked him how they could become successful in New York. He couldn't help them. He didn't know. He had never been successful in New York. But he decided he could help in other ways. There was still little or no experimental art in China, still little idea of conceptual art or pre-retinal art. So Weiwei began work on his three books that have now achieved cult status: *The Black Cover Book* (1993), *The White Cover Book* (1994) and *The Grey Cover Book* (1997). In these books, he wanted to explore new and different ways to think about art, to introduce Chinese artists to the aesthetic revolutions that had occurred in the west while they languished under Mao. The books contain many quotations from Warhol and Duchamp and Johns, and many examples from the work of western artists, but also from the work of Chinese artists that Weiwei knew. It was a collective effort, as was China Art Archives and Warehouse, the space Weiwei founded in 2000 to nurture the new art in China. There was no other artist from China who had

learned so thoroughly from the western tradition and Wei-wei's experience had given him an almost evangelical zeal: he wanted to change China by changing its ideas about art.

These books were of great importance in the late nineties in China. They had a huge influence on art at the time but by 2000 Weiwei felt there was no need to write more. Instead, together with his friend Feng Boyi, he created an exhibition. *Fuck Off* took place in Eastlink Gallery, in a warehouse at 1133 West Suzhou River Road, at the same time as the Shanghai Biennale. The exhibition included works by forty-eight artists, and the work itself and the curation of the work were a million miles from the Biennale. The organisers of *Fuck Off* and the artists involved were not interested in the Chinese curatorial establishment, which was managed by the Party, nor were they interested in western curators or collectors. Again, the impact was felt throughout Chinese contemporary art. 'We had to say something as individual artists to the outside world . . .' said Weiwei later in an interview with Chin-Chin Yap, 'and what we said was "Fuck Off".'

Alongside his curatorial activities, Ai Weiwei continued to make art. Several works stand out from his first decade back in China: *Studies in Perspective* (1995–2003), *Dropping a Han Dynasty Urn* (1994) and *Grapes* (1997) from the furniture series. But by 2003, his work was changing. Indeed Phil Tinari, one of the pre-eminent authorities on Ai Weiwei, suggests 2003 as a useful marker between the outright provocation of his earlier work and the more nuanced and abstract work that has come after.

After 2003 Ai Weiwei turned repeatedly to Jingdezhen,

the great porcelain centre of dynastic China, and commissioned the expert workers there to manufacture dozens of his designs: giant hollow porcelain pillars, oil slicks, *Ruyi*, the seminal porcelain *Hanging Man*, and perhaps most beguiling of all, his beautiful take on Hokusai's painting of waves, titled *The Wave*. The idea of executing a Hokusai-like wave in porcelain came to him suddenly one evening in 2004. He worked late into the night sketching the design and then went to bed. The following day he woke up and heard the horrifying news that a great tsunami had broken across Asia.

Alongside these smaller works Ai Weiwei continued to practise as an architect and to expand his work with photography and video, exploring the changing physical structure of Beijing, filming hundreds of hours of footage through the windscreen of a vehicle as it drove round the city (*Beijing 2003*). This later period also saw him produce works of a monumental scale, such as 2007's *Fairytale*, and in 2008 he became deeply involved in the investigation into the collapse of school buildings during the Sichuan earthquake, covered very well in the deft film made by Alison Klayman, *Ai Weiwei: Never Sorry* (2012). Klayman records Weiwei's journey from artist-activist to activist-artist and captures too the ambiguity felt by many people who know Weiwei: does his campaigning zeal ultimately spring from his unhappy life experience, the persecution of his family and the humiliation of his father? Or is it just a factor of his ego? Or does its ultimate source have nothing to do with his own life experience or ego; does he just want to see the world a better place? Or, most likely, is it a bit of both? And is the greatest danger, for

him, or for anyone confronting tyrannical power, that you run the risk of turning into your enemy? And finally, in 2010, with *Sunflower Seeds*, the vast work that seemed to tie together so many of the disparate threads of his thought and practice, Ai Weiwei emerged onto the world stage as an artist of undisputed talent and significance.

*

I carry the fresh tea back into the room. Weiwei pauses, his hand resting on his dog's back.

'You know, sometimes they actually tried to make my conditions better,' he says quietly, almost to himself. 'Once, after two days I couldn't shit. Normally, every day I shit. Regularly. I go to the toilet every day. I said, "I need a banana." They gave me a banana but it was totally black. I joked: "It must be from the Beijing Cave." You know: Beijing has a cave with fossils of monkeys that are supposed to have evolved into human beings. It's called Beijing Cave. These are the earliest signs of Chinese people. He laughed and said, "I'm sorry we don't have any more bananas. This is the only banana we have left." But after that he started to routinely bring me bananas and oranges.'

'This is the man who looked like a professor?'

'Yes. Because this man, although he is definitely kind of arrogant, he's a little bit proud of himself as well. He said, "I smoke but I never take a cigarette from someone else." He's not, how you say, corrupted.'

I found this incredible. I had assumed that the sort of

people who work as secret policemen, and definitely as interrogators, must be ideologically pure – two-dimensional even – like characters in a Hollywood movie. As I listened, I couldn't help wondering if Weiwei's judgement had become compromised. Perhaps this was a sort of variation of the Stockholm Syndrome that one might expect him to suffer. I pressed him repeatedly on this: surely, I asked, some of the people who dealt with him must have had the zeal and the values of the Red Guards – the fanatical young supporters of Mao who would think nothing of beating their ideological opponents to death.

'I'm talking about the place I was in for the first fourteen days,' Weiwei says. 'At the very end of the fourteen days both of the men had become soft. They started telling me they had given up. One of them said, "I cannot interrogate you, Weiwei. I would rather interrogate a murderer or a thief. I cannot do this any more."'

'But do you think this transformation was genuine? Or were they trying to trick you?'

'Later I found out it was genuine. They were telling me the truth. But at that moment I thought, well, maybe this is just a tactic.'

'What happened at the end of this first fourteen days then?'

'On day fourteen the interrogator came in and said, "Weiwei, the rest will be even more difficult. You may be transferred to many bad places that are much worse than here. You will remember your time here and wish you could come back. But you have to have patience. You have to be strong and have

patience." I tried to capture every word they said. You want to save them because it is so strange they are saying these words to you. But you also don't know precisely what they mean. These two interrogators just suddenly disappeared, which was a big surprise. They thought they would be doing the whole case. In their mind, they told me they would. They said, "We want this to be finished fast. We never imagined a case can be like this, but we can't tell you the details because we're not allowed." The main one, the Professor, was very sorry when he left, he touched my shoulder. Then four guys suddenly came in and said, "Time for you to move." They were all dressed in black suits. They stood, one of them in each corner of the room and then one of them said, "Stand up. Where are your belongings?" They covered my face and I was driven off and moved to another place. Now I was in a military compound. There were two soldiers in front of me.'

'When you arrived, you were in what vehicle?'

'A van. Something like a Buick. Three rows of seats.'

'And your hood comes off again only when you are finally sitting on the chair?'

'Yes. They take me out a few times but always covered so you don't know what is beyond the door.'

'How do you know it's an army base then?'

'The soldiers are in the uniforms of Tiananmen Square. They walk like a performance. They are like robots. Every movement, even the smallest movement is like that. If they want to change position, they stamp their feet like robots. Like badly designed robots. What immediately came to my mind was the movie *Blade Runner*. There is a guy in the

movie who likes to design little robots. They walk, hit the door, spin round, walk off again, hit the wall. It's just like that. But of course it's deadly serious.'

'So now what did you feel?'

'I understood that was what the interrogator had been trying to tell me. Because, you know, this was a completely different kind of condition, a whole set of different principles.'

'So you must have suddenly looked back on the first fourteen days as being better?'

'Yes. It is not nice to find yourself in an army base at all. It is terrifying, really another level of fear. I was very afraid that they would now use other techniques – techniques that I have heard about from other people who were arrested. I wouldn't say I hate the army . . . but yes, I really do hate the army because I hate any kind of army because it is the most inhuman way of organising people. You are into the hands of people only nineteen, twenty years old. But later I found out it's not so bad because everything is so regulated, so empty, so abstract. If you behave in this condition you are perfectly fine. They completely don't understand what's going on. They're doing their job just like the guards in front of the big gate at Tiananmen. "You cannot come in," they shout. You say anything else to them and they just shout "You cannot come in!" Trained to do only one thing and incapable of doing anything else. But for the first week or ten days I was so terrified.'

'But where were you kept?'

'Again, a room. A kind of hotel room. But this room looked so funny because everything was covered with soft cushions.'

'You mean it was a comfortable room?'

'No, to prevent suicide I think.'

'Oh – I see: a padded room.'

'Yes. That's the word: padded. But so badly taped and everything. Very badly. Soft foam everywhere.'

'The walls? The floor?'

'Everywhere. Even the water taps. You turn on the water and the foam around the taps is so dirty because of the moisture. Even the toilet. After a while the foam gets loose, they re-tape it. After a while the wall becomes curved, where it sags because it is so old. But you can't touch anything anyway. You have two guards. All the time. Twenty-four hours a day. When you sleep they sit there and they're not like police. The police, they like phones. They play phone games and they're a little bit loose, you realise later, because when you have soldiers, even at midnight they are still like this: stiff like brooms. They cannot doze but they are so sleepy because their minds are so empty. And sometimes they would argue. One would say, "You cannot blink your eyes!" And the other said, "You did, not me!" Because there's two cameras watching the room all the time and if either one of the guards is caught, if they are found to be sleeping or blinking, they're both in serious trouble. The two cameras can blow up their eyes to the size of a wall. So the cameras can really see if they doze. You realise they are soldiers but they too are just like criminals. They are really being highly watched. Even when they come out of my room they are searched. There's two other soldiers whose job it is to search them . . . They cannot talk to you. They cannot talk to each other. The whole day is silent until someone

comes to interrogate you. The silence is exhausting. Being silent with other people in the room. And when you go to pee you have to raise your hand and say, "Sir I need a pee." They have to say yes before you can even stand up. Then you can stand up but they have to go with you, in this tiny room. One person before you, one behind. One goes to the bathroom door. He stamps his feet and turns round and looks at you and then goes backwards into the bathroom. Then you go in. Between the two of them. The other one follows you in. Stamp, stamp. Then you start to pee. Then they look at your dick because, you know, they have to make sure it's really a dick. It's true! This is their regulation and there's also a camera in the bathroom. They are being watched. After peeing you report to the soldier, "Sir, I have to wash my hands." If you don't say anything they say, "Report!" So you say, "Report, sir, I have finished washing my hands. Can I go out?" They say yes, then one goes backwards. Stamp. You go backwards and again the other one stamps feet and follows. This is total full protection. You cannot make any single strange move.'

'How close were they?'

Weiwei moves his chair towards me. Now his face is forty or fifty centimetres away from mine. Already it feels very uncomfortable.

'This close. And if you do like this –' Weiwei wobbles – 'they immediately jump. They say to me, "If you hit the ground I will be in jail, in your position." But there's so many stories . . . It's another world. They are just nineteen-year-old boys. Before they come to the camp, they are in places where there is no electricity. They are farmers' sons. No toilet.'

'How do you know? You can talk to them?'

'We develop techniques for talking. They change shifts every three hours and every time when their shift came to an end I could see that it was such a relief for them and always as the end of the shift was approaching, they would always keep looking at their watches and muttering, "Fuck! They're late." They would do this even though the next shift might only be late by one minute. Even one minute was too long to bear; it would make them so frustrated, it would make them so mad, "Fuck! They're late again. Fuck." Because they are so desperate to escape the prison cell as well – they're almost as desperate as I am. They signed up to the army for two years when they were still so young and as soon as they become soldiers they have to do so much daily exercise. It's very hard. They have to run five kilometres in less than twenty minutes with all the gear and then there's lots of physical training. Then they have to come and sit in this room and for two years literally they never leave this army camp. There's no vacation, no Sunday, no Saturday; they can only call their family for ten minutes each week, in front of the whole army, with no privacy.'

'Are they conscripts or volunteers?'

'First two years they are volunteer soldiers. They are paid less than forty dollars a month. They join up because they are from such poor areas. In those parts of China, life is so hard. Before they arrived at the army they would never have seen a toilet. There's no electricity, there's no toilet sheets, I mean the paper, they just use newspaper or whatever comes to their hands; leaves, rocks, whatever. Then they see on the

television some advert or something – a movie – so they start to admire the army uniform and they start to say, "One day I want to be a soldier." But now they are so miserable. They're just farmers' children. They feel very sad. All the time they become ill because of the training. Their bones make noises when they move, cracking everywhere because they have to stand all day. They have problems with their backs and they have problems with their legs but they always have to stand to attention. They are not allowed to talk to me. If they do that it would be a very severe crime. They can be removed immediately. They are not supposed to reveal what their names are or where they come from but because they are only eighteen or nineteen they start to talk to me. They are curious. They have so much curiosity.'

'How do they do this?'

'Everything happens during the period when I walk around the room or when I am lying on the bed pretending to sleep. They develop this technology – not technology – I mean they develop this technique. They talk to me without moving their lips. They talk like this, like a, how you say, like a ventriloquist. They have to look at me but they are not allowed to look at each other and I am forbidden to look at them, even for a second. But when I am walking round the room and they are walking next to me, guarding me in this tiny room, we talk without moving our lips. Of course I have to hold my pants because I don't have any belt and my button is already loose. I walk, holding my pants round and round in circles and they march next to me. They have to march and stamp their feet when they turn. It's crazy. I keep asking them if they

can just put in a few stitches, so I don't have to hold it. They could never even agree to that simple request. Every time they said, "We have to check. We have to report to our leader; report about the loose button and see if anything can be done." Every day they walk with me in this military fashion, every turn, every move, maybe even just one step, all very precisely done. Clicking their heels. It's so ridiculous but they have to do it. The camera is watching them so they have to do that. They are being examined. And they keep telling me, "Don't just think about you; think about us. We're still young and we have no criminal record but we are just as much a prisoner as you are." Then they say, "The first day I arrived in the army I so regretted coming. I realised it was such a big mistake." Someone's watching them all the time but they keep telling me these stories. They keep saying to me, "You sleep, we have to stand to attention next to your bed. You eat, we have to stand next to you. You shit, you take a shower, we have to stand there. What crime did we ever commit?" They don't understand what has happened. One day, I noticed that one of them was sad and I said, "Why do you feel so sad today?" He said, "Because the person I look up to, the person I respect..." How do you call that?'

'A mentor?'

'Yes. A mentor. He said, "I am sad because my mentor has died." I thought: What? But he's a farmer's son. How can he have a mentor? I said, "Who is your mentor?" "Bin Laden," he said. "He was killed by the Americans." That day was 2 May. I was completely shocked. It was incredible. I was not supposed to know any information from outside and this guy

was telling me that bin Laden had just been killed by Americans! I said, "He's not your mentor." But he said, "I respect him. I hate Americans." They all say they hate Americans but they don't really hate Americans. They love American songs, they love whatever Americans do but they've been told Americans are brutal, crazy, inhuman. But you can sense this military education . . . but you can sense this whole military education.'

'So, it was sixty-six days you spent there. Was there a third place?'

'No, I stayed there till the end. I stayed almost seventy days in there.'

'Who were the interrogators?'

'The guy at the army camp was about my age and you can see that he grew up during the Cultural Revolution.'

'Was he a soldier?'

'No. He was a soldier once, now a policeman. Many policemen were soldiers before. He was a very hardcore type of person.'

'Did you meet him on the first day?'

'No. After two days. The first interrogator came to tell me: "Weiwei, this guy will replace my work, my job. He will be the one to take over."'

'Was he uniformed?'

'No, plainclothes. He likes to wear shirts like me. But they always have bright colours printed on them. And big English words, very sporty – but I'm sure he doesn't understand one single word of what they say.'

'What is his accent?'

'He's from the northeast. Dongbei. That's a sign. Because normally Beijing police are Beijing people. When somebody's not from Beijing they must have been in the army.'

'And during this second period, on the army base, were the interrogators more resolute?'

'This guy at the army base was a real gung-ho person and was leader of the team. They have a team of four or five people.'

'It's a police team?'

'Yes. It's a Beijing police team. The military police. APF, that's Armed Police Force. Their job is just to do the capture. They know nothing about the case.'

'And the Beijing police force is responsible for the interrogation?'

'Yes.'

'But during the second period you didn't find the same sympathy among the interrogators?'

'Later I did. But not at first. The interrogator who came in was so stylish, so self-conscious. He questions me but of course you can see that mentally he has no idea about political crimes or art. They know nothing about art.'

'Yes. How did they deal with your art?'

'At the beginning he was yelling, very mad. I said, "Why are you doing that? Why do you have to raise your voice so high?" He looks at me like I'm a criminal or something. Then gradually he became calm. I can sense that they are all so frustrated with the situation. Firstly, they don't understand art. Especially they don't understand my kind of art. They have no idea why *Sunflower Seeds* is art. He shouted at me, "Why do

you think the twelve animal heads from Yuan Ming Yuan are your work?"'

The work the interrogator was referring to was the circle of giant animal heads that Weiwei had cast in bronze. They were inspired by twelve animal heads that had acted as fountains in the old Summer Palace in Beijing. Each head was an animal from the Chinese zodiac. Anything to do with the Summer Palace, which was burnt to the ground in 1860 by invading French and British soldiers, is a lightning rod for Chinese nationalism. Weiwei points out that the ruling Qing dynasty were not actually Han Chinese (being descendants of Manchurian invaders) and the designers of the original heads were also foreigners (Jesuits), as were the craftsmen who cast the figures.

'It's impossible for them to understand. So I have to do a lot of explanation.'

'But did he know about all those pieces?'

'Of course. But like the others, he thinks these pieces are really economic scams. Big scams. He became very angry. He said, "This is not art. I tell you what this is, my friend. This is a scam. We know how much it costs to make *Sunflower Seeds* and you sell them for this much." They said, "How can *Sunflower Seeds* be art?" I said, "It's art, or not art, I don't know, I don't care. It's not the thing I care about the most. I care if I can provide a new condition, a new perspective, and from that angle, see something completely new."'

'Condition? For other people or for you?'

'For me and also for others. So that in the new condition people can look at the world differently and draw different

conclusions. It's not practical or logical; it's not science or rational thought. It deals with our imagination, our fears, our dreams. We talked quite a lot on these things actually. First they don't understand: "What other view? What condition? What new angle?" I tried to tell them that the classical view about art is very limited and it cannot really cope with today's life or today's understanding of ourselves or our universe. Very often it is beyond our aesthetic judgement. Then later on they start to understand a little bit. They really did. And they learnt. They want to know the nature of my work: why did you stick a finger at Tiananmen – it's not art, it's just a gesture of insult in the west, everybody knows this means "Fuck off." I said, "The work is entitled *A Study of Perspective* and in the old days in the west, in Renaissance times, perspective was suddenly very important." So of course first they think I'm just lying. But they are fast learners. They are very smart people. They are all very smart, intelligent people. It's only because their job limits them to a very limited position. So, I explained art to them and then many times they said to me, "Weiwei, why whenever we talk about art and concepts do you get so excited that you keep talking? And why when we talk about facts, you say, 'I don't know'?" But I say, "You know, I like to talk about art, and it makes me joyful and when I get to talk about art and explain I get very high spirits." But when I talk about which day, and how much money and all that, I really don't remember those things. It's not what I care about. And later they realise there are movements like Dada, or surrealism. It was incredible. One day they came back in to interrogate me some more and they were very

happy, as if they had made a great breakthrough in the case: "OK, we found out! You're part of Dada." I said, "Ahh, yes, you're a little closer.'"

The picture of Weiwei handcuffed to a chair bringing secret policemen round to his views on conceptual art is one of the strongest images from this account he gave me of his eighty-one days in detention. And he somehow succeeded in his quest. I asked him if he had changed their views on art and he said he was sure he had done so. But art wasn't the only thing that they wanted to talk about. Once Weiwei was in the army camp, it seems the interrogators became less shy about their real motives for locking him up.

'After a while they gave up talking about pornography, economic crimes and digging on those issues, and finally they started to very carefully approach the political situation. The evidence that they produced was taken from my blog articles, which I wrote back in 2007 and 2008. They printed out many of the blogs and let me read them, and to be honest I did not even remember writing them because the blog was shut off in 2008 and since then I have been writing a lot more tweets. It was interesting that they didn't print out any of the tweets. I think maybe this was because they think that as Twitter is outside the Chinese firewall it cannot be used as evidence. I don't know. I have no idea. But I read the blogs and I realised that what I had said was quite strong. Although I could not immediately recognise the writing because it was from so long ago, I think it must be mine because I am the only person who has spoken out in that way.'

Many of Ai Weiwei's old blog posts are available in English

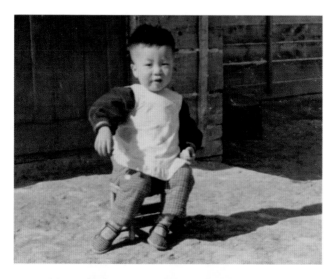

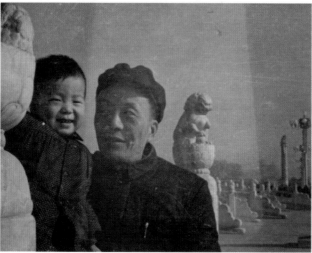

TOP: Ai Weiwei was born in 1957, the year the anti-rightist purge began.

ABOVE: With his father in 1959, after the family had been banished to live in a hole in the ground on the edge of the Gobi desert

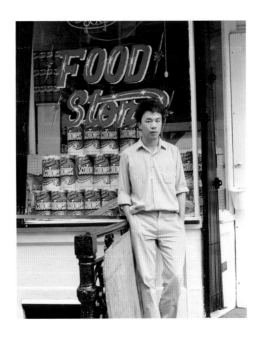

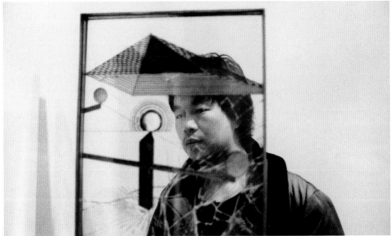

TOP: Hanging out in Brooklyn, New York. New York – particularly Manhattan's Lower East Side – was home to many in the Chinese exile community.

ABOVE: The young Weiwei at the Philadelphia Museum of Art, finally coming face-to-face with the works of his masters

TOP: Wang Keping, roommate and fellow founding member of Stars group, takes it easy in their Lower East Side apartment. Like Weiwei, he lived off his wits, doing odd jobs and building-site work.

ABOVE: Weiwei's roommate, the virtuoso violinist Tan Dun (right), and another friend. Years later Tan Dun achieved worldwide recognition, but during the time they lived together, he was making a meagre living by busking.

In his art manuals, *The Black Cover Book, The White Cover Book* and *The Grey Cover Book*, Weiwei sought to introduce the latest developments in western art to a Chinese audience.

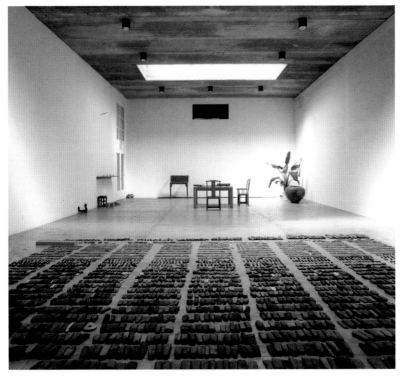

TOP: Weiwei's self-designed, self-built studio – the beginning of his work as an architect

ABOVE: The studio interior: an arrangement of prehistoric flints from a site near Beijing – an eye-pleasing readymade

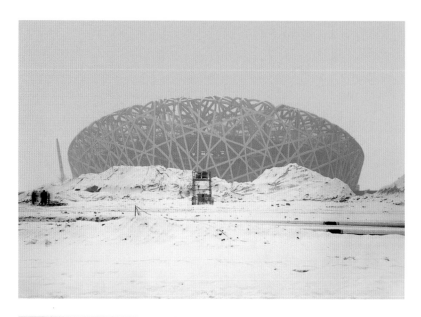

TOP: The Beijing Olympic Stadium under construction, designed by Weiwei for Herzog & de Meuron. Weiwei later described the Beijing Olympics as nothing more than 'a fake smile.'

ABOVE: Shi Jia Hutong, one of the many old lanes that surround the Forbidden City

TOP: Liao Yiwu, climbing the hill back up to his room overlooking Lake Erhai. A few weeks later he walked through the jungle to freedom, across the border into Vietnam.

ABOVE: The poet Mang Ke at home in Tongzhou, in his sub-arctic digs

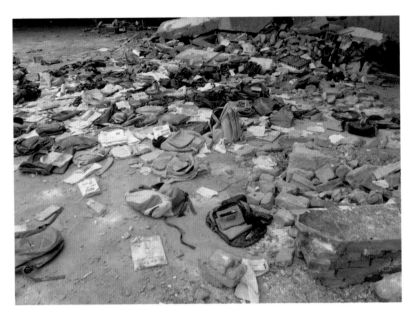

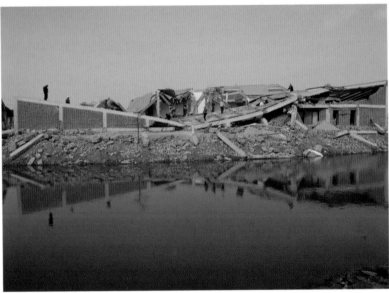

TOP: The aftermath of the 2008 Sichuan earthquake, which provoked Weiwei's haunting artwork *Remembering*. Children's school bags lie scattered in the rubble.

ABOVE: Planning permission withdrawn. The local government decides to teach the outspoken artist a lesson by demolishing his studio.

translation in Lee Ambrozy's excellent book *Ai Weiwei's Blog*. I ask Weiwei if the posts that the interrogator is referring to are the same as those in that collection.

'Some of the blogs the interrogator was using as evidence of my subversive activity are in there. But some – the toughest, most critical ones – are not in there. The ones where I curse the Communist Party are not in there. Actually when I read them back, I was a little bit shocked by what I had written because that is definitely a solid evidence, very solid evidence of subversion of the state.'

'So how did they handle that?'

'They told me only three people have ever been accused of subverting state power. One is Liu Xiaobo, one is Gao Zhisheng [a human rights lawyer who has won several high-profile cases against the government] and another is Hu Jia. Look what happened to them. I think all of them are quite soft, not really very tough, and I did much more than them and so every time I have to compare myself with them I think: this is not good.'

Nobel Peace Prize laureate Liu Xiaobo is one of China's greatest dissidents. Born in 1955, Liu had his schooling interrupted by the Cultural Revolution, like everyone of his generation. He did eventually attend university and went on to do doctoral studies in literature at Peking Normal University. Quickly he established himself as an intransigent critic of contemporary Chinese culture, which he found to be weak and dishonest and hamstrung by the decades of Communist Party oversight and intervention. In 1986, Liu spelt out his misgivings. 'I can sum up what's wrong with Chinese writers

in one sentence. They can't write creatively – they simply don't have the ability – because their very lives don't belong to them.' Political indoctrination, self-censorship, an inability to look beyond purely Chinese preoccupations and a lack of concern with transcendental human values were just some of the faults Liu found in the writings of his contemporaries.

As with Ai Weiwei, it is not hard to see how Liu's position on the arts led quite naturally to political dissidence. On 2 June 1989 Liu led a hunger strike in Tiananmen Square. Afterwards, he was labelled one of the 'black hands', the leaders who were instrumental in fermenting unrest. He was jailed for eighteen months but on his release he immediately picked up where he had left off and began to submit articles on democracy and human rights to publications in Hong Kong. In due course he was rearrested and jailed for a second time. After his release he became Chair of Chinese PEN, part of the writers' organisation International PEN which promotes freedom of expression and attempts to draw attention to the plight of writers who have fallen foul of repressive regimes. As his profile increased, he found himself the subject of constant police harassment and was frequently beaten up in his own home by police thugs. Liu remained undeterred. In 2008, he joined with some friends in the creation and dissemination of Charter 08, a petition calling for human rights, democracy and the rule of law in China. The day before the petition was published, on 8 December 2008, Liu was arrested and held for over a year until finally, on Christmas Day 2009, he was sentenced to eleven years in jail. He was awarded the Nobel Peace Prize *in absentia* in 2011. His wife was barred from at-

tending and the Nobel committee placed the award on the seat of an empty chair.

'Did the interviewer mention their names to you?'

'Yes. On the first day they said quite clearly to me, "You are number four. We did three of them already." So from the very beginning I know this is a big problem because for these crimes there is no real measure. They can sentence you to over ten years or one year, two years. They can do whatever they want. So now I start to have such a big struggle in my mind.'

'But I don't understand, if they had the evidence, which they did, because they had all the printed-out blogs . . . Why then did they need to go through the whole charade of all those days and days of interrogation?'

'Yes! In those blogs I would say such strong things, like, "This government is most disgraceful, unreliable, unacceptable government." They would say, "What does this mean?" or they would say, "When you say 'this government' which government are you referring to?" I said, "This is just the article, I write this way. You have to just read the article. You cannot ask me this." Then they would say, "Why are you being so timid? Are you scared of us? You always say you are very open? Why can't you say very clearly what you mean by 'this government'?" They keep coming back and I have to spell out, "When I say this government in the blog, I am referring to the Chinese Communist Party." Then they would type it down as evidence and I said, "Why not give it back to me and I can rewrite it more clearly for you?" They were very mad when I would say something like that.'

'Did they beat you?'

I had wanted to ask this since I had first stepped through Ai Weiwei's door. The specifics of his treatment, and whether or not he was physically tortured as well as mentally tortured, are significant. However, I hadn't felt comfortable about asking the question and I had been waiting for Weiwei to volunteer the information.

'No. They didn't beat me. They said, "I wouldn't hit you because only cowards beat people." I said in response to that, "You cannot say that. You beat Gao Zhisheng, in such a bad way." And they just said, "Oh! Don't listen to him. It's not true." But I know they did beat him and they beat many others too. It was quite normal. But they were very nice to me.'

'Why was that?'

'I have no idea why they didn't beat me but I think that maybe the higher level told them not to touch me and so they are very nice to me, very courteous.'

'But this goes back to the beginning of our interview because you do communicate with the people in charge, don't you? You have channels to people who are very high up?'

There were rumours in circulation that Ai Weiwei was in direct communication with members of the Politburo. Anecdotes dating from 2010 told of how on some occasions Weiwei would ask everyone to leave the compound and not return until late at night. People in the neighbourhood claimed that on these occasions they would see black limousines pull up outside his door, teams of plainclothes officers would be disgorged and then one or another of the octoge-

narian Chinese leaders would totter into Weiwei's courtyard. Weiwei was utterly dismissive of all this:

'Me? I don't have any channels. I know people but we don't have any communication.'

'But you were invited to join the Standing Committee of the People's National Congress?'

'Yes. They talked to me but even today I don't know if it's a trick or real . . . I still can't figure it out. I think it's real but how do you know? One thing after another. You are offered great laurels and then you are arrested and in such a terrible situation. Everything seems so ridiculous. You can't trust what they say.'

'But given your treatment, which was bizarre in a way, it must go all the way to the top.'

'It's simple: they don't know how to handle me. They said they were watching me for over one year. They have twenty-one accounts of close engagement with me, I don't even know. Finally they decide to arrest me.'

'But who made the decision? And why then?'

'I have no idea who made the decision to arrest me or who made the decision to let me go.'

'But you would agree that it must be someone on the standing committee or in the Politburo?'

'That's for sure. It has to be someone on that level.'

'There is one man who seems to be Big Brother in China. He is always proposing things like, electronically tagging the whole population.'

'Yeah, yeah, Zhou Yongkang [a senior leader in the Communist Party well known for his especially hardline stance].

Yes. Definitely he knows. But I cannot say he made the final decision. Who knows? But he must have been notified of all this, kept up to date. That's for sure.'

'There would have been elements at the very highest level who would have not wanted you to be arrested because there is all this investment in soft power by China, and to arrest you meant all this effort was wasted?' China under Wen Jiabao and Hu Jintao has tried very hard to improve its image abroad, setting up the international network of Confucius Institutes and investing heavily all over the developing world.

'Yes. But who would calculate this? I have no idea,' says Weiwei.

'They would calculate it round a table ... Someone would say, "I don't think we should do this, the whole world is watching," and someone else would say, "But he is stirring up trouble. Look what happened in Egypt, in Syria," and so on ...'

'I heard a rumour that the Premier, Wen Jiabao, finally said, "This is going to ruin everything." He reflected on his trips to Germany and England and realised that if I was still in jail then all his diplomatic efforts in Europe would be wasted because of protests about my treatment. Then I think he referred to Hu and I think they made the decision to let me go because they never really imagined this can cause such trouble. They never really imagined one person can cause such trouble.'

'But they are both sympathetic to being more open anyway. They are not such hardliners as some of the other Politburo members; they think soft power is the way forward for China, not aggression. But then again, this is all just speculation.'

'Yes. This is really just speculation. It is impossible to know.'

'But if you think about it, it must have been the Arab Spring and then Zhou uses it . . .'

'Yes. He uses that as a tool, as an excuse for a crackdown which he wants anyway . . .'

'And when the leaders see what is happening in the Arab world they get scared.'

'Yes, yes. It's like that. Remember what they did a few years ago to Falun Gong, that group, which was really nothing at that time. They started to get scared and the whole nation was doing such a brutal clampdown – which was absolutely ridiculous. But today they are little bit more calculated. A little bit more practical.'

'Pragmatic?'

'Yes. Pragmatic. All their efforts can just be destroyed by bad press. So they are more careful. In any case, this isn't about individuals; it reflects the system. It's the system that is the problem.'

'Yes, just as you said the soldiers are prisoners themselves.'

'The big machinery. Big old machinery of the system.'

'Finally, at the end of eighty-one days, what happened? Was there any indication?'

'No. Nothing. The day it ended they interviewed me and said, "Weiwei, you are facing ten years in jail, or maybe even more, so don't be ridiculous and be optimistic about your situation. You will feel very sorry if you do." They keep telling me that. It's not interrogation. Then they said, "I give you a test." I said, "What?" He said, "If you have to see one person before

you get into the whole process, who you want to see?" "Why?" "Because once you are in there you cannot see your relatives for a long, long time." I said, "Well, maybe my mother. My mother." "Why?" "My mum is old; if I'm in jail for a long time, I owe her a lot. I would love to see my son but he's a baby." So they said, "OK, I'll make sure you see her. That's what I can promise you." Then they have to record everything. I have to tell them. I gradually feel they are preparing something. Everything they have to record. To give someone else to look at. They said, "You have to admit the crimes." I said, "But this isn't a court, I have never even been arrested. Why do I have to do it?" "You have to do it, trust me, otherwise I will never come back, even to interrogate you." I don't even know whether or not what I am being accused of are crimes. I don't know about tax laws, or whether or not it is illegal to have a child with a girlfriend when you are legally still married. What is the law? I have no idea. He just said, "Trust me, if you haven't violated the law I will not arrest you. You think we are joking? If I ask you to say you killed somebody and you say you kill somebody, you think I can sentence you? There have to be some facts. So just admit it, for our records, that's all." You can see they have such anxiety to get me to admit everything.'

'Why?'

'Now I understand. He said, "Just trust me," he even gave me a lot of signals. OK, so what you want me to do? He said, "Just say you admit: admit you are willing to take punishment." "OK," I said. "If I've violated tax law, if it's been proved that I have, then I should be punished." That was as far as I was prepared to go and for every accusation I said the same thing and

then when we had finished, they said, "OK, you're on bail."'

'So it happened in one day?'

'Yes! It's crazy. Now I see that they must have been under such pressure. They had to release me but they had to first make me admit. They said, "Come on! Just admit then you can go! I promise!"'

'But at the time you didn't know.'

'No. So, it was such a burden. I was so confused. Because before he sent some weak signals but I cannot do it. They said, "Why are you so stubborn? If you don't do it, if you don't admit you are a tax criminal, then you will be here for months or years. You want to stay here?" I said, "Come on, it's not lawful." They said, "What is not lawful? Are you crazy? You have no choice. Either do what I say and go back to normal life, or stay here. We are helping you." They truly were helping me in their way.'

'When he released you what did you feel?'

'I had no feeling. I had already become a person where like you take everything as the same, because even when you're released you are still in this big, unlawful prison. Nothing really to protect you and everybody just listens to the decision of somebody high up. So I don't really feel anything. Of course, I feel a little bit better not to have two soldiers standing next to me but I don't feel happy.'

'But psychologically speaking, what happens? One day you were in this room facing years of jail and then the same day you find yourself back here.'

'Yes. One day. That's all. It's like a bad dream. It's totally illogical. It makes no sense.'

129

'They just dropped you at the door?'

'Yes. And I suddenly see two guys from Associated Press standing at the door shouting, "Weiwei!" I had to hold my pants. My pants had no belt. They're so loose. It looks so funny. They just have no time to give me anything in jail.'

'So how did you get in? You must have felt relieved?'

'My housekeeper. I went inside. To my home. The door shut behind me. I stood in the courtyard, just outside this room; over there. I feel nothing. I feel empty.'

*

It is the hot, oppressive, dead centre of the day and the cicadas in Ai Weiwei's bamboo garden are making so much noise that they sound like a football crowd during the last minutes of a World Cup final. Weiwei has gone to do something and I wander over to his office and find an empty desk. Five people are working in the office. There is very little conversation, absolutely no office banter. That is not to say that they are gloomy – they weren't. They are working hard in the knowledge that any day the authorities might strike again. After Weiwei's arrest, the staff had all gone away. Those who returned, about a fifth of the original number, are very brave and motivated people.

I have been sitting there writing for half an hour or so when a short, portly, jolly-looking man lets himself in to the office from the courtyard. He is dressed in chinos and a polo shirt with red and grey horizontal stripes. He has an open smiling face. He looks very much like a schoolboy; completely

unthreatening in every way. Various people in the office rec-
ognise him and immediately go over and greet him warmly,
pour him tea, make him sit down on the comfortable sofa.
They are clearly excited to see him. A group of them cluster
around him and listen as he tells a story. There is a lot of
gasping and expressions of horror but I'm not listening; I'm
concentrating on my work.

Then, ten minutes later, just before lunch, Ai Weiwei
comes into the room. As soon as he sees the guest his face
lights up in delight and the two of them fall into animated
conversation, as if they are old friends who haven't seen each
other for a very long time. After ten minutes or so, they come
over to my desk and Weiwei introduces me:

'This is Jiang Li [not his real name]. He is a famous lawyer.
He defends activists. He was arrested on 19 February, and
beaten very badly. They beat him with soft-drink bottles, wa-
ter bottles full of water. They beat him all the time.'

Weiwei turns to Jiang, who has been grinning at me mer-
rily, and says in Mandarin, 'Can he ask you a few questions?'

Jiang nods and smiles and Weiwei turns back to me. 'Do
you want to talk to him?'

We talk, with Weiwei translating where I fail to under-
stand. At one point I ask Jiang why they released him (need-
less to say he was never told why he had been detained in the
first place and was informed repeatedly in between beatings
that he would never ever see the inside of a courtroom). Jiang
is one of those crazy people who one meets occasionally in life
who can only make jokes:

'Because when I went in I was very fat but after three weeks

they had wrung me out like a towel and I was all thin. So they threw me onto the street!'

He tells me more about the conditions:

'All day I sat with my back straight being watched. Sometimes they would make me sit on the floor. It is very tiring . . .'

'Special treatment!' interrupts Weiwei, laughing. 'Favouritism! I was never allowed to sit on the floor.'

Weiwei and Jiang both had to sign forms saying that they would not talk to anyone about their experiences, that they would not meet each other, or anyone else whom they had consorted with before their arrests. Jiang has just turned up this morning unannounced. He strolled in past the plain-clothes police. They simply don't care about the restrictions that they are supposed to be living under. When I point out that what they are doing must be somewhat risky, they simply laugh.

When Jiang has gone, I ask Weiwei why the police didn't stop him coming in. He was, after all, breaking his bail as well as Weiwei's.

'I don't think the police outside care. I think the government is sick of this situation. It's a huge problem for them either way. They don't know what to do.'

'But don't you think that's very significant? Twenty years ago it would have been different . . .'

'Yes. It is very significant. Twenty years ago we would all have been murdered. Jiang thinks it's changing. We all think it's changing; that this old machine cannot go on like this. Their reality is out of step. They cannot keep up so soon they will stop.'

We join the others at the long table for lunch. People come and go, some stand up and pick at their food, others sit down and really tuck in. The food is excellent but then that is quite normal in China. Gao Dan, the doorman and helper, sits down next to me. Gao Dan is tall, six foot two, with thick short spiky hair. He neither smiles nor frowns. When he first opened the door to me, he was suspicious. Now, having established to his own satisfaction and in his own silent, cautious way that I'm acceptable, he tells me how he too was arrested, the day after Weiwei was taken away.

'After Weiwei had been gone for one night we knew that he wasn't coming back. I decided to go home to my ancestral village for a few days. I had to go there anyway as it was time for me to pay my respects and light incense at my grandparents' graves. I arranged the incense sticks on the grave and just as I stood up, four men in black stepped out of the trees and told me I was in big trouble and I had to come with them. They took me to a five-star hotel and kept me locked in a room and questioned me for hours. They were convinced that I must know something. "Did you ever meet Liu Xiaobo?" they asked. "Did you know Gao Xingwen?" Every time they asked something I just shook my head and replied, "No. Nope. No. I don't know anything. I'm just a doorman." They were getting very frustrated with me, I was sure they were going to beat me. I've heard all the horrible stories and I was really scared. They didn't believe that I knew nothing but it's true: I *am* just a doorman and I really don't know anything. Finally one of them said, "Does the word 'jasmine' mean anything to you?" [They were referring to the

Jasmine Revolution, an idea cooked up on the internet in foreign forums, by anonymous people encouraging Chinese citizens to mimic their Arab brothers and sisters.] At last, a question I could answer. "Yes!" I replied excitedly. I was as sick of saying no as they were of hearing it. They all perked up and listened and I spilt the beans. "It's a beautiful-smelling flower." That got them pretty annoyed. They dumped me back on the street and said, "Fuck off and stop wasting our time."'

Everyone at the table, except for Gao Dan, bursts into laughter.

'What did you eat when you were inside?' I ask Weiwei.

'Actually, the food was excellent. It was for generals. Four dishes at every meal and soup. But no knife and fork obviously, and no chopsticks. They are all dangerous weapons. So only a spoon. A ceramic rice bowl and a spoon. I had eight minutes to eat it in. But it is impossible to pick up the slippery food with such a spoon, so I had to stir it all together and eat it like that. Then I washed the dishes and gave them back to the soldiers. They always kept a portion of the food aside so that they could later test it in a laboratory if I suffered an allergic reaction.'

'So they were very worried about your health?'

'Yes. It was crazy. In a way I was like a Ming vase. They were terrified something might happen. It was so strange. Every day I tried to walk a bit. I spent four to five hours walking. But when I walked I always had a soldier in front of me and one behind me and one on either side. And this was in my tiny room! We walked round and round in circles, together,

like a little army. This was when I got to talk to them, when I learned about their mothers, their family, and their hopes and fears . . .'

We finish lunch. Weiwei is going to see his infant son. We agree to meet the following day, very early, and then I slip out through the back door and pick my way through the back alleys of Caochangdi until I reach a busy road where I catch a cab back to the youth hostel.

Part 2

5

It is 5 a.m. in Beijing and I wake to find myself in the youth hostel dormitory. I am a little jet-lagged, but I am pleased to discover that I am in high spirits. Lying in bed, reflecting on yesterday's meeting, I decide that given all that has happened to Ai Weiwei he is in good shape – better shape than I had expected. I also conclude that yesterday's interview was a success. But in truth the main reason for my high spirits is because I know that if I can get through the front door this morning, then today will be the last time I have to run the police gauntlet and deal with the intense claustrophobia of Ai Weiwei's compound. After this meeting I will head to Hong Kong.

I shower, I dress and I carefully pack my computer and valuables into a small rucksack. I don't want to leave anything in the dormitory – not because I don't trust my *compagnons de route* but because I think it is likely that it will be searched. I step into the corridor, shut the door quietly and then turn around. For a minute panic grips me. The air at the far end of the forty-metre corridor is tinged with a gossamer-fine veil of blue-grey smoke. There is a fire in the hotel. I have to sound the alarm. I break into a run and bound down the stairs into the lobby. There is no one around. I can't see a fire alarm any-

where. I decide to open the huge double doors and press the doorbell; surely that will get someone up. I wrestle with the bolt and push the heavy doors open. I have a clear view of the quiet hutong. Smog. Thick, soupy smog, as thick and white as fresh bonfire smoke, hangs in the air and curls itself around the treetops. Smog so thick that it has infiltrated the corridors of the hotel. The Beijing smog is a ghostly milky white; you can almost imagine reaching into it and stirring it with a giant spoon. I haven't seen pollution like this since I was in Jakarta in 1997, when the rainforest floor was on fire, the coal seams deep beneath the earth smouldering, ignited by the careless flames of the slash-and-burn planters who destroy millions of acres of virgin forest a year and convert it to rubber and palm oil. In those days in Jakarta, people went round with facemasks on – some nights we even wore them inside – but here in Beijing no one seems perturbed. There are hardly any facemasks at all.

It's 5.30 a.m. The streets are comparatively empty. Chen Fei, the ancient bread salesman, who looks like a piece of raw ginseng dressed in vest and shorts with a few strands of white hair on the top of his skull, greets me as I step out of the hostel and click the front door shut behind me. I buy a stick of bread. Beijing bread is deep fried, like a churro, the Spanish breakfast pastry. I take a bite. It is delicious. I start to walk east. Despite all the pressures of my current, self-imposed mission, it is – as always – a joy to be in China: wondrous in its sophistication, China offers a living, breathing alternative to western modes of thought.

My first experience of China began in 1990, one year after

the fateful events of 4 June 1989. I was at Shenzhen University, which had been a hotbed of student rebellion in 1989. Many Shenzhen students had been taken away never to return.

The two or three years directly following Tiananmen were a strange time to be in China. On the ground the atmosphere was characterised by uncertainty, and by fear as to what the future might hold. There was a sense that China could go either way: it could lurch back to Maoism, or forwards in a new and unknown direction. No one knew and no one dared to guess in public in case they got caught out by the sudden change of direction. Only a fool would entirely discount the possibility that there might one day be a repeat of some of the most dreadful episodes of recent Chinese history. Gone was the 'culture fever' and the optimism of the 1980s, the decade that could almost be billed as China's decade of the intellectual. Indeed many Chinese intellectuals describe the pervasive mood of the eighties as having been more open than it is today (certainly you could write things that you couldn't write today). The official verdict on the events of 1989 attempted to draw a line under the past: Tiananmen had been caused by 'foreign spiritual pollution' and 'black hands'. And after the brutality of the events in question, people could no longer doubt that the leadership was prepared to do anything to stay in power.

It was typical that Deng, the master of staying the course in Chinese politics, was the catalyst for the eventual mood change. His tour of the south of China in 1992 had a decisive effect: it sent out a message and it raised morale.

Suddenly my contemporaries – who had put many of their cherished ambitions on hold since 1989 – felt they could dream again.

In the early nineties, Shenzhen was a bustling, rapidly growing provincial town on the border with Hong Kong. It was the capital of the Shenzhen Special Economic Zone that had been created by Deng's reforms but it had not yet become the gigantic and sophisticated metropolis that it is today. Of course, there was no internet, so there was no news of any substance, as every single printing press in the country was controlled by the Communist Party. So, even among the student body at the university, people had little idea about what was going on in the wider world beyond the borders of China, and this ignorance wasn't simply confined to esoteric subjects. Chinese physicists could not keep up with the latest advances being made in physics round the world; Chinese chemists were ignorant of half the advances in chemistry, and so on. It would still be some years before Chinese academics would become an integral part of the global exchange of ideas, as they are today.

Poverty was ubiquitous but it wasn't the poverty of much poorer countries in Asia. Still, there were no such things as consumer goods. There were no mobile phones, very few private phones, no personal computers, and very few new ideas that might change the social or cultural order in any way. I had a small room with a balcony that looked out over the South China Sea. Once a week I would travel by bus to the best bookshop in Shenzhen and browse its tiny collection of English books, books that were printed on photo-

copied paper. I saved up and bought an edition of the select-ted works of Tennyson. I learned great chunks of it off by heart between endless games of football and today, more than twenty years later, lines of damp, autumnal, Victorian gothic beauty, lines like 'Dark house by which once more I stand', or 'The woods decay, the woods decay and fall/The vapours weep their burthen to the ground', still conjure up for me the blazing sunshine of China's tropical south coast and the twinkling emeralds and turquoises of the pleasantly warm sea.

I found it a very agreeable life and for most of my peers on the football pitch and in the classroom, political storm clouds aside, it was a good life as well. Even if things were to change for the worse, even if the clock was suddenly turned back, they were still the lucky ones: 'Shenda' was a top-flight university and a passport to a job, which was what everyone was after. Besides, there was no conceivable alternative and it simply didn't cross most people's minds that they had grounds to feel unhappy, or that they should be hankering after something else, something as abstract as representative de-mocracy for example. To exaggerate and simplify – but not by much – they rarely heard about life abroad and if they did, it was presented to them through the propaganda machine of the Party. They had never known life before the Cultural Revolution; they had been trained to think that China's four-thousand-year-old culture was for the most part a wicked sys-tem of feudal oppression and that foreign governments were imperialistic and hypocritical.

Yet in the epoch of globalisation such static cultural fields

always require force to sustain themselves, and there were people who did feel unhappy or ambivalent despite all of this. Somehow I was drawn in, however loosely, to the *omertà* of those Chinese students who surreptitiously honoured their colleagues who had died or disappeared. My friends were people born in the late 1960s and early 1970s. They were the children of the Cultural Revolution. Among my close friends was a young woman from Beijing who was the daughter of a high-ranking Party official. On the night of 4 June, when the tanks rolled into Tiananmen and the killing began, her father woke her up and forced her out of bed. He told her to stand at the open window and listen to the sounds of her fellow students being massacred. As a grey dawn broke over Beijing, her father led her through the streets. Strips of burnt human flesh were hanging from the trees. And on 4 June 1990, I stood on the roof of my accommodation block and watched as, on the neighbouring rooftops, rows of my fellow students queued up to have their heads shaved in memory of those who had been taken away. Later that evening, crates of beer arrived and the atmosphere turned very dark. The small beer bottles were emptied down throats and then smashed to the ground (the middle character of Deng's name *xiao* means 'little' and a homonym for *ping* means 'bottle'). Very soon groups of police moved in and broke up the party.

Summer turned to autumn. We would play football all afternoon and in the evenings we would go for cheap meals in the makeshift restaurants that were constantly springing up on the giant building sites that every day were extending further and further into the paddy fields around Shenzhen

University. In the darkness of the tropical evenings, we would cycle home, two people on each bike, one pedalling, one sitting sideways on the back. We would stop to buy great pieces of sugar cane the size of rolling pins and to watch the magical clouds of fireflies as they drifted through the trees and across our path and then we would end up in each other's rooms, engaged in heated discussions, long into the night. If Tiananmen had put off much of the student population in China from attempting to articulate an alternative to the rule of the Party, it had also galvanised a hard core. To them, the Party had shown its true colours: it was a monster that would resort to anything in order to stay in power. This small group of people found obscure foreign books in the library and shared material that had flooded into China during the eighties, prior to the crackdown on foreign 'spiritual pollution' that followed 1989. They wanted to know about the outside world and to discuss different forms of government. I remember particularly well the humiliation of one evening, having to admit to my group of friends – who listened in utter disbelief – that it was true: Britain really was still governed by its aristocracy; the House of Lords really was stuffed full of hereditary peers.

I was eighteen when I went to Shenzhen. Since then I have spent further years living in China and Hong Kong but it was the year that I spent there when I was eighteen that had the most profound impact on me. The advantage of going abroad when one is young and very ignorant is that one very quickly and very thoroughly assimilates. Very quickly one feels at home with the habits, the food, the customs, the body lan-

guage, the smell of the houses. And very quickly one makes friends. And since that year in Shenzhen, I have continued to be interested in China and the fate of its people.

<p style="text-align:center">*</p>

I devour the stick of deep-fried bread as I walk. Beyond the hutongs Beijing is a city of broad boulevards, laid out in a grid. There are five concentric ring roads, with Tiananmen at the centre, each ring road about a mile and a half from the next. Towards the centre of the city many of the big roads are like Oxford Street or the Champs-Elysées. The shops are just as smart, the pavements and road surfaces are better and all the usual labels are on display in the shop windows. Yet the centre is surprisingly low-rise. The real skyscrapers are to be found in the Central Business District, some two miles to the northeast. I can only imagine it was planned this way to ensure that no one could overlook Zhongnanhai, the area where many of the Party elite conduct their business. It wouldn't do to have normal office workers gazing down on the leaders as they bat badminton shuttlecocks back and forth or stroll in the gardens. These people are beyond scrutiny and above the law.

The question of whether or not the rule of law exists at all in China is of utmost significance, not only for people like Ai Weiwei but also for the average Chinese citizen. Ai Weiwei can be seen as marginal and exotic in his obsession with free speech (and on occasion universal suffrage) but not so when he talks about the necessity for the rule of law. Demanding

that the Party and its officers obey the law is becoming quite a mainstream pastime and the changing relationship between the Party, the constitution and the law may well define the next decade of Chinese politics. In his exhaustive book on the misuse of forensic psychiatry in China, published in 2006 and entitled *China's Psychiatric Inquisition*, Robin Munro looks in detail at the wider legal context in which these practices take place. It is a very thorough book and it makes for depressing reading. In case after case, people have been incarcerated in lunatic asylums solely because of their 'incorrect' political or religious beliefs. As Mao once remarked: 'Without a correct political standpoint one has no soul.'

Throughout its two millennia of imperial rule, China did not have anything resembling the fair, impartial rule of law. From the Tang dynasty of the seventh century AD onwards, there existed a codified framework of norms concerning the administration of the empire alongside a scheme for deciding upon and implementing punishments, but the ethic behind this system was Confucianism and behind Confucianism lay imperial power. The Confucian ethic, with its notions of justice derived from a strict social hierarchy, is not compatible with the idea of equality for all under the law. Under a Confucian system of law it would be impossible to imagine that a child might have rights, or that a woman might have rights equal to those of a man.

In 1911, with the founding of the Republic, Chinese law-makers began to look to western models. The Nationalists, the warlords and the Communists all attempted to create fairer legal systems but the civil war prevented any new, com-

prehensive, nationwide legal system from emerging. When the Communists finally took power in 1949, they set about creating the basis of a legal system. Legal institutions such as a procuracy and a court system were created; however the nature of Chinese communism meant that even this new, renovated legal system was never going to be able to protect the individual's rights to the degree that is necessary for a system as a whole to be described as 'the rule of law'. Marxism-Leninism and Chairman Mao Thought regarded the legal systems of the west as bourgeois tricks designed to subjugate the proletariat, and after 1949 Mao intended the law to be a tool of the dictatorship of the proletariat. Law should be a stick with which to beat class enemies, certainly not some higher authority to which even the Party must answer.

Naturally, during the Cultural Revolution this extreme position was taken to its logical conclusion and legal institutions were either abolished entirely or neutered – the procuracy vanished and the court system became a rubber stamp in the hands of the Party. Civil law, a criminal code, contract law and so on ceased to exist. In their place, the People's Liberation Army became responsible by default for civil security.

In 1978, along with so much else in Chinese life, Chinese law was reborn. The 'rule by man' (*ren zhi*) of the Cultural Revolution years was to be replaced with 'rule by law' (*fa zhi*). And since 1978 the laws have indeed come thick and fast: environmental law, trade law, criminal law, civil law, procuracy law, litigation law, every type of law. But despite this revolution, even as late as the 1980s the Chinese government was

still referring to the concept of individual human rights as a 'bourgeois fallacy': a Trojan horse that was being pushed by the west in order to undermine the Party and the rule of the proletariat. By the late eighties China had begun to engage with the rest of the world and this included engaging with the UN and ratifying many of its conventions concerning rights for women and children, the elimination of racial and other discrimination, and so on. But despite this increased engagement and despite the fact that the institutions of law in China have grown so much from the days of the Cultural Revolution (there is for example now a professional class of lawyers who are putting pressure on the Chinese government from the inside to reform), the Party still continues to pay lip service to much of its own relatively newly minted law. It is as if it regards all legal institutions, indeed the legal system itself, as having no more status than any other administrative branch of government. This lip service can be most keenly felt in the law regarding administrative detention and as Munro points out:

If one had to choose a single criterion or yardstick for determining whether or not a country had attained a minimum standard of observance of the rule of law, then the consensus view among law and human rights scholars would probably be that freedom from arbitrary detention is the *sine qua non* standard for the assessment. In the absence of this fundamental guarantee, attempts to safeguard and protect all other key rights – notably freedom of expression, freedom of association,

and the right not to be tortured or subjected to other forms of cruel and unusual punishment – become highly problematic if not impossible.

Today in China there is no guarantee against arbitrary detention, or detention without trial. Indeed, the legal system makes much provision for detention without even a minimum level of judicial oversight or supervision. 'Re-education through labour' is perhaps the most ubiquitous of the many permissible forms of such administrative detention (more than three and a half million people have been sent for labour re-education since the 1950s). Sentences of re-education are supposed to be handed out by 'Labour through re-education committees' but in reality these often do not meet and the sentences are handed out directly by the Public Security Bureau. The crime can be as general as 'endangering state security' or the equally general but more old-fashioned 'counter-revolution'. Additionally, there is no right to habeas corpus. There is no right for the detainee to see a lawyer. It is for these reasons that Amnesty International has been forced to conclude that in China people can face 'punishment without crime'. That is to say, they can be sent down without a court hearing to establish the facts of the case or to apportion criminal responsibility or to decide upon a sentence. To summarise: there is no rule of law in China as the phrase is ordinarily understood by lawyers and human rights activists. In China, Chinese law is not the supreme authority. The Party is the supreme authority.

Some foreign observers, while admitting that in theory

things look grim, point to such statistics as the fact that fewer and fewer people are being detained or sent to re-education camps, and claim that in reality the situation in China is improving. Robin Munro gives this optimistic assessment short shrift. He says it reminds him of the observations that tourists tend to make about the Highlands of Scotland, about how wonderfully 'empty and natural' the countryside is. What the tourists don't realise is that they are looking at an artificial wilderness. Prior to the Highland clearances of the late eighteenth century, the Scottish countryside was a busy place. That there are fewer dissidents than ever before in China is because the government has been extremely effective in making it clear to the Chinese public that any challenge to their authority will be ruthlessly crushed, and not because the government is going soft. The Party is above the law. This is the world in which the brave Chinese dissidents choose to act.

*

I walk for ten minutes and cross several large roads. Finally, when I feel I am far enough from the hostel, I catch a cab. Once again, I ask the driver to drop me on the outskirts of Caochangdi. The place is already fairly busy: people are bustling up and down, there is almost always the odour of food being cooked drifting in from somewhere, small food stalls, each one selling dishes I have never seen before. One is nothing more than a hotplate mounted on a bicycle serving pancakes filled with chopped lettuce and meat of unknown provenance, another sells dumplings, another deep-fried bread.

The police are waiting on Weiwei's street again. I walk past hurriedly and ring the buzzer. Eventually, after two minutes of uncomfortable waiting, one of the staff arrives and opens the steel door. Inside the courtyard everything is just as it was when I left yesterday. The place is very calm. The bamboo and grass and the various pots and giant jars and the stone table laden with prehistoric axe heads all add to the atmosphere of permanence and rest. Weiwei is already up, at work on his computer. No one else is around. We greet each other and then immediately cross the courtyard and enter his house to talk.

The atmosphere is superficially the same, yet when we have sat down in the same seats as the previous day, I look more carefully at Weiwei and see that today he is exhausted and very stressed. My high spirits drain away in an instant. He has clearly had a terrible night. His face has the bruised look of someone who has been drinking heavily. His face is so swollen round the eyes and the cheeks that for a moment it occurs to me that he might have gone the way of so many of the Soviet dissidents who, similarly prevented from leaving their country, emigrated to the land of alcohol. But these days Weiwei doesn't drink much, and it isn't alcohol, it's exhaustion and the intolerable pressure he is under that are ravaging him. I begin to doubt the feasibility of my plan to talk about the early days after the end of the Great Proletarian Cultural Revolution. I begin to doubt whether Weiwei will be all right, whether he will get through the day, let alone the year.

'Are you OK?' I say.

'Last night, we had some police,' says Weiwei, slurring his words with tiredness.

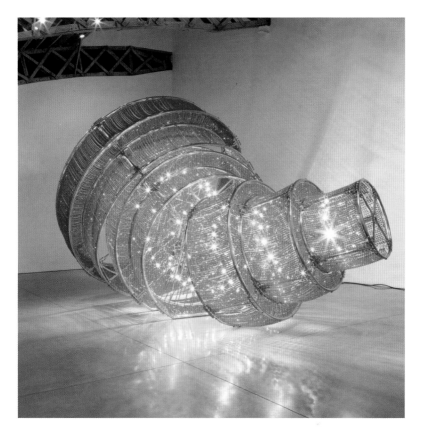

Descending Light (2007), one of Ai Weiwei's signature works, is evocative of Vladimir Tatlin's *Monument to the Third International* and also of the series of descending cones that join the bachelors to the chocolate grinder in Marcel Duchamp's *Large Glass*.

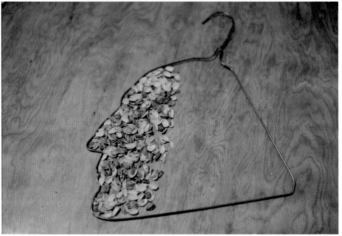

TOP: One of Weiwei's Mao paintings, from a series made in 1985. After this, he abandoned painting forever.

ABOVE: When you have no money for materials you have to make do with what you find lying around your apartment. *Hanging Man*, the seminal work, was made from a bent coat hanger in 1985 (shown here thrown into relief using some sunflower seed shells).

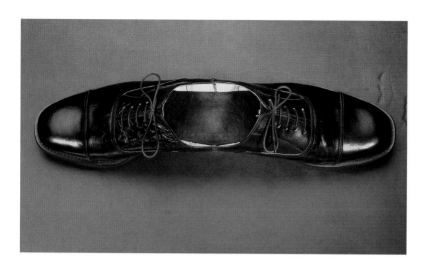

TOP: *One Man Shoe* (1987) – the logical conclusion of the drive for efficient modes of production: one shoe for both feet

ABOVE: *Violin* (1985). A violin with a shovel for a handle has huge resonance in China: 'owning a violin in 1966 could earn you a beating, or worse.'

TOP: One of Weiwei's famous *Studies in Perspective*, this one featuring Tiananmen Square (1995)

ABOVE: *Fountain of Light* (2007), a construction based on a never-realised design for *Monument to the Third International* by Vladimir Tatlin. 'Tatlin had a great imagination . . . he tried to imagine what the new world was going to look like' (Ai Weiwei).

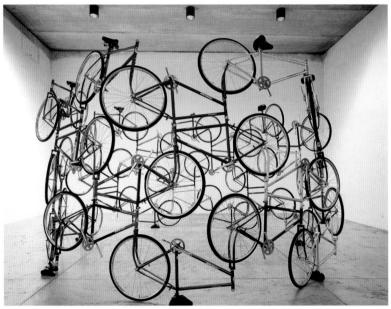

In much of his work, Weiwei plays with the banal realia of existence. In *Grapes* (2008; *top*), he melds together Qing dynasty stools. *Above*, a labyrinth of bicycles (2003).

TOP: *Dropping a Han Dynasty Urn*, Weiwei's 1995 artwork that made even the most unsentimental Party members wince

ABOVE: Some of the participants in *Fairytale*, an artwork in which 1001 Chinese people wandered the streets of Kassel, Germany

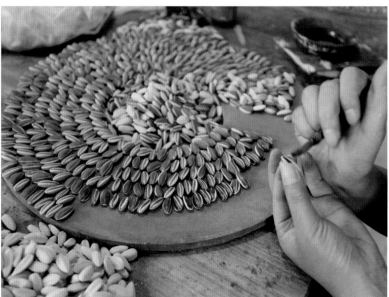

The production of *Sunflower Seeds*: Each tiny seed is hand-painted. At one point Weiwei had fifteen hundred people working on his most famous artwork.

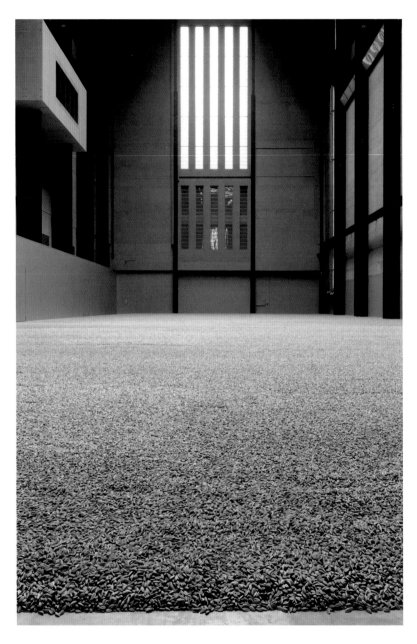

The finished work in the Turbine Hall of the Tate Modern in London in 2010. Weiwei provided millions of extra seeds to the Tate, as he fully expected people to take handfuls home. It was to be an artwork that would go on giving, like the overflowing porridge pot in the children's story.

'What do you mean?'

Barely able to keep his eyes open, Weiwei takes out his phone, finds a video file and puts it on the tabletop so we can both see it. The clip has been filmed in a busy restaurant.

'It's very hard to see,' begins Weiwei. 'Wait . . . let's see.'

'Is this the restaurant from last night?' I ask.

'Yes. That's the secret police there. Both of them. That one, he notices me, he knows I have seen him and so he puts his secret camera down in the bag there. A secret camera. That's them. Both of them.'

A couple, dining at a round table, not talking to each other. The man is sitting on a semicircular high-backed banquette. With his left hand he is hiding a camera behind his thigh. The man and his companion look sheepish and annoyed as Weiwei's camera phone lingers on them. Then Weiwei's camera pans into a small dining room. (Chinese restaurants often have private rooms off the main dining area to cater for small groups.)

'Look,' says Weiwei. 'That's our room.'

I recognise some people from Weiwei's office and also his lawyer, who spoke out on many occasions during his arrest. Then the camera spins back round to film the other diners in the restaurant.

'The police are both looking at me again,' says Weiwei.

'But why do they bother?'

'Well, I think it's a very dangerous situation for me now. See: two of them, that's her, that's him. But there are more. They have somebody else too. There. See?'

The camera moves away from the table with the fake

couple and points at the long bar. Sitting on a bar stool is a man in a grey T-shirt, on his own, not eating or drinking anything.

'You see – it's dangerous. I cannot go anywhere. If I go to the shop and come back to another place they are always there. I am very surprised: how do they always know where I am? But I remember, when I was let out they tell me that my phone has to be on during all this time. So I think they have some tracking equipment.'

The video continues and now it becomes clear, absurdly enough, that the man with the grey T-shirt is trying to hide behind a menu.

'He realised that I am taking a photo of him and he sits there like that. Then another person comes. This guy, that's the person, that's him.'

'Him as well? But how can you tell he's one too?'

'Oh, we can tell,' says Weiwei grimly. 'We are quite good at this now. Earlier in the day, he was with me in the park. It's impossible that it can be a coincidence. Beijing is a big place. Both of them. Look at him. See, they left, before eating they left...'

Then another young man appears in the frame, very close up, smiling.

'Who's that?'

'Suddenly someone saying he is a fan came up. He said, "I support you." It's so strange. He said, "Can I take a photo with you?"'

'But that's so many people. In one evening,' I say in disbelief.

'Yes. There are always even more. You see here. He is using the menu to cover his face again.'

The well-muscled, crew-cut man with the grey T-shirt is holding a large, ostentatious menu up in front of his face, as cartoon spies are supposed to do with newspapers. Occasionally he snatches a glance over the top then hides again when he sees Weiwei is filming him.

'Nobody would do that!' says Weiwei. We are both laughing. 'See. There is only one reason that can explain why they are doing that. The danger is still very strong. They are still doing some kind of planning. They don't just follow me, they take photos, they make recordings; they're preparing for another strike. They're always preparing, yes. They are crazy. Because nobody is happy. They arrest me, then they have to let me go . . . they have their own reasons but they are a big group of people and they argue. It's like the Mafia.'

'But they can hardly rearrest you straight away. They would look foolish.'

'Yes but they can still prepare. And anyway, they do many things that are foolish. I always think they aren't going to do something but then they do it anyway and you always think: oh, why? Why would you do that?'

'But what can you do?'

'I can do nothing. Absolutely nothing. I sit here, a citizen but subject to this kind of harassment. I'm an individual. I have people in sympathy with my actions. You can see: I go anywhere and people come up to me, even when I go to toilet to wash my hands someone comes in and says, "I support you." But how can they support me? It's not possible. Of

course, they feel the same way but there is no way. I can't even get internet in China.'

Weiwei's internet provider turned off his broadband service without explanation and now he and his staff share one dial-up connection. It is no exaggeration to say that it was through the internet that Weiwei first came to popular notice in China. His blog and later his Twitter account became hugely popular and he developed a following numbering in the hundreds of thousands.

The Chinese Communist Party is terrified of the power that the internet has to allow like-minded people to form communities. The people in charge are sophisticated enough to understand that letting groups of people get together online to discuss the problems that they have with the government is not so different from allowing mass congregations in Tiananmen Square. Indeed it may even be more destabilising as, thanks to the internet, people from all over China can contact each other without having to convene physically. The risks are there, still, yet they are less tangible, less immediately forbidding than attending a meeting or marching in public. And if people are allowed to get a taste for dissent, if they begin to realise that there are hundreds of thousands of others who feel as they do about the regime, then where will it end?

The Communist Party has become so paranoid that it has begun to clamp down on all sorts of seemingly harmless groups. For example, the Beijing Vegetarian Association, which was campaigning against the government's failure to ensure food safety, was summarily shut down in 2011. After

the crackdown began in February that year, the police worked their way down the list of registered human rights lawyers and other supposed dissidents. Some people were held briefly, others for months, and some sent to re-education camps. Almost all were forced to make videotaped confessions and sign guarantees that they would not talk to foreigners or fellow dissidents. Wang Songlian of the Chinese Human Rights Defenders network told the *Guardian* newspaper:

> People are genuinely scared and that's why they are not talking. I think all of the people who disappeared for a period of time have experienced some form of torture or mistreatment. Even when the human rights community was being targeted before, people were always quite defiant. This time it is like a bag with a hole punctured in it: the air has all gone out of it.

Ai Weiwei is stubborn. He is a rallying point and the Chinese authorities clearly know this. By making it extremely difficult for him to run his operations online, they aim to slow him down, inconvenience him, demoralise him at least. 'Their tactics are very efficient,' Weiwei acknowledges. 'They know they have to cut my connections with people. They know that if they don't do that it will be impossible for them to win.'

As we have been speaking Weiwei has been taking his diabetes pills and checking his blood pressure. There is a ripping noise as he undoes the Velcro band around his arm.

'How is your diabetes?' I ask.

He laughs.

157

'Actually, it's very good now. It's under control. But that's the result of this detention. It was never under control before now but under such severe conditions, with a doctor coming in at least four times a day, it is cured. Sometimes it was even two doctors and at least four times a day. It's amazing what they did. When they first arrested me one of the doctors said, "Many people come out from our detention and their diabetes has gone, their blood pressure has returned to normal. We don't know why." Weiwei laughs again. 'I can open a company later. A secret police cure. I think it will be very popular!'

Weiwei carefully packs away his diabetes kit. His face is serious again.

'They are foolish because they miscalculate. They miscalculate the situation again and again. They make the wrong evaluation because they don't have the right information. They shut off themselves from the world and that itself is the biggest source of danger because it means they never have the right information. The people around them, the people whose job it is to feed the information into the system are totally out of touch. So the people making the decisions have a wrong picture about what is going on in the world.'

He pauses.

'They may think that my dinner at the restaurant is me trying to organise something.'

'But in reality it was just you and some friends having dinner.'

'Yes. There was just one outsider, Lu Xiaoyuan, who was with us because he's alone in Beijing. His family lives in another province. The police try to flush him out. So every

dinner he has to eat by himself. This is not good. So I said, "Why don't we just eat together?"'

'But you are not meant to be meeting people like him, under the terms of your bail?'

'My bail is not lawful.'

'True, but under the terms . . .'

'We had an understanding. I am not supposed to meet foreigners, or journalists, or any activists because it will be very bad for me.'

'It was a verbal agreement? It was never written?'

'It was written but it's totally illegal. I have to make a promise not to go on the internet or meet foreign press; not to criticise Chinese government in any form; not to sign any papers or petitions or join human rights causes, or civil rights movements; not to meet anybody who is involved in such activities. But all of this is unlawful. They say either you sign here or you will be stuck in here and you will never come out. Of course, I want to come out. Because in there, every second is torture. Every second. So I sign. But there are a lot of people who haven't released and they are in very extreme conditions. I can't just keep quiet. I still have to help them, right?'

'But how long can the government keep this level of repression up?'

'How long? For thousands of years. They have been doing this for thousands of years. But today the only difference is we have the internet and then there is globalisation as well. They depend on globalisation so they are forced to be pragmatic. They have to maintain the economic progress, otherwise . . .'

'Otherwise, they have a civil war . . .'

'Yes. So that's OK. They have to be a little bit more careful about what other countries think. That's the only factor. You know the high-speed train crash a few days ago? Prime Minister Wen Jiabao was there yesterday, trying to say "Sorry I'm late." He always says stupid things. He's a stupid old guy. His excuse was that he was late "because for the past eleven days I was in hospital". But it's not true and today he can't say these things without getting exposed. Immediately people went online and wrote down what he had really been doing for the past eleven days. They put up photos and say where he was every day. He wasn't in hospital. He was doing some other state affairs. So today, thanks to the internet, it's harder to be a successful liar and an event like the train crash really educates people. The whole nation listens to what the government has to say and then says, "But this is bullshit."'

'So in your more hopeful moments, do you see there will be eventual change in the next five years?'

'There will come a moment when this system collapses. It will stop working altogether. It will come to that, I know.'

Over the course of a conversation Weiwei is quite capable of swinging from one extreme to the other. At one moment, he is convinced that the regime is doomed and that it is only a matter of time until it collapses; the next moment, he argues that the regime will never change, that China has been governed this way for four thousand years and that it is folly to hope that things will ever be any different. I think such extreme oscillations from buoyancy to despair are quite inevitable in such circumstances: determined optimism, even sincere hope, then horrible moments of plain nerves and de-

moralisation, because of the incredible pressure under which he operates. And yet he parcels up his fears, he makes dark comedy of his situation, he continues nonetheless.

'I don't know how you manage to focus on your work in these circumstances, with the police breathing down your neck, all the restrictions, the threats,' I say.

'I see all this as my work.'

'But don't you wish you were back in New York sometimes?'

'No because that means you totally give up your emotions, what you are familiar with, your understanding. I would have to give up everything I care about. I'm already too much involved in the situation. And New York, what came before, that's another world, a very different living.'

'But you could just do nothing and in twelve months' time go to Berlin and have an easy life?'

'Yes. I could, I could. Yes. That's what I dreamed about every day when I was in prison. Every day. I thought, if ever I am released, I will just go to a beach, just rent out a place, stay with my family and rest, forget about it all. Forget about this because this is a game that is almost not playable because there are no rules. Not even the poorest rules. They can do anything . . . they are so ruthless and they make up new rules when they want.'

'Maybe you should still consider, you know . . .'

'What?'

'Consider not doing anything. Just lie low for one year. It's not so long. It won't kill you.'

'I know. That's what I thought. I've been through so much.

I didn't even talk to the press when I came out. You know, I said no to the press over a hundred times, BBC, CNN, *60 Minutes*. To all them, I said, "No, I just can't. Really I can't. I cannot. I would lose my freedom again." My so-called freedom. My family feel desperate; it's so terrible. I try to stop, to do what I am told. But when friends come to my door, dissidents, human rights lawyers, I cannot say no and turn them away. I think because I have become a symbol to people. And if the government can do something to me then they can do something to anybody. My case was so publicised and they were so ruthless and unlawful to me. What about the other cases that nobody even notices, that nobody has heard of? That's why I feel it's necessary to clearly explain the situation to other people so at least we have a record. We may never get revenge for these crimes but at least we have a record of it. That's why I told all the others, "Write it down before you forget." But most people refuse even to write it down because it's really a very sad experience, too horrible, and they have very, how you say, very bitter feelings, too painful to write down. But you have to write it down, it's the only thing you can do.'

Outside it is pouring with rain. The courtyard garden, the office, the police car outside, the whole of Beijing seems utterly unreal. The only things that have any meaning at all are the monstrous, lowering presence of the Chinese Communist Party and Weiwei's determination to try, by whatever means necessary, to force the secret policemen, the Chinese Communist Party, the whole country even, to change. He is committed to doing this – he is almost condemned to it. And

whatever the cause of this manic obsession, maybe it is at moments like this, when the perilousness of his situation is most clear, that his art and his struggle for freedom of expression become one. It is easy to begin to feel that the extremely conceptual pieces like *Sunflower Seeds* or *The Bowl of Pearls* are acting like a Zen koan, forcing all who look upon them to open up new channels inside, to think in new ways – and to change.

6

On my previous visit to Beijing – during Ai Weiwei's spell in detention – I had decided to track down Liao Yiwu, the writer. Liao Yiwu has a lot in common with Ai Weiwei and so I thought that by talking to him I might be better able to put Ai Weiwei and his fellow dissidents in some sort of context. For one thing Liao Yiwu has been arrested because of his writings and he has spent time in jail, in his case more than three years. He is also from the same generation as Ai Weiwei and so he and his family went through all the horrors of famine and the Cultural Revolution. And also like Weiwei, he is monumentally stubborn and will always take the line of most resistance. Furthermore, like Weiwei, he understands the power of the most simple gestures and his unadorned writing, which is banned in China and which so infuriates the authorities that he has suffered imprisonment and torture, really consists of nothing more than pointing out: 'Hey! Listen to what this perfectly ordinary person has to say about their experience of life in China today.' He is like the little boy who points out that the emperor has no clothes; the Chinese Communist Party cannot bear it.

Like Ai Weiwei, he is constantly at loggerheads with the regime because he speaks his mind and rejects the Communist

Party's view of reality, instead articulating his own vision of Chinese society and the vision of the people that he meets. He is indefatigable and personally courageous.

At the time I went to find him, in April 2011, Liao was living in Dali, an ancient and extremely beautiful city that sits on the shores of Lake Erhai, at the base of the sacred Mount Cangai. One of the most amazing things about China is its vastness and consequent incredible variety: variety of languages, of peoples, of landscapes. There are jungles, there are deserts, there are glaciers; there is the Tibetan Plateau, the oasis towns of the northwest; there are villages without electricity and then there is Shanghai's Bund. China is diverse in its diversity because it is one hundred countries yoked together.

Dali, in the province of Yunan, is as different from Beijing as a small town in Romania is from London or Frankfurt. Its city walls are short by Chinese standards, only six kilometres long. The landscape here is mountainous but the vegetation is subtropical – forests of emerald green – and the soil is as red as the face of Mars. Flying into Kunming, near Dali, I looked out of the window and saw armies of diggers at work clearing the vegetation and turning over the red earth. They left a livid scarlet trail gouged through the forest. Today, Kunming itself shows the indelible signs of globalisation and industrialisation. My uncle swears that when he visited it thirty-five years ago it was really rather charming. It isn't charming any more.

For centuries the people of Dali were traders and merchants. Today they work in the tourist industry and cater for

the millions of Chinese who come to watch the famous cormorant fishermen pole themselves out onto the misty lake and use their trained birds to catch carp and hake. Many great trade routes converged on Dali and the city's restaurants still reflect this traffic: lamb's eyeballs from the Muslim west, worm and spinal cord omelette from Canton, halal meat, dishes from Burma and Vietnam. There are churches in Dali, and mosques and meeting houses for Baha'is. In the old days there were even communities of Jews and Zoroastrians.

It was Liao Yiwu's epic poem 'Massacre', composed in response to the 1989 student uprising, that landed him in jail. A howling dirge – part funeral oration, part shamanistic chant – it was passed around literary circles in Beijing on old-fashioned magnetic cassette tapes. *Magnitizdat*, this was called in the Soviet Union: the technological extension of the samizdat culture. From the perspective of the internet age it was unbelievably labour-intensive.

When Liao finally got out of prison and made his way home to Chengdu, he discovered that his wife had left him and taken their infant son; his former friends were too frightened to speak to him; his registration permit had been cancelled, so he couldn't find work and he could at any moment be expelled to the countryside. He was penniless and his only possession was a wooden flute that he had made in prison. So began Liao's new life as an itinerant busker on the streets of Chengdu.

One of the characteristics that most defines Liao is his incredible resourcefulness, or rather not so much resourcefulness as his ability to continue his work without any re-

sources at all. Just prior to his imprisonment, Liao's writing had taken a new turn: he had begun to interview ordinary Chinese people, people with poor chances in life, the *diceng*, as the Chinese call them: those on the bottom rung of the ladder, the innumerable dispossessed and hopeless whose stories no one ever hears. The reality of everyday life for the mass of ordinary Chinese citizens is not something that the government wants to see portrayed. Prison was intended to bring to an end Liao's subversive activities but instead he simply began to interview his fellow inmates, and when he was finally released to wander the streets of Chengdu he quickly befriended the prostitutes, beggars and restaurateurs of his new milieu and set about interviewing them as well. It is a shared characteristic of many of the brave and inspiring people I met in China that even in the depths of despair they still attempted to preserve their individual voice (though I should point out that while in jail, Liao was subjected to such inhuman treatment that he did attempt to commit suicide on two occasions). One month before I met Liao the government had imposed yet another travel ban on him to prevent him from attending the International PEN Festival in New York.

Today Liao's writing only has an audience at all because of the efforts of a handful of total strangers, devoted people who have never even met Liao but who found themselves deeply moved by his work and who were determined that it should see the light of day. Wenguang Huang, a Chinese American, first heard one of Liao's stories on public radio in 1990 and immediately recognised its freshness and significance. He wrote to Liao and offered to translate his work, and to find

it a publisher in the west. For years they collaborated without having a chance to meet – indeed they still have not met at the time of writing. But they were both crystal clear about what they were trying to do: show China as it really is, not as it is presented in the government-controlled media. Then came Peter Bernstein, a New York literary agent and the son of Robert L. Bernstein, who founded Human Rights Watch and Human Rights Watch China. Though Wenguang Huang and Liao Yiwu were unknown in the US, Peter Bernstein took Wenguang's approach seriously and instantly recognised the quality of Liao's work. The third angel of serendipity was Philip Gourevitch, a New York-based writer who at the time had just been made editor of the *Paris Review*. Gourevitch read a story by Liao that Wenguang sent him and decided that it had to be published. None of these three men has met Liao but thanks to their efforts on his behalf Liao's work has now been widely disseminated. His collection of interviews with *diceng*, with the translated title *The Corpse Walker: Real-Life Stories, China from the Bottom Up*, was published in the US in 2008 by Pantheon Books (a division of Random House), translated by Wenguang and with a forword by Gourevitch. The interviewees include 'the professional mourner', 'the leper', 'the peasant emperor', 'the retired official', 'the mortician', 'the former red guard', 'the Tiananmen father', 'the Falun Gong practitioner', 'the illegal border crosser', 'the grave robber', 'the safecracker', 'the migrant worker' and 'the survivor'. As Gourevitch writes in his foreword:

[Liao Yiwu] is a medium for whole muffled swathes of

Chinese society that the Party would like to pretend do not exist: hustlers and drifters, outlaws and street performers, the officially renegade and the physically handicapped, those who deal with human waste and with the wasting of humans, artists and shamans, crooks, even cannibals – and every one of them speaks more honestly than the official chronicles of Chinese life that are put out by the state in the name of the 'people.'

It is no exaggeration to say that Liao is a totemic figure among certain sections of the community of Chinese writers. And thanks to Bernstein, Wenguang and Gourevitch, and others who have backed his work in the west, he is now rated, as Gourevitch explains, with writers 'as diverse as Mark Twain and Jack London, Nikolai Gogol and George Orwell, François Rabelais and Primo Levi'.

I had spoken to Liao by phone before I arrived, but the circumstances for the call hadn't been ideal. I had been on the deck of a Star ferry as it shuddered across Hong Kong harbour from Kowloon to Wanchai. There were brightly lit skyscrapers reflected on the dark waves, flashing lights from other boats, the noise of the engines, the loud voices of other passengers on the ferry. Liao has a very strong Sichuanese accent and the line was very bad so I could barely understand him. Two days later I found myself waiting under the south gate of the walled city of Dali. For a long time no one came, and I began to wonder if I had misunderstood completely and was meant to be in Dalian, a thousand miles to the north. Finally, I saw Liao moving through the crowd. Fortunately, he

is the first writer in history who actually resembles his dust-jacket photograph.

On the way to Dali I had been overtly followed and as we made our way to a café we were joined by two secret service agents. It was only Liao Yiwu's aloofness and utter contempt for them that steeled my nerves. The interview, which I had hoped to conduct in the same way that Liao conducts his own interviews with the *diceng* – that is to say, in an informal manner that encourages the interviewee to explore even the most troubling aspects of his or her life – ended up being somewhat surreal, and not just because it was being overheard by two members of the secret police.

Because Liao's English is even worse than my Chinese, and I didn't want to misrepresent his words in any way, I had decided that we would need a translator. There was no way to arrange this from Hong Kong so I had gambled on finding someone in Dali. It is a tourist resort, so I hoped there would be plenty of English speakers around. However, this was a risky strategy for two reasons: first, I only planned to be in Dali for a few hours. The light aircraft that I'd flown in on, bumping over the mountain tops like a rollercoaster, was returning to Kunming at midday. The second problem was that there was a distinct possibility that as soon as anyone started translating Liao's words they would realise who he was and the risks they were taking in helping him to talk to a foreigner, and they would stop. The two secret policemen weren't helping either. We made a strange-looking group as we shuffled through the old city searching for a translator: Liao slightly hunched, with a permanent expression of weary defiance; my-

self tall, white, more and more paranoid as the minutes passed; and then the two policemen, skulking along behind us.

Thankfully, as this was Yunan province and we were far from Beijing, the police were comparatively relaxed. Liao told me that occasionally, depending on who was tailing him, he could persuade them to have a drink with him. After half an hour, just as I was beginning to panic, we found a youth hostel in a large, elegant old Qing dynasty-style villa, threadbare but copiously decorated with carved wood and red lacquer. I approached the manager, a middle-aged man with a kind, sensitive face. Although the weather was mild he was wearing a heavy brown leather jacket. His English was excellent and he agreed to translate. However, at this point, he still didn't know who Liao Yiwu was, though I did try to explain, to give him the chance not to get involved if he didn't want to risk it.

We sat down at the coffee table. The police agents, who hadn't taken off their coats, sat down at the next table. 'Can you tell me your earliest memory?' I asked Liao. It's a question that he often asked his own interviewees. The translator duly translated the question, Liao nodded and paused and then said something back in Chinese. The translator, looking a little shocked, turned to me:

'He says his earliest memory is almost dying of starvation during the Great Leap Forward. Famine came and he was only four years old and he swelled up like a loaf of bread. Everyone thought he was going to die but then his mother took him to see a doctor and the doctor held him over a boiling cauldron filled with herbs. The herb steam cured him.'

The translator glanced at Liao again – who was sitting patiently, waiting for the next question – and then he turned back to me and said, 'Who is this guy?' I tried to explain again that he was a writer who had suffered at the hands of the government and whose work had been censored and suppressed. I thought that the interviewer would now call it a day but he didn't; he only became more interested, and he too was strangely unmoved by the presence of the secret police.

The questions continued and Liao's stories became more and more incredible. 'The corpse walker,' he said, 'whose job it is to carry the dead body back to its final resting place in its home village, has a special code for communicating with hotel owners in rural Sichuan. They knock on the door and then shout out in a loud voice, "The god of happiness is here." That way the hotel is warned that the prospective guest has a dead body strapped to his back, hidden under a cloak, and he can either turn the corpse walker away quietly, or give him a room at the back and charge some extra dough. After the Cultural Revolution the Communists tried to crack down on this but of course it still goes on all the time because it is very important that they take their dead home for burial, whatever the Communists like to think.'

I asked Liao about the people that he had interviewed. Several of his interviewees had made a particularly strong impression on me. Two of them he had met while in jail; one, 'the peasant emperor', was an old man who claimed to be the emperor of China and insisted on everyone, prison staff included, addressing him as 'Your Highness'. He explained to Liao that he was in prison voluntarily as it was the only way

for him to escape the constant and exhausting sexual demands that were otherwise made on him by the young women of his kingdom.

Another interviewee whose story had particularly compelled me was 'the safecracker'. His account of his own life was especially moving because it was quite clear that he was a highly intelligent, sensitive human being who had fallen into a life of crime because of a complete lack of opportunities. He was a very good safecracker and he was also charismatic and highly resourceful. At one point in his colourful career he was caught and sent to prison. It was one of the old prisons built by the Nationalists during the war and it had high, strong walls but the safecracker was determined to escape. Finally he figured out how to do it. Over the wall, he could hear the cleaners when they came to empty the prison toilets. He deduced that the cleaners didn't need to enter the compound because the cesspit beneath the toilet holes extended right under the walls, so that it could be accessed from the street outside. Unappealing as the prospect was, it was obvious to him what he would have to do to escape and so the next day, during the exercise period, he went to the toilet and then squirmed his way through the toilet hole and dropped like a bomb into the murk below. Luckily his theory was correct and he only had to swim for twenty feet, although he said that it felt like a lot further than that at the time and he thought he was going to go mad. He clambered out the other side onto the street, ran down the mountainside and eventually found his way into a student dormitory where he showered and stole some clothes. He went back to safecracking and became a rich

man, with lots of villas in the north and more money than he knew what to do with. But he was bored and depressed. Because he was an intelligent, thoughtful man, he felt his life was shallow and worthless. Eventually, on a job in Beijing he had to crack the newest and best kind of safe. Naturally he succeeded, but for some reason that he couldn't explain he just sat there with the safe door open, slowly setting fire to the bundles of money. When the police arrived, he went with them without complaining.

I asked Liao what had happened to the safecracker – was he still in touch with him?

'He was executed,' said Liao bluntly, drawing his finger across his throat.

As the interview went on, the translator became more and more involved. I would ask a question and he would translate it for Liao and then Liao would answer back in Chinese, but instead of immediately translating Liao's answer back into English, the translator would ask his own question instead and after a while the pair of them would be deep in conversation. Occasionally, they would remember my existence and the translator would turn round and summarise some aspect of Liao's life or thoughts for me.

'Lao Liao [*lao* means old and is a mark of friendly respect] says that many of the dissidents today start out as ordinary people with an ordinary gripe. Take for example the protests over the polluted baby formula milk. The parents who dared to complain and insist that the government do something were slapped down but they had lost their children and so they were angry and they didn't care any more about govern-

ment threats and instead of being quiet they began to support other people's causes as well. You see the government creates dissidents out of people who have legitimate local grievances. Lao Liao says that they do this again and again because they can't handle even very minor criticism and so they end up turning anyone who opposes them into an extremist, even though all these people wanted in the first place was to complain that their cooking oil was full of shit or that the local Party had sold off a corner of their field to a property developer or someting simple like that. It's the same with the case of Ai Weiwei. He was so shocked by the earthquake that he went down to Sichuan and spoke to the mothers and fathers. He heard about the poor-quality tofu-dregs houses and about the corruption and kickbacks to local politicians. He got involved and tried to help. Then the police attacked him and gave him a beating and he almost died and because of this he became even more of a rallying point and everyone wants to listen to his criticisms of the government. They are control freaks who can't handle criticism.

'Lao Liao says all he wanted to do, the only thing, was to describe what he saw around him every day. He wasn't calling for the overthrow of the Party, or demanding for the laws to be changed. He is just a historian, a chronicler. A chronicler in cold blood who will say what he sees. But the government hated that so much that they threw him in jail. So then he wrote about what he saw in the jail. That made them even more mad. All he wanted was to be like Sima Qian, the old historian who wrote *Records of the Grand Historian*. Sima Qian was very objective and he wrote the first good history

in China and he wrote lots of honest biographies of people. Nothing more. But the government can't bear Lao Liao saying out loud what is happening in front of everyone's noses. They are embarrassed and ashamed. And when Ai Weiwei started to do it they couldn't bear him either. First they beat him, then when he doesn't stop but instead starts to criticise them for other things as well, they arrested him. But all they had to do was listen in the first place, then they wouldn't have created an international dissident.'

Liao said he would show me his rented room, which was in a block a little way up the hillside. The translator came with us, but strangely the secret police didn't follow us there. When we left the café I expected them to come along, but after a while I realised they had gone elsewhere. Liao's room was very peaceful, and from the balcony there was a view over the old city, all the way to Lake Erhai. At my request, Liao took out the bamboo flute that he had made in prison and played us a couple of tunes. I asked him how well he knew Weiwei and he said that he didn't know him well at all but he had met him in Chengdu in 2008, just after the Sichuan earthquake, when they had both gone there to investigate what lay behind the official government story. A mutual friend had introduced them.

'The mutual friend has since been disappeared,' said Liao matter-of-factly.

It was time for me to leave. I thanked Liao and then walked back with the translator to the youth hostel.

'He's an incredible man,' said the translator. 'That generation has been through so much.'

With the help of a Chinese lawyer, Liao Yiwu is now suing the government for human rights abuses. His determination is undimmed: 'I am trying to overcome, little by little, the fear that has been inflicted on me,' he is quoted as saying in Wenguang Huang's translator's introduction to *The Corpse Walker*. 'By doing so, I try to preserve my sanity and inner freedom.'

Not long after our meeting, Liao left Dali and went by bus to a small village near the Chinese border with Vietnam. Following in the footsteps of one of his most famous interviewees, 'the border crosser', Liao packed a bag with supplies and headed off into the jungle. The border crosser had stumbled into a camp filled with remnants of the ultra-red Chinese forces, preparing for the next leg of a war that ended decades ago. He was forced to become a soldier until he finally managed to retreat back to China. Liao had obviously learned from this unfortunate man's blunder: after a journey the details of which have still not been fully clarified, though it included transfers in Hanoi and Warsaw, Liao arrived in Berlin on 6 July 2011.

7

In Ai Weiwei's compound it is as if night has fallen. The torrential rain is drumming on the roof and if the overhead lights weren't on we wouldn't be able to see each other across the table. I am becoming extremely conscious that our time is running out and that this might be my last opportunity to talk to Ai Weiwei. Indeed, at the time of the interview, many people are convinced that he will be rearrested and vanish into the 're-education' system. Censorship of writers and artists, including self-censorship, is something that I have been specifically hoping to talk to Weiwei about; perhaps this is going to be my last chance.

'Weiwei, do you have the energy . . . can we talk a bit about Yan'an, about Mao's ideas about art and literature and about how this has affected Chinese art and writing over the last decades?'

'Yes, yes.'

'In the west we are familiar with revolutionary artistic movements and figures but we are not familiar with a government that wants to dictate what the aesthetic should be, to tell everyone what reality is,' I say. 'Of course it happens in the west as well all the time, but you can say most things, you are not in mortal danger if you say the wrong thing. All societies

have self-censorship to sustain their worldview and all new art has to break through that, but here we are talking about very conscious programmes of censorship, of constructing a reality. At Yan'an, this is what happened. And you must know a lot about that because your father went to Yan'an, didn't he? Did you ever talk to him about it?'

Weiwei pauses for a moment and sips his tea. I can see his mood changing. It's as if he finds it a relief to talk about something else, something a long way away from the here and now, from the secret police officers and the looming threat of jail. He begins decisively:

'That was in 1942. Chairman Mao was very frustrated by what art or literature was at that moment in time in China so he called my father in. He wrote him a letter and said, "I really want to talk about art and writing. I want to have a proper discussion." My father went to meet him. You know Yan'an is a very small place, relatively speaking, and he and my father had several discussions and he asked my father to have a meeting with all the writers and artists in the cultural field. He said they should have a round-table talk and gather negative information; they should get the artists and writers to criticise the Communist Party's line on literature. This was often Mao's tactic. He had a way of drawing out critics by encouraging them. But then sometimes he really did want criticism as well. Anyway, he wanted to hear my father's thoughts because my father was a famous poet by then and a revolutionary hero. He had returned from his time in France influenced by liberal thinking and then he had been arrested. The crime was something like "disturbing the public security".'

179

'Arrested by the Nationalists?'

'Yes. My father was arrested in Shanghai and sentenced to six years in jail. That's when he became a poet. He was a painter originally; he studied painting in Paris. But in jail he couldn't paint so he started to write poetry, very beautiful poetry. And when people came to visit him they smuggled the poems out of jail and the poems were published and by the time he came out he was the most famous poet in the whole of China.'

'So it is true that he wrote most of his great poems in jail?'

'Yes. That's why the first day I was arrested I told them, "Eighty-some years ago my father was accused of the same crime you accuse me of today, of subversion of the state." So in China, even after eighty years we are still fighting for the same thing: "freedom of expression". Of course the interrogator got quite mad and said, "No, you are wrong. It's not the same at all. Now is very different. We are a very different society." I said, "But there's not much difference. There's not much political change. For the people who control the society will not allow any sort of opinion, other than theirs, to be publicly displayed. At least my father could still send out his poetry from jail but I cannot write, there's no way to send anything out, nobody can come to see me." Even the guards who guard me cannot take anything out, not even a single speck of dust. That's one hundred per cent impossible to even take out a speck of dust. So the conditions are much worse today. And that time my father even, he can publish poetry when he's in jail and the Nationalists will not do anything to him.'

'Which year was he arrested?'

'1932 I think. He had been in Paris for three years.'

'And before that?'

'He was an art student in Hangzhou.'

'At what point did he become a Communist?'

'He actually joined the Party in 1942. At Yan'an.'

'But his poetry was already popular and the Party liked it?'

'The Party loved it. Young people all loved it because it's all about fighting for a new society. Today's leaders like Wen Jiabao and Hu Jintao, they all memorised his poetry. They said, "We came to the revolution with huge influences from this person." Because his poetry was so popular.'

'So when did he get to know Mao? Was Yan'an his first meeting?'

'Yes, at Yan'an the first meetings between the two men took place. He met Mao many, many times after that and Mao wrote him five letters. My father memorised those letters and in exile he sometimes recited them to me.'

'Do you think your father had any influence on Mao at Yan'an?'

'No. I don't think he had any real input. That is not how Mao worked.'

'So how did Mao formulate his opinions?'

'Well, he talked to a lot of people, it is true. But Mao was a person who was very strong-willed.'

'And he was a poet himself. A conservative one – he used very traditional forms, didn't he?'

'Yes. He was a poet with a very strong character. And he was quite knowledgeable in Chinese history. A scholar.'

'And literature?'

'Literature, I would say, not really. Apart from one book. He loved *The Dream of the Red Chamber*. He loved that one. He said that to understand that book is to understand Chinese feudal society. And so the Yan'an meeting set up a new tone for literature. Literature now had to work for the revolution. From then on there were only two types of literature. Good literature that is for the revolution and bad literature that is against the revolution. The only way to be an artist or writer is to be part of the struggle with farmers or workers or the army. The orders are so clear and so severe. Remember: Yan'an was like McCarthyism.'

'And the conclusion of the conference was that he ended up with a manifesto that sounded much like Soviet socialist realism.'

'Yes, because he thinks art has to reflect the Party struggle at the moment. And it has to present only one reality; the only permissible reality. But Mao is not the first to do this. It happened first in the Soviet Union and even Hitler was the same. Hitler himself made a collection of one or two thousand paintings. He also had a big art exhibition about corrupt art: abstract painting, surrealism, he hated that stuff so much.'

'But totalitarian states always hate that sort of art, don't they?'

'They're afraid of it partly because it's about individualism. About the individual viewpoint. They want to unify people; they want propaganda. They want to brainwash people into thinking the same, into accepting one view of reality. That is the purpose.'

'Is this partly why you got interested in Tatlin?'

Weiwei once produced a magnificent piece entitled *Fountain of Light*, which was directly inspired by Vladimir Tatlin's monstrous plan conceived in 1919 for a Tower of Babel-like construction, a kind of spiral ziggurat, angled at sixty degrees or so, that would straddle the Neva River in St Petersburg and house the new Soviet government. Tatlin's work was named *Monument to the Third International*, after the Third International communist organisation inaugurated in 1919, the same year as the critical events of 4 May in Beijing. Tatlin's work was a fabulous metal construction, reminiscent of both a giant helter-skelter and an unravelling coil of DNA, not unlike Anish Kapoor and Cecil Balmond's *Orbit* in the Olympic Park in London in 2012. If it had ever been constructed as planned, with its four gigantic steel legs planted among the beautiful classical buildings of the Fontanka and Vassily Island, it would have looked like something out of an H. G. Wells novel. But it was never built. Funds could not be found, nor were there the engineers and architects to bring it to reality.

Ai Weiwei's *Fountain of Light* was shown at Tate Liverpool in 2007. It refers directly to Tatlin's plan, though Weiwei realises it on a necessarily smaller scale. Made in stainless steel and glass, standing around twenty-three feet high, it is lit up with hundreds of bulbs that lend it a vaguely Victorian fairground air. The utopia that Tatlin foresaw of technology and metal structures and industrial progress is echoed and parodied – and to anyone who cares to look, there is the more oblique reference to China's own 4 May movement as well. Modest, humble almost, dwarfed by the husks of the indus-

trial revolution that lower over it, *Fountain of Light* looks like some kind of beached jellyfish: exotic, beautiful, emanating an internal light, totally out of its element. Ridiculous.

'Well, I think that Tatlin had a great imagination,' says Weiwei. 'He saw a new world coming. His *Monument to the Third International* is a kind of symbolic figure for the future – he tried to imagine what the new world was going to look like. So it is very interesting. It is a utopian type of thinking but of course it's all so limited. It's always interesting to look back to some historical moment, to see how people saw the future then, how they imagined it, how they pictured or sculptured the future. And then to compare with what happened. Tatlin and that group that he was part of, all those young people; they were very brave and they had strong minds, or strong nerves at least, and they made many manifestos but later on most of them came to tragic ends.'

Like so many of the Chinese artists and writers of his generation, Weiwei is very knowledgeable about the early Soviet experiments in art. We talked about Tatlin and the constructivists and the lives of Malevich and Lissitzky and then we moved onto Giorgio Morandi, the Italian painter who died in 1964, whom Weiwei greatly admires. On the face of it, Morandi was not at all a political painter, nor was he involved in any kind of radical or conceptual work, so it would be easy to assume that Weiwei had no strong views on his work and that there was no connection between the two artists. Today, to most people, or rather to most non-painters, Morandi is not a household name and even within the international art world his reputation was not cemented until late in his career.

Perhaps his relatively modest standing has something to do with the obscure lifestyle that he forged for himself. By today's standards he appears at first glance to be thoroughly uncharismatic. He was neither a socialite nor a womaniser, he was never in the public eye and he wasn't particularly interested in commenting on anything that was happening in the outside world. His father died when he was eleven. He never married. He lived with his mother and his three sisters in the same house for fifty years. He habitually dressed in a formal suit; his hair was short, parted on the right. He was the sort of man whom one might expect to find in the same seat at the same restaurant every day, ordering the same meal. It is true that he was professor of etching at Bologna University for some years and that in the summers he would make it up into the hills at Grizzana, but there is nothing in his biography that would justify a biopic. Morandi was interested in one thing – painting his next picture. When he was asked by a curator towards the end of his career about the whereabouts of some of his works, his reply captured his ethic perfectly:

I cannot give you any indication because I'm afraid I have never made a note of where my paintings have ended up . . . I am always at work and work is my sole passion. And unfortunately I have become aware that I must always start from the beginning, and ought to burn what I've done in the past.

Consequently, for many years Morandi was mistaken for a dry, religious, almost insipid man, a man of monkish habits

and few outside interests. To make matters worse, his work appeared to some foreign curators and collectors to be thoroughly repetitious and provincial. Day after day, year after year, decade after decade, he painted the same handful of pots, bottles, jars, clocks, compote bowls and mannequins, occasionally running off the odd landscape, though these were equally repetitious. Carefully, and over decades, Morandi built up a collection of these humble objects, finding them in junk shops or making them himself, allowing them to stand for months to gather dust. Like Duchamp, Morandi believed in dust. Along with the elaborate system of curtains and blinds that he employed in order to create a uniform zenithal light, the dust dulled the edges of the objects and helped them on their way into the solitude and obscurity that he prized so highly. Eventually, after a lengthy period of repose, an object might finally be picked out from among the crowd and moved carefully onto a shelf, nearer to the easels and paint pots, nearer to the drama of the stage. Selected objects were then arranged on a table, rearranged countless times, over weeks, until Morandi felt that the balance was right. Later in his life he worried that three weeks was never enough time to arrange a *natura morte* and he regretted his impatience, wishing that he had spent longer, months possibly or years, making sure that he had the light just right and the perfect selection of objects.

Here, it must have seemed, was a slightly weird, reclusive man of modest talents and little originality – in short, a minor painter who would not leave any kind of mark on the world. Today however those who become acquainted with

Morandi's work are usually astonished by what they discern within it.

Like Ai Weiwei, Morandi is a political artist in the sense that he was trying to capture his own vision of reality, a vision that was radically at odds with that of his time. And like Weiwei, he found inspiration in the ordinary or the banal. In Morandi's case, this exercise of his freedom of expression didn't put him in danger, it just meant that it took several decades for audiences to begin to fully appreciate his work, but his urge to paint springs from the same source as Ai Weiwei's – from the urge to renovate our vision of the world and to find new meaning. And this gets to the heart of the inevitable conflict between artists and repressive regimes. In the past I had talked with Weiwei about the great icon painters of Russia and Weiwei had emphasised this same point. The forms of art are endless, what counts is the individual's engagement with the world, and their own personal attempt to find meaning.

For Ai Weiwei, or Morandi, or any other artist practising today, perspective, or realism in general, is of course a series of conventions. It is *not* reality. It is a schema and that is all. One schema among many. An orthography that we can choose to use, in the same way that for millennia the priests of Sais chose to use their own canonical orthography, with crocodile-headed deities and ibis beaks and the whole plethora of dynastic symbols all rendered without perspective but with something else, some other fifth element. The cave painters of Lascaux or the conceptual artists of the late twentieth century used another. But the idea that realism is merely one way of seeing among many is anathema to Maoism.

Totalitarian regimes, like the regime in China (though it is rapidly becoming less totalitarian, not voluntarily but because its censorship mechanisms fail to cope with the internet and civil society continues to expand), cannot abide alternative articulations of reality. Mao, as an accomplished poet himself, understood very well the link between form and content, and that if you limit the forms of art you also limit the possible content. He knew full well that by controlling forms of artistic expression you are able also to control people's inner lives. But it couldn't last forever. Art doesn't stand still. As time passes the old ways of seeing grow stale and only new ways of seeing will do, and there was nothing Mao nor any of his successors could do about this.

'I believe', said Morandi, 'there is nothing more surreal and nothing more abstract than reality. What has value in art is an individual way of seeing things: nothing else counts at all.'

*

'Morandi', began Weiwei, 'has been very influential on so many artists, not only painters. There are so many characters in his painting. It's very – how can you say – religious. And also he is like Van Gogh. Because the act itself is so believable, so pure, so purified, so cut off from others. He paints what he sees. The reality he sees. We have to catch up. So he leaves us a perfect example. Yes. You can always take that kind of action as the perfect kind of quality, the most convincing quality. Everything is related to integrity. The persistence to believe, to never get confused.'

'And so Morandi persisted but he wasn't in danger as you are. You find yourself in a different position because you're not just being ignored by a critical establishment, you are coming up against people who don't want to know about your way of looking at the world and instead of just traducing or ignoring your art, they are putting you in jail.'

'We all somehow have to be honest enough to face our condition and of course the artist always, always is the one who recognises a certain kind of reality and tries to announce it. You know poets, writers or artists, at first they are the only ones who see it. They have to announce it. They hear a kind of voice or they see some possibilities so clearly. But that all comes from the inner core, from the kind of nature they have. If there is anything valuable then it comes out because their nature perfectly reflects everybody's nature or instinct at that time.'

'Did you find this was the case with the artists from the Stars, back in '79 and '80?'

'Actually, my first taste of this was in 1976. I think it was winter – I don't remember. Zhou Enlai had passed away and the entire nation started to mourn his death. A lot of poetry was written in Tiananmen Square and people would gather there and that's when I started to go there as well. We all met at the big monument to the 5 April movement, in the middle of the square.'

On 8 January 1976 Zhou Enlai died after a four-year struggle with cancer. Like Deng he had been a communist from the very earliest days, when he lived in France as a young man in the 1920s; indeed that was when he had met Deng

and given Deng his first Party job. As the century had progressed he had watched as comrade after comrade had been sidelined or purged by Mao: Liu Shaoqi was murdered (or died of medical neglect), Peng Dehuai, the loyal general who dared to criticise the Cultural Revolution, was stripped of his rank, arrested and beaten to a pulp (and died of medical neglect), and even Deng was purged on three occasions. Zhou Enlai, almost alone of the high-profile members of the old guard, somehow always managed to avoid a similar fate. He never publicly criticised Mao, he supported both the Great Leap Forward and the Cultural Revolution, albeit reluctantly, and yet the people retained a great affection for him and over the years he had come to be seen as an avuncular protector figure. This might seem odd given that he was drenched in blood. He had been responsible for the murder of countless 'traitors' and enemies during the civil war and he had been in the top ranks of leadership all throughout the 1950s when 'counter-revolutionaries' and 'class enemies' were murdered in their tens of thousands. Furthermore, there was something conspicuously un-Maoist about him, something almost cosmopolitan. He could dress well, he spoke French, he loved art; during the Cultural Revolution, normal people were murdered in the street for much less. Perhaps this in part explains why people liked him.

Zhou Enlai's death occurred just as the battle to succeed Mao reached boiling point. There was a huge groundswell of emotion, a spontaneous wave of support for the deceased founding father. From the end of March 1976 people began to gather in Tiananmen Square and lay wreaths against the

Monument to the People's Heroes. People wrote poems in praise of Zhou and stuck them on the wreaths or on the monument. Many of them were historico-allegorical attacks on the regime and in particular on the Gang of Four and Jiang Qing, Mao's much loathed wife, who was constantly portrayed as a Lady Macbeth figure. Mao by this point was very ill himself, scarcely able to talk and unable to attend meetings.

On 4 April, the eve of the Qingming Festival, the Festival of Pure Brightness, the annual celebration that falls on the hundred and fourth day after the winter solstice, when Chinese people celebrate the coming of spring and sweep the graves of their ancestors, hundreds of thousands of people congregated in the square. The Gang of Four, who were in effective charge while Mao was ill, became very alarmed. Overnight, Tiananmen Square was cleared. On 5 April hundreds of thousands of fellow citizens gathered in the square again, the young Ai Weiwei among them. The Gang of Four and the other members of the leadership could watch events unfold through binoculars from the windows of the Great Hall of the People. Deng was accused of master-minding the entire demonstration and with lobbying from the Gang, Mao was persuaded to remove him from all posi-tions of power.

The crowds were warned that congregating in the square was an anti-revolutionary activity and that they should dis-perse immediately. Most people did leave, but a hard core remained in the square as night fell. Just after 10 p.m., ten thousand militiamen, backed by troops, entered the square

and dealt with those demonstrators brave enough or crazy enough not to have gone home.

'Who started the Qingming demonstration?'

'People who had a bad experience in the Cultural Revolution. It was a big thing. And then they started sticking poems on the memorial and I started to copy these poems down and take them home and show them to my father.'

'But who were the people doing the writing?'

'You, me, whoever. And very soon, that thing was crushed. It was called an anti-revolutionary act. One night they sealed the whole square and they beat people and put a lot of people in jail and in hospital.'

'Did you know any of the people who had been arrested?'

'I didn't know them personally, they just beat everyone who was there at that time and then it was illegal to go there any more. It made me very sad and angry. Of course, before I'd seen everything that happened to my father and family but that was because of one person, my father, and I was just a spectator. But this time in Tiananmen I was no longer just a spectator, I had become a little bit involved myself. Only by observing and watching what everyone was doing but I was involved and then I saw the result, which was very shocking, very terrifying. Then of course in 1976 Chairman Mao died and everything began to change. I stayed in Beijing till the time of the Democracy Wall and Wei Jingsheng, and *Jintian*.'

After Mao's death his successor Hua Guofeng recalled Deng. This is slightly to elide a complicated episode, but certainly Hua was weak and he needed Deng to help counterbalance the power of the Gang of Four. Very soon Deng

became de facto leader and as part of his strategy to consolidate his power he calculatedly exploited the immense resentment that the people felt towards the Gang of Four and everyone else whom they perceived as responsible for the Cultural Revolution. Criticism of the Gang of Four was encouraged, and on the streets of central Beijing a tent city had begun to appear as people from all over China came to the capital in the hope that they would find a sympathetic hearing for their grievances. There were hundreds of thousands of them and they became known as the *shang fan ren*, 'the people visiting or appealing to the higher-ups' (to use the China scholar Philip Pan's translation): the people who had come from 'below' to petition the authorities in Beijing. They wrote down their complaints as poems and prayers to Deng and to the Party. Many were written in the form of big-character posters, which they stuck onto the buildings in the centre of the city. In the past if an ordinary citizen had dared to post anything on a city wall they would have immediately been arrested, but the mayor of Beijing was one of Deng's men and so the police must have been instructed to stand back and let them carry on. And when it became clear that this was now official policy, that people were allowed at last to express their decades of frustration, the entire city was swiftly plastered with posters and writings and in particular with poetry, which was the traditional form for registering official complaints.

The focal point for this flyposting was the Democracy Wall. Despite its grand name it was in fact nothing more than an old brick wall that backed onto the bus station at the

Xidan junction of Chang'an boulevard. The Democracy Wall became a symbol of hope to many people; it was a sort of mirror image of the Berlin Wall. People no longer felt isolated. This was an entirely new experience; it emboldened them. (Today the internet is having a similar effect in China. It is a limitless democracy wall. You can post anything up on it, and of course once it is there it is not quite the same as tearing down a poster. The postings are not physically anywhere, and yet, potentially, they are everywhere.)

'Did you know Wei Jingsheng?'

'I knew his writing but at the time I never met him. Later I met him, when he came out of jail. That was in 1993.'

'Why?'

'I went to see him to support him. He had just come out of jail and I had been in the Stars group so we were very close and of course we had mutual friends from that time. We were all the same group. Some literature people. Some art. So I was really emotionally involved. You are an artist, with other artists, you feel like it is a peaceful revolution and then suddenly we were crushed completely and we were so disillusioned. And I listened to the radio and they accused Wei Jingsheng of being a spy for the west, which was completely ridiculous, and they put him in jail for so long and ruined a young man's life.

'I felt very sad. Why did they have to do this? Why did they have to put him in jail for thirteen years? If you want stability maybe put him in jail for a few months. But why do you have to finish this man's life? So that was when I decided I had to leave, to escape China, to go wherever I can. I realised the new

government of Deng's were really just as brutal as butchers, and nothing would improve. If I wanted to be an artist, if I wanted to be free, I would have to leave.'

Weiwei falls silent. He stands up, his face very long, and picks up our tea glasses and pads slowly through to the kitchen.

8

Liao Yiwu wasn't the only one of Ai Weiwei's generation of writers and artists I'd sought out on my last visit to China, while Weiwei was still under arrest. I had also tracked down some of the people who had been in Beijing during that time of dissent after 1976, who had been involved in *Jintian* and the other radical flyposted magazines. Some of them are dead, and many others have disappeared. But I was lucky enough to meet some very interesting people and one meeting above all others made a particularly strong impression.

Mang Ke, one of modern China's most important poets, today lives in penury in a Beijing suburb called Tongzhou. With a Chinese friend, I set off to track him down. Although Tongzhou is only twenty kilometres east of Tiananmen Square travelling there is like a journey to the dark side of the moon. For the first five kilometres, the highway is raised and balanced on tall, ugly concrete stilts that pick their way indiscriminately across roads, through car parks and between buildings. It would be natural to assume that this is the result of intelligent town planning but very quickly one begins to suspect that the city authorities have simply conceded defeat and abandoned the ground level to the forces of entropy. Below, in the smaller streets, the traffic is at a standstill and in

all directions as far as the eye can see, which is only at most half a mile, an evil, milky-white smog the colour of rheum drowns the city.

On either side of the highway giant, ugly rectangular sky-scrapers line the way. They are not the height of New York or Hong Kong skyscrapers but in most cases they occupy a comparatively larger footprint. Perhaps a more fitting name for them would be skyblocks. Most of them are great slablike edifices; none of them display any particular artistry in their design except that occasionally they come in bizarre and troubling Escher-like geometrical shapes. One, for example, looks like a triangle, another resembles a copper hourglass, but most of the time they are faceless, blank-windowed, con-crete and steel tombstones and all of them are shrouded in smog.

There are few places in the world where the smog is as bad as Beijing. Indeed the UN claims that Beijing now has the worst smog in the world. The US embassy, perhaps in an attempt to shame the city authorities into doing something about it, publish their own smog readings from equipment in their compound in downtown Beijing. They measure PM2.5 particles and ozone levels. PM2.5 particles are particles smal-ler than 2.5 microns in size – for example waste particles from diesel engines. Ultra-small particles like this can be extremely damaging to the health. A reading of under 100 is OK, al-though under 50 is preferable. Anything over 100 is very bad and would be seen as a disaster in a European city. Anything even approaching 300 is heinous, and at these levels people are advised to stay indoors and if they must step outside then

not to indulge in anything amounting to exercise. On the day I travelled to Tongzhou the PM2.5 level was over 500, which the US embassy Twitter feed now records as being 'Beyond index', one up from 'Hazardous' which itself is one up from 'Very unhealthy'. The Embassy has been caught out: their original scale, designed on the assumption that readings would never approach the stratospheric levels that they do today, had tagged everything over 500 as 'Crazy bad'. These days, in winter, 'Crazy bad' is the norm.

Sometimes the smog is the colour and consistency of bonfire smoke, sometimes of fog; on other days it is brownish, on others greyish. On particularly bad days it is the yellowy-white colour of the baleful face of Saturn. For newcomers to the city it can be overpowering and it takes a few days for the body to adjust. Out for an evening stroll on my first night back in Beijing I found myself retching into the gutter outside Dongdan tube station.

Another effect of the disgusting, overpowering, debilitating smog is that it adds to the general feeling that human life is not valued quite as highly in China as it is in some countries round the world. Later that day in November 2011 I had a drink with a friend who lives near Ritan Park in the diplomatic compound. He told me how the night before the local council had come to spray the small patch of lawn in the middle of his compound with pesticide. It is very toxic stuff they use and when he went out later that evening to a party at the German embassy, a German scientist informed him that only a drop or two of such a chemical can cause terrible long-term damage to the nervous system. Feeling a little

anxious he wandered home, trying to remember how close he had been, whether or not he had felt the fine spray on his skin. He was walking down the pavement of a narrow street that was lined on both sides with desiccated-looking trees. Suddenly, out of the blue, a white lorry came into view. It had two long articulated arms sticking out on either side at forty-five degrees and it was unleashing a monsoon of spray as it passed. The spray covered the trees, the earth, the road, the pavement, the fronts of the buildings. Before he even had time to think he was completely drenched in pesticide, so much so that his shirt stuck to his skin and as he ran his fingers through his hair it felt like Brylcreem. They didn't even honk. Listening to my friend recounting this tale, I am reminded of Thomas De Quincey and his opium-induced fears of the numberless multitudes of China, the *officina gentium* – 'the factory of nations'. Mankind, says De Quincey in terror, becomes so numerous that he is treated like 'a weed in those regions'.

After five or six kilometres the skyblocks start to thin out and the Tongzhou highway briefly runs parallel to the Beijing River. Beijing river water looks like off-white matt paint; polluted matt paint which has stood unused for some time. A thin layer of oily rainbow spirals make pretty patterns on the surface. After ten kilometres the skyblocks give way altogether to globalisation's second architectural style. In Beijing, in Manila, in Bogotá or New Delhi – all around the world – endless acres of square whitish-grey concrete buildings of varying dimensions but of identical style and materials are being thrown up every day. Most of the time it isn't immediately possible to distinguish the function of these creations:

they might be apartments, or warehouses, or factories, but then again they could equally be civic buildings, or prisons, or army compounds – it is impossible to know. And every few hundred yards, on either side of the highway, little scenes of human tragedy are being played out, scenes that could almost come from the corner of a painting by a Chinese Breugel: a cyclist, an old man in his sixties, stands up and presses down on the pedals of his bike, his face contorted in pain, the tendons in his neck straining all the way to his collar bones, his bike piled up with cardboard or asbestos sheets. Fifty yards further on, a group of young men crowd round a homemade brazier. They have the high cheekbones and rosy red cheeks of Tibetans; their clothes, their hair, their skin are filthy.

Onwards, through the chthonian fires, runs the Tongzhou highway. To the south, a fist's height from the rooftops, a strange pink disc is visible. It is the pallid, feeble light of our apparently dying sun. When I first set eyes on it I turned to the taxi driver in astonishment: 'Na shi shenme?' 'What is that?' I thought it must be the moon but I was sure the moon was recently new, so it couldn't be the moon. She looked at me as if I was mad: 'You silly ghost from England! Don't you have the sun where you come from?'

At Tongzhou, the taxi finally slipped off the highway and descended into the white soup and we were amid the drab, baffling multi-function architecture of the suburbs. Every-where, on the bonnets of parked cars, on the road surface, on anything that had not moved in the last twenty-four hours, there was a layer of white dust that made it look as though the entire neighbourhood had just woken from a frosty night.

Could it be possible that the smog was even worse here, out in Tongzhou? Perhaps there was a big factory near by? The white soup seemed to part visibly as cars rolled through it and then close again behind them in great swirls. It was 1.37 p.m. and our driver turned her lights to full beam. It was time to begin the usual procedure of trying to find an address in Beijing where the buildings, the streets and districts even, come and go and the inhabitants are invariably migrants. We stopped and started, drove down alleyways, through construction sites, and with an electric hum the window descended and ascended again and again, and the freezing cold bonfire smoke poured in.

'Do you know this address?'

'*Bu zhidao*,' replied the grinning, friendly locals: '*Women bu shi beijingren*.' 'No idea – we're not from round here.'

Half an hour later we finally drove down a cul-de-sac. It ended abruptly at what in England we would describe as a housing estate. We were close now. We got out of the cab and were immediately struck by just how cold minus six degrees centigrade is after an hour in a warm taxi. A preposterous white elephant of a new-build development in a confused style: part English mock Tudor, part Basque Etxea – stout, gabled two-storey buildings, but with a pagoda-like roof. From where we stood, stamping our feet, we could see twenty or so of these block-like buildings. Some were only half complete and to the right there was an abandoned building site.

We followed the footpath into the white mist, stepping round huge piles of sand and bricks along the way, until we

came to the heart of the development. Everything was covered in the icy sprinkling of dust. The central courtyard was totally deserted and on closer inspection there seemed to be absolutely no rationale to the numbering of the buildings – 3b came after 5 and before 2 – and to further confuse things, there was not a soul to be seen anywhere; it appeared that not one of the buildings was inhabited. Suddenly, as we were standing there, half paralysed by cold, wondering where on earth to turn next, black snow began to fall; tiny black snowflakes, drifting slowly downwards. It was a beautiful, terrifying sight.

'What is this?' I asked my friend in horror.

She looked uncertain and slightly panicked. She was already dressed like a highwaywoman, wearing her scarf over her mouth and nose. She caught a flake in her hand and rubbed it and it disappeared into a grey smudge.

'I think it might be money.'

'Money?'

'Someone is burning money for the dead. Paper money. Lots of it.'

'Why? Is it the right time of year?'

She looked anxiously around, unconvinced by her own explanation.

'You can never tell in China . . . Things happen differently in different places . . . Come on: let's try down here.'

Eventually, we found a four-storey square tower, built in the same confused style as the rest of the development. This was the place. The entrance was a pair of huge steel-framed glass doors – the glass so covered in grime and dust that it was

impossible to see into the lobby. We heaved the doors open and stepped inside. The hallway was unfinished. There was a door-sized hole that opened into the darkness of a lift shaft.

'Top floor,' I muttered to my friend, not taking my eyes off the first flight of stairs. Slowly we climbed the steps of the great tower, like Du Fu, the great classical poet, climbing his waterfall in his poem of thirteen centuries ago. Outside the black snow continued to fall.

At the top of the last flight of stairs I stepped over to the window to look at the view. There was no view, just the evil white smog. Below, beyond the housing estate, was a vast graveyard and a huge smouldering bonfire, perhaps the source of the black snow. I recalled from my days in Hong Kong that most Chinese people hate to live within sight of graveyards – proximity to graveyards makes a property almost impossible to rent out.

'There's no one here. Look at this. Could this really be where he lives?' My friend had her face pressed to the glass of the door. I stepped over. Through the dirty glass we could see the room beyond. It was ten metres square, taking up the entire top floor of the tower, bar the stairwell and the landing. There was a bed. It was unmade. There was a large table littered with papers and dirty crockery and three duty-free cartons of cigarette packs, one half finished. On the other side of the room, on the floor next to a plug was a small white plastic kettle. Leaning against the walls were various paintings, all in the same style: pointillist canvases of red dots, highly impressionistic, as if the artist had been dreaming of harvest time in the great red sorghum fields of the north,

where so many intellectuals were sent during the Cultural Revolution.

Suddenly, we heard the clanging of the door downstairs and the slow slap of leather-soled shoes on the undressed concrete steps. Finally, a tall, thin man in his sixties stepped onto the landing. He was wearing jeans and a worn-out bomber jacket. He had a thin, rugged face and a full head of white hair.

This was Mang Ke, one of China's most significant living poets and the co-founder of *Jintian* magazine. His words and deeds have been woven into the fabric of many people's lives. He looked exhausted and he looked ill. Naturally, Mang Ke didn't appear to care at all about his immediate environment. He was well used to it, and what was more, he possesses an immediately tangible integrity that has somehow protected him from the depredations of the mundane world.

We shook hands. Mang Ke unlocked the door and ushered us into his home. Instinctively I took off my coat, which was a mistake. It was colder in there than it was outside. Our breath streamed out of our mouths as we talked and condensed in the freezing air like great clouds of cigarette smoke. Mang Ke poured us each a glass of boiled water then lit the first of an unbroken chain of cigarettes.

For the next two hours I sat in silence. Mang Ke talked of his youth spent in Bai Yang Dian, in Heibei province, where he went during the Cultural Revolution to work on a farm. He talked of the first days back in Beijing after the end of the Cultural Revolution, how everyone shared the yellow books (he explained that many translations of foreign literature that

were intended to be read by the senior cadres alone were bound in yellow covers); how they would sit around and read in each other's rooms – Kerouac, Dylan Thomas, Baudelaire, Eliot and Whitman. He recounted the inception of *Jintian* ('Today' in English) – how he thought up the name and how they gathered together a selection of poems for the first edition from the community of underground poets in Beijing. These were poets who had shared his own trajectory: self-taught, exiled to the countryside and relying on dog-eared shared translations, often working in isolation until they could get back to the underground salons of Beijing and the other big cities. He explained how some of the Stars group had offered to paint the covers and make illustrations. The art was revolutionary, the poetry was revolutionary. It was a celebration of freedom. They used new forms, they dispensed with all the strictures of Maoist thought on literature and art.

But as Mang Ke talked about the old days he began to tell me something else. He warned me that the past is a very perplexing place, that it is necessary to be suspicious of the passage of time itself – that time in its very essence is cruel, that it is radically ironic, and that it will always get the better of us if we give it the upper hand. He said that time is like the wind and that we have to stay on its shoulder and that if we fail to do so it will destroy us in a second; that time has the capacity to render every human life ridiculous, irrespective of the achievements or past glories of the individual human being. And those people who cling to the past and linger on their stories from long ago are tragic figures, and that if you fail to let go, and if you refuse to recognise that today you are

not the same person at all that you were all those years ago, then not only do you become a tragic figure but also you become inhuman.

Then as if to show that he had mastered time, he began to describe in graphic detail the small house in the vegetable patch on what was then the outskirts of the capital, in what is nowadays Sanlitun in downtown Beijing. He recalled exactly what they did that day, how they ate what they feared would be a valedictory meal of Beijing noodles, and how they then mixed the buckets of paste and hooked them over their bicycle handlebars and each taking a broom and one hundred copies of *Jintian*, they cycled to the Democracy Wall and began to paste them up all around the streets. There was little doubt in their minds that they would be arrested and sent down, or worse. But as he recounted these events from long ago, what was most clear was that he was quite deliberately describing the scenes from a distance, and he was doing this for a reason. He could easily have woven all sorts of emotions into his account – 'I felt so scared,' or 'we were filled with joy,' and so on – he could have made his claim on history as any normal person would, recounting the glorious days of their youth, but he refused to do this. He refused to wear the mask of the hero poet. His goal that day, just as it was back then, was free, truthful self-expression, and he told me that this can only be achieved in the here and now and it can only be achieved if one is prepared to sacrifice everything, including the past.

All works of art, he said, are first and foremost acts of art. The works of art by great artists that come down to us from

history are more or less just accidental by-products of the real work, of the superhuman efforts that the artist makes to ensure that their viewpoint is honest, unblemished and free of outside control. To the initiates into this alchemy, Mang Ke said, the price that must be paid can sometimes be the ultimate price. For once you have seen the truth, even if only for a second, there is no turning back. The ground may swallow Ai Weiwei up again but if that is the case then he will be like Mansur al-Hallaj, the great Sufi mystic who was beheaded for daring to cry out in the market square 'I am the truth,' and the Chinese government will be like the Abbasid Caliph al-Muqtadir, who could not bear to share the earth with such a human being.

'It is not because Ai Weiwei is a friend in the old days that I speak so well of him,' said Mang Ke. 'It is because he really is an outstanding person and he speaks directly from his heart. This cannot be said of any of his peers. They are for the most part dishonest, though many of them are not even aware that they are so.'

9

Weiwei returns to the table with our glasses full of fresh tea. He is looking very sombre. It is time to move the conversation on, away from people like Mang Ke and Wei Jingsheng, away from his own ghastly present predicament and on to something more positive.

'Can we talk about America a little more? You left for America in '81 didn't you?' I ask.

'Yes. I never graduated. The third year I left school. Then I went.'

'Was it easy to go?'

'It wasn't difficult but very few people knew how to do it. America was still the big enemy and I did it because my girlfriend, the girlfriend I had at the time, her whole family went to the United States after the 1949 revolution. Only her mother and father, who were revolutionary young people, stayed here. But during the Cultural Revolution her mother was killed.'

'Why was she killed?'

'Because she was an English teacher. Because she dressed differently. You know, she read lots of literature and had nice clothes. She read foreign novels. That's all it took. She was killed. My girlfriend found her in a public toilet, hanging

there, beaten. So she would never come back to China. She still hasn't come back, even today. Whoever went through the Cultural Revolution has been damaged.'

'Yes. Your own upbringing wasn't so good.'

I am thinking about Weiwei's childhood in the Gobi desert, living underground, and how it must have made the ordinary penury of the struggling artist fade into insignificance.

'Weiwei, can I ask you to clarify something for me? You've told me this before and I can't understand it. Do you mind me asking: you've said in the past that you lived underground. How can you live underground?'

He doesn't seem to mind. 'Let me show you,' he says. He puts out his hand; I give him my pen and notebook. 'Thank you. This is the ground. They dig a hole, like this, and then actually you put some branches like this, you cover this with earth, so there.'

'Where's the door?'

'Anywhere! You can just come down anywhere, slip in anywhere for the door. So we live in there. Very warm. Whole of the earth for your walls!'

'The whole family?'

'Yes. And here is a hole so maybe some kind of light can come in . . .'

'And a fire? To cook?'

'Cook? You just need a stove.'

'Do you remember? Did you have a stove?'

'Yes. I had to make it myself when I was ten.'

'What about your father?'

'My father was sixty. He was a poet all his life. He never knew how to do these practical things. My mum can do many things but at very beginning my mum was also sometimes not there so I had to do everything.'

'Why wasn't she there?'

'She would go to Beijing with my brother to file a complaint but of course it didn't get anywhere. So we lived under there, very warm in the winter, the walls very thick.'

'But who made the hole?'

'Somebody left it there. Nobody lived in these conditions any more. It was there because the military has passed through. They dig holes and put branches on top for the soldiers.'

'And who lived around?'

'It's a small village. About two hundred, three hundred people and as you know, my father was criticised, a criminal of the state, punished to clean public toilets. And I grew up, from ten years old to fifteen years old. Five years, in which I learned everything.'

'Was there a school?'

'Yes. But at the school we only learned Chairman Mao's sentences and then we would go to fields whenever needed. We woke up at four o'clock in morning when the stars were still there and we walked to the fields to prepare work.'

'Was your father part of a big round-up?'

'Yes. He was part of the big round-up in 1957. The anti-rightist campaign. He was one of the top writers in literary society. I think Chairman Mao never had good relations with so-called literary men or artists. He never really trusted them.

He disliked them. And when there is power those kinds of people always make problems. Like Stalin said, the writers and artists are the engineers of the human soul. But Mao wanted to be the engineer of human souls, only him, no one else was allowed.'

'And who rehabilitated your father?'

'Well, it was a policy when Deng took over. But there was one person behind it: Hu Yaobang. He was also taken down by Deng. He's a nice person in the history of the Party. In fact it is interesting because the 1989 student movement was all because of his death. Initially, people wanted to take flowers to Tiananmen Square to remember him.'

'And he is still remembered fondly?'

'Yes. He was a very nice Communist leader. He was an honest man, passionate, tender. He wanted to do the right thing.'

'That was a very hard life, your childhood in Xinjiang.'

'Yes, but during the Cultural Revolution so many people were killed or died of starvation because there was almost nothing to eat. We will never know their stories. We didn't have medicine. Every year we had stomach problems. It has to disappear by itself or I take a handful of medicine, just eat like this, just grab antibiotics; your body is so weak.'

At this point Lu Qing comes into the room and gives Weiwei a copy of this morning's newspaper. He looks at the front page and laughs heartily.

'What a joke! About the train crash, PM Wen said, "No matter what the problem, we will get to the bottom of it." In the whole conversation he had with the transportation head, he said just a few words: "Rescue the people." It's ridiculous

that anyone would say this in any society. There's no question about whether or not to rescue the people but what about trying to find out what's wrong so that we can prevent it happening again?'

I am reminded of something I heard the night before:

'Did you hear the Japanese always record the decibel level of their high-speed trains as they pass through the stations?' I say. 'They do this because the more noise it makes as it passes through, the more likely something is going to break – because even if the joints between the doors are beginning to get loose it makes a tiny noise and it all adds up. And the Japanese bullet trains, they normally measure sixty-eight decibels, and the Chinese ones, like this one, measure around 120.'

'Someone did this just recently?' says Weiwei.

'Yes, and they say that in Japan they take any train over a hundred decibels out of service, because they know that something is definitely bound to go wrong. Something will definitely happen.'

I'd been discussing the train crash in a bar the night before, with a group of expat journalist friends. Of course, all countries have train crashes but this crash had exposed the corruption of the system and also the myth of Chinese technical capability. A journalist friend had told me the story about the Japanese measuring the decibel levels of the trains. He had phoned up the Japan Railways Group and spoken to an engineer. Inspired by what he had learned he had bought a decibel meter himself and recorded a Chinese high-speed train as it flew by. Incidentally, the Japanese engineers were quite certain what had happened. The Chinese had stolen a

lot of Japanese technology, attempted to copy sensitive, important equipment and failed badly. And this is a familiar story. People tend to see China as the assembly line of all western technology, but while it's true that about ninety per cent of iPhone production, for example, is based in China, the most complicated five per cent of the components (if one is to believe stories in the London *Times*) have to be assembled in Japan and elsewhere. Now China has a vast network of dodgy rail infrastructure, none of which can really be trusted, and the government knows this, as do the people.

'That's so bad,' says Weiwei, shaking his head and turning over the pages of the paper. 'Even a hundred years ago, in China many, many thinkers believed in a new society. China needs two things, "Mr De and Mr Sai". China needs these two people to escape its feudal past. "De" means democracy and "Sai" means science. But still the government refuses to believe in this. The Communist Party still refuses to let in Mr De and Mr Sai. Even yesterday a newspaper asked me, "What's your political belief, why you always fight like this, what's in your mind?" And you know the secret police, sitting in your position, opposite me, right where you are sitting now, asked me, "Weiwei, what are you trying to do? What is it that you are hoping to achieve?" I said, "We have to believe in democracy, we have to be a scientific society, only that way can we meet the challenge." But they would never trust that. They would never let go of power, let the people rule.'

Outside the window in the garden it is as if night has fallen. The bamboo is rocking backwards and forwards in the wind and rain. Our conversation turns to the revolution and to the

early years of Mao's rule and to the Chinese language itself, which became a tool in the hands of the Communist Party. In *1984* George Orwell imagined a state-sanctioned language, partly inspired by Basic English, which was first proposed in a book published in 1930 by the English linguist Charles Kay Ogden. Orwell's Newspeak was designed to prevent bad, unrevolutionary thoughts, and just as in Ogden's real language the vocabulary was shrunk to under a thousand words. Give people only the words that you want them to have and their thoughts and feelings will be circumscribed. You deprive them of the conceptual framework to subvert or question the established order.

I don't think that either Ogden or Orwell was aware that this nightmarish idea was put into practice in China. (Ogden's associate I. A. Richards is said to have promoted the idea in Chinese schools in the 1940s, as a measure to improve cross-cultural communication – but Mao needed little help.) If you were a sensitive person, particularly if you were born after the Great Proletarian Cultural Revolution and deprived of an education in Chinese classic texts that might expose you to old words and complicated sentiments, then you found yourself unable to express so much of what you felt. Many Chinese friends have commented on this, and have despaired of the manner in which their ability to think and communicate was tampered with and reduced. The Party controlled everything: all printing presses, all publishing houses, all newspapers, all TV. If they didn't want a word to be part of the language they would simply make it disappear, or never allow its introduction in the first place.

People who have been brought up in the west and who have never lived under such conditions are often astonished by the brazenness of Communist or Fascist lies: lies such as 'Arbeit macht frei' or Stalin's 'Life has become happier.' But the statements that are so obviously contradictory – that slavery is freedom, that preparations for war are steps towards peace – demonstrate more thoroughly than anything else the limitless power of the Party and the complete powerlessness of the individual.

'I think any type of revolution in art or literature or in reality is always about how many new concepts are being introduced. And the words are the basis of that. The new vocabulary is the most essential thing. To use new vocabulary means you can really set up new ideas, really expand people's minds – you never just use old words. But Chairman Mao and the Party controlled this process completely. They only let in the words they wanted, the words that they were in control of,' says Weiwei.

'So when you were young, growing up, before you went to America for example, at eighteen, nineteen, did you have the conceptual vocabulary to think as you do today?'

'No. No, we were still using, how you say, Chairman Mao's dictionary. We were limited in our reality. Very limited by our language; by our lack of language.'

'You feel things you can't possibly express?'

'Yes – you cannot use – it's very much like . . . it's hard to use chopsticks to take soup. It's the wrong vehicle. You don't have the right tools. How can you cultivate an individual point of view if you do not have any of the vocabulary that

you need in order to have such a point of view? I remember that "friendship" in the people's dictionary was defined as "comradeship, as in the comradeship between China and the Soviet Union". That was supposed to be our definition of friendship. What a joke! Except it wasn't a joke. So when you are in such a position, when your language is so poor, you often find yourself aching with emotion. You feel something deep inside but you do not know what it is you feel, because you no longer have the word. So this is how they shrink the human being.'

'So when you went to America as a young man there must have been a sense of excitement at being exposed to new ideas?'

'When you arrive, first of all, you want to give up the past. You see a new society and you realise that things don't have to be the way they were in China. They are only like they are in China because of the political system. You are clear about that. So this is really the reason to go to the US. Just completely to give up the old way of thinking. I'll tell you a story. Before I went to the west there was this very famous translator, Yang Xiangyi, probably the most famous translator in all of China. He was a friend of my father's. After the Cultural Revolution he of course was out of a job. They were all part of the same group of people. One day he gave me some books about western art, you know those little, well-printed books about post-Impressionists, like Van Gogh, or Manet and Degas, and also he gave me a book on Jasper Johns. Of course I like Manet and Van Gogh, and so we all circulated these books in the small art circles in Beijing.

Everyone loved these beautiful paintings but nobody understood Jasper Johns. I also hated his work. *Red Yellow Blue*, an American flag? It made no sense at all. So we just threw that book away. But later when I went to New York somehow I was immediately attracted by Jasper Johns.'

'Why? What was the process of the change – in your mind?'

'I think I responded to the new definition of the conditions of art. Johns was breaking a bit from the past. He was giving a new starting point. He saw a new way of art.'

'But still, in China, it made no sense to you? Then you go to America. What caused it to have meaning for you?'

'I think it was the whole environment. Seeing the whole new society. You know the United States has a very short history compared to China. There are people from everywhere. They came up with a new society and a new set of rules, which was not exactly a development of the past. It creates new problems but also it gives a lot of new definitions to the moment.'

'But given your training in China, at Beijing Film School, how did you engage with this American art?'

'When I arrived, I remember the first class at Parsons college, where I studied. I was figure drawing and I put a large piece of paper on the ground. I used ink and brush and it took me maybe fifteen or twenty minutes to make a very nice figure drawing with ink and brush, which requires a lot of control. I remember all the class standing there behind me saying: "Wow! If this guy can draw like this what can we do? We can never get to this point." And my teacher was Sean Scully. Sean

Scully is a famous Irish painter. He came in to see how we had all got on. He sat behind me and said, "This is the worst painting I have ever seen." You know this guy, Sean Scully, was always a very, very tough guy. He painted those strokes, like Jasper Johns. The whole class was shocked by what he said and also I was shocked because in that moment I immediately understood. The other students had put a lot of effort trying to just draw a little bit, maybe a hand or a foot or something, but it never really worked. They tried to erase it. Then they tried again. Their effort was so strong, so sincere and their actions were so much more important than someone who is so skilful producing a so-called beautiful work just using a convention. So that moment I changed and I knew in a second that I had to give up all those skills I had learnt in China. Now it had to be about effort and the sincerity and the tension there. That is a contemporary understanding rather than the classical sophisticated understanding, where people try to communicate something through the exercise of some kind of highly practised skill. The limitations of the classical method are that each skill is a language and each language itself can only lead to certain kinds of aesthetic results. If you use that skill the conclusion is inevitable. You will have this kind of aesthetics, this kind of reality, this kind of meaning. Then I began to pay a lot of attention to what Jasper Johns did and to what influenced him; to Duchampian thinking, the attitude and lifestyle, the philosophy.'

'So in that year you were already starting to think about Jasper Johns?'

'Later Johns had a show and Sean Scully liked him so we

went to see his show. Sean Scully likes only a few people. Sean Scully is a very narrow, focused type of artist.'

'Let's talk more about Andy Warhol. Tell me more about when you were first exposed to his work?'

'Yes. I remember there was a book, I think it was called *Off the Wall*, that talks about the generation of Jasper Johns and Rauschenberg. It's a very little book but very interesting writing. It talks about art after the artists like Jackson Pollock, de Kooning. So, of course it immediately mentioned Warhol. And I was very attracted by this guy Warhol because he was so insecure. He was a commercial artist and he really wanted to become an artist and yet he was so ironic. He was homosexual, very sensitive, but very insecure but despite that he tried everything. And his character really, really attracted me. I think he is more the American artist than anybody else. At that time nobody really understood him – not even in the eighties. People were still saying, "He's not serious, he's just commercial."'

'In the eighties?'

'Yes. Even right up until he died. Right after his death he became more established but before that even I can buy his paintings, his prints. I remember once, I had just done a construction job. I was so dusty because we had been destroying a basement and we were doing carpentry work. I had just been paid four hundred dollars for all the work and so I had money in my pocket and I walked past a yard sale and one of his prints was there: *Chairman Mao*, and I said how much and they said "Oh, four hundred dollars." So I bought it and from then on it was always hanging in my apartment.'

'Where is it today?'

'I gave it to a friend before I came back. It's the first painting I bought.'

'What does the Chairman Mao image mean to you?'

'It means emptiness. I grew up with this guy everywhere, still today even. I knew everything about Mao. I even had to memorise all the sentences from Mao's book and I have a good memory. When I was in detention this shocked the interrogator very much. He said, "You know much more than us. You know about the leadership, about how Communist Party members should behave." The reason I knew all this was because Chairman Mao had very clear thoughts about all those things and he wrote them in his book and I can still remember them even now. The secret service agents were all shocked. But that was my education. And so gradually this person, Mao, become a cult figure, like the Bible. So to me he became emptied of meaning. His image reflects a whole condition; he's not a personality any more. I was the one person in whole of China who made a set of Mao paintings. It was in 1983, 1984.'

'You did what?'

'I painted Chairman Mao at an early time, for a short period of time.'

'Here, in China?'

'No. In New York. But I really don't like it. No. It's like you would paint an apple or an orange and the artist in Italy, Morandi, might paint a vase. I would paint Mao because that's what there is. He's the person we see every day. Or at least it's his image that we see every day. It was just a graphic, no meaning.'

'So, after Parsons, did you continue to make art?'

'After Parsons my main desire was to stay in the States. I don't like school. I was a good student at Parsons but I've never liked the school experience. So I said, "I want to be in the United States for the liberal conditions but not for school." I had no money and I had to do all kinds of very odd jobs to survive. And I didn't want to waste time working in bad jobs just to pay the tuition fees so instead I was just hanging around. Of course, I called myself an artist but what kind of an artist was I? I didn't support myself through art and I didn't have anywhere to exhibit. My habit was to paint very intensively, passionately, for a very short period of time and I quickly would accumulate a lot of canvas, a lot of work. But I moved about ten times in Manhattan. And every time I moved, I threw out all the old paintings. You can't drag them about, it would take half of the room anyway, so why you need those canvas?'

'So when did you first move on to the conceptual stuff?'

'At that time I was already having trouble thinking about painting. It wasn't really attractive to me any more. Painting had already stopped making sense. Of course, it didn't help that there was nobody to buy the work, or even to appreciate it. So I had one show much later, in 1987. That showed the *Hanging Man* coat hanger and *One Man Shoe*. I called this show *Old Shoes, Safe Sex.*'

'Where was that show?'

'A little gallery in SoHo called Art Waves gallery. It was run by Ethan Cohen. His father is an extremely famous lawyer in China called Jerome Cohen. On my case, my recent case just now, he made a lot of arguments. Most important arguments.

He made the most important arguments during these eighty-one days.'

'Was the 1987 show a success?'

'I thought it was a great success! But it was only me who thought it was a great success. There was an article in *Artspeak*, a newspaper in New York. The title was something like "Ai Weiwei is the heir to Dada." At that moment everyone was talking about abstract expressionism, or new expressionism. Nobody was interested in Dada or whatever. But in the article they mentioned Andy Warhol and they mentioned Duchamp and they said if Duchamp saw this show, his soul would laugh. I liked the show very much but nobody paid any attention to it.'

'But you didn't give up after that?'

'I didn't give up in art but I didn't *do* any art. Those were the only works I produced.'

'Did you know other artists in New York?'

'No. I didn't know anybody. I was a foreigner. I knew some underground artists. Many of them had AIDS. This was the eighties. But I didn't know any famous artists. At that time in New York it was Julian Schnabel and the gallery was Mary Boone and all those people. Only a few lucky artists then made a very big impression.'

'But what did you think your chances were?'

'No chance at all. I thought it would be impossible for me.'

'So what made you continue to call yourself an artist and carry on?'

'Well, I'm an artist by nature. I'm not interested in practical matters.'

'But didn't you get sick of being poor?'

'Yes, but also I grew up in very bad conditions so if my refrigerator still has a glass of milk in it then I think things are OK. Perhaps for other people that's poor, but for me I don't need more. I can easily survive. Also, I'm not interested in the American dream. You know: getting established in society, becoming wealthy, the material life. I'm not interested.'

'So then you were in New York for a decade more or less, then you returned home, and you came back to Beijing and what was your ambition?'

'I had no ambition. Bottom line. People said, "Weiwei you will be the last person to go back," because of my lifestyle, my way of thinking, I can never go back. I would be the last Chinese person and also I told everybody I would never come back. Twelve years I don't even write back a letter almost. Then I asked myself a simple question: will I ever come back and if I do what is the worst that can happen to me? You see, I was kind of involved in the democratic movement in New York – you know, Human Rights Watch. I often had contact with them, particularly around the '89 student movement. I was involved with the Chinese exile group in New York. So I thought that the worst thing can happen to me is that they put me in jail. Because back then I was naïve, I said to myself, I'm ready for that. Which is ridiculous. You are never ready for jail. But I thought, my father was in jail for a while and he seems OK. So I came back.'

'What happened to your New York work?'

'I packed some small works. Gave some to friends to look after.'

'And what did you do when you got home?'

'Nothing. Just what I do today in fact. I saw my family, some artist friends.'

'But did you still have contact with other artists? How did you know who to see?'

'They all know me because I'm quite known. But all my gang had stopped or gone abroad. That's why I make a book called *Black Cover Book, White Cover Book* and *Grey Cover Book*. I was shifting into the conceptual and experimental.'

'I suppose what I'm getting at is what did you think of the artists who were working at the time, when you returned? Clearly there can't have been much conceptual art?'

'No. Not really. We did the first conceptual art. We did *The Black Cover Book, White Cover Book, Grey Cover Book*, and later we did the *Fuck Off* show.'

'When was that?'

'The books in 1993, 1994. Just after I come back from United States. We were trying to promote the ideas behind art, the concept. Then the *Fuck Off* show was in 2000.'

Weiwei readily admits that it wasn't the best show they could have mounted. They had very little time to prepare it and they thought at any moment the police would shut it down, as it was an unauthorised exhibition. But the artists were enthusiastic and the most important thing for Weiwei was that the attitude was there. The show is still talked about today as a seminal event in modern Chinese art history, precisely because the concept was so clear.

'After 1989 Deng Xiaoping and all the top Communist Party leaders concluded that Tiananmen Square was the result

of the spiritual pollution that had come in from the west in '85 and in the middle eighties,' Weiwei is saying. 'It was then that the Communists had opened up the country for the first time and allowed western ideas to be introduced. At that time a lot of books were translated and all kinds of strange and novel ideas began to enter China. But China was quite weak after the Cultural Revolution. It was like a person has been locked under sealed glass for the past thirty years. So when the glass is finally opened, the person simply has no immune system. All kinds of ideas came flooding in from abroad, from societies that developed gradually over the past three hundred years with the French Revolution and the American Revolution. So it was concluded that 1989 was the result of all this: the students suddenly saw what was happening elsewhere in the world and what other people had thought and said and they wanted to change what they thought was a quite rotten society. The problem is that although it is quite rotten, it's a military-controlled government and the military are incapable of negotiation. Today this is still true, almost. There's almost no way to have conversation. They just finally have to use tanks. Deng wanted modernisation, he wanted aspects of modern society but he was against what they called spiritual pollution. He said we have two hands to grab very firmly. One hand will be used to modernise China and the other one to stop imperial capitalism. This is what makes China so terrifying. Nobody can discuss contemporary things...'

'So in art schools, say in Hangzhou, or Sichuan Fine Arts academy, what were they painting after 1989? What were they studying?'

'They painted French classics. Copies of French classics and still life.'

'They were still doing that? Even after 1989?'

'Even today! The model – sitting there like this. Oil painting, drawing, for seventy hours the model of Jacques-Louis David, his clothes, his hair . . . they are very good at it.'

'But did they teach anything else?'

'No. No concepts. No concept of art history.'

'This is still true even today?'

'For the majority, yes. For the mainstream it is still the same even today but at least today there is so much more information and there is the internet so you can get it from outside. Back then there was no internet. And today they have to hire teachers from abroad sometimes but the basic structure is the same.'

Outside there is an enormous rolling crack of thunder and the room is pitched into darkness. The noise is so close, so deafening that we both flinch.

Weiwei stands, walks over to the window, gazes out at the teeming rain.

'This year everything is so wrong. The Chinese say something is definitely going to happen. Do you know the story about the snow in the south? One lady, her name is Dou-E, "Innocent", was wrongly accused by the old men of the court long long ago, and then in June the snow comes down, so people believe that she is telling the truth.'

There is another enormous crack of thunder that rumbles on for almost a full minute. Weiwei is beginning to look thoroughly exhausted. Throughout our conversation the thunder

226

has been growing louder and louder and now it is booming above our heads.

'Do you need a rest?' I say, after the thunder has died down again.

'Yes. I think a rest.'

10

Six months earlier, I had been in Paris, sitting at a little zinc-topped table in the Marais, nursing a glass of beer, talking to the artist Gabriel Orozco. Orozco is a strange human being. On first meeting he comes across as amiable, straightforward, lacking in any kind of side. He is in his late forties, he has greying curly hair and a rugged handsome face that has seen its fair share of sun and rain and smog. His clothes are work clothes – he could easily walk onto a building site, take his denim jacket off and start work immediately. He drinks a beer, he relaxes into his chair and as he talks he plays with the beer glass, tipping it onto the rim of its base and swilling the last drops of spray around and around. He has time on his hands; it is important not to hurry, in art or in life. Like Weiwei, he moved to New York, in Orozco's case in 1982. Like Weiwei he had no money for materials and no studio, so he made his art on the street. It was a radical *arte povera*. It took him a decade to feel his way. He used whatever came to hand: bicycles, puddles, yogurt pots, balls of plasticine – he even famously used the condensation of his own breath on a piano lid. Throughout this period of his life, Orozco toiled away without recognition. He had, he says wryly, the most exclusive of audiences that any artist can have: his mother and his aunt. For some

reason he managed to persevere. Today his influence on the contemporary art scene is vast and in spring 2011 there was a major retrospective of his work at Tate Modern.

Orozco orders a coffee, smokes a cigarette, and talks about Manhattan and about Mexico in the old days. He says he is looking forward to taking a holiday with his family. He is a solid, warm, avuncular presence, like Weiwei. And like Weiwei nothing he says or does is in bad taste, not a single word or gesture. It is all good, clear, appropriate, honest. And he is not vain. People respond well to him; everyone likes him. Waiters and passers-by smile at him; an aggressive and dangerous-looking dog bounds up to him wagging its tail and licks his hand; the small child from the next table totters over and leans on his knee. Even the woman behind the bar, a stick-thin Parisian in skin-tight jeans, who had looked at me so reprovingly when I entered the bar, instantly treats Orozco with respect.

But then there is something else that occasionally breaks the surface. It is hard to put one's finger on it but there's a particular fineness, a particular sophistication to the way Orozco listens. It's different. It's almost disarming. It seems somehow at odds with many of the other aspects of his character. His head is cocked, his brow is furrowed; he's deep, deep in thought. He is strangely thoughtful and it is this quality that reminds me so much of Weiwei. If these two great conceptual artists share any characteristic it is that they think about problems of which most people are not even aware. They are both thoughtful in the way Isaac Luria must have been thoughtful, or even Lao Tzu. During my conversation with Orozco in the

Marais, as soon as we touch on any subject to do with art or thinking about art and particularly conceptual art, the nine tenths of the iceberg that normally lie submerged suddenly rise to the surface and in an instant it becomes clear that his worldview is utterly particular to him, wildly out of the ordinary.

I ask Orozco if he makes his art with the intention of changing people's consciousness. No, he answers, it is the other way round: he makes art when he feels his own consciousness change. When that happens he reckons there is a chance he might be on to something. Furthermore, he says, it is becoming increasingly difficult to make new art these days – but then again, he corrects himself, it's always been hard to make new art. It's hard specifically because when new art first appears, there is no audience for it. There is an audience for the old style of art, for the last reincarnation of art – you can bang in a few nails and hang up some Impressionists and people will come in droves, you won't be able to keep them away, not even if you charge a fortune, as so many galleries do. But there is not yet an audience for the new art. The artist must therefore be exceptionally strong. This new art has to somehow survive a certain period after birth, like a Spartan baby on a mountainside, so to speak, before it is taken in by a gallerist or a collector, or a curator, and perhaps with luck, if it means anything to anyone, gradually the warmth of more and more human attention will keep it alive long enough for it to grow and prosper.

Orozco is the conceptual artist's conceptual artist. After suffering a collapsed lung he spent four months indoors,

during which time he created *Black Kites*, a human skull painted inside and out with a geometric, black-and-white pattern. Damien Hirst, who it turns out is a gentleman, wrote to Orozco to thank him for the inspiration he drew from this work when he made his own *Diamond Skull*. And Orozco's hand can be seen elsewhere too. He was one of the pioneers who took the sigils and runes of *arte povera* and formulated a new fully developed language, a new orthography for a certain kind of conceptual art.

All art – modern art, postmodern art, conceptual art – is, in one very important respect, trying to do the same thing. All art is, to use Orozco's phrase, attempting 'to build a bridge to reality'. And it is no coincidence that so many of the great modern artists, artists who are habitually thought of as difficult or esoteric, go out of their way to stress that they are realists; Rothko, for example, insisted on this fact. They just see reality differently from how we do, so it looks strange to us – for a time – but our children may see reality the way they do; it will become normal.

And Orozco's other emphasis, on the artist's change in consciousness, reminds me of a Chinese fable that Weiwei sometimes refers to: 'You're on a boat, on a river, in a valley. Overhead between the cliffs you see a white horse jump the gap and then it's gone. Astonishing! But where has it gone? Why are you in the boat in the valley? Where are you going? You don't know; you will never know. That's life. That's it. The only thing for certain is you saw the horse for that brief second, and it changed the way you felt. That's the only thing...'

It is often said that China is moving into the modern world. As of 2012, its population is now predominantly urban; it has industrialised; it develops and manufactures technology; it has a quasi-free-market economy; and people have more autonomy. If they are lucky, they can make decisions about how they marry, where they live, what job they do. And yet politically, it seems stuck. The Party likes to say that it has created a new kind of capitalism – capitalism with Chinese characteristics; that China can take the by-products of a way of seeing reality without having also to accept the new way of seeing itself. Ai Weiwei argues that this can't be done. He says you cannot pick and choose when you import ideas. Even the humblest technological innovation causes changes in people's worldviews, let alone something like the coming of the internet. The Chinese government can't – won't – accept this fact as it spells its demise. In these new times, when people's everyday reality has changed so much, people need new bridges. Chinese artists exposed to contemporary art from all over the globe find nineteenth-century realism as inadequate as Cézanne or Picasso did, and if you look at Chinese art today, it is the match of anything going on anywhere else. And this hunger for a new way of understanding existence is not just confined to artists. Almost everyone in the new China can feel the strain that has been placed on the old Maoist-Marxist worldview. Its dictums and theories mean less and less to many people – it is a worldview that belongs in a museum, just as the great propaganda works of revolutionary realism belong in museums. It is true that China's noisy Maoist youth might not necessarily concur –

the people who meet at the Utopia bookshop and website, and the many other Maoist sites; the people who spend their money on the red tourism industry, or are part of the Maoist revival that has been growing in strength since the 1990s. But I believe they are nostalgic for something that can't come back – for a way of seeing that is no longer capable of explaining the present-day reality. Ai Weiwei is at the vanguard of the social, intellectual and aesthetic alternative. Through his art and through his writing, he is determined to consign the old way of the Party to the dustbin of history and to help usher in a new epoch in China where the dreams of the 4 May movement will finally be realised, almost a century on.

*

Weiwei re-enters the room. I am standing at the window, transfixed by the storm. The rain has reached monsoon proportions. We sit down but neither of us can muster the energy to recommence the formal interview. Weiwei turns back to the front page of the paper, shakes his head.

'It's so crazy, the whole thing is so crazy. Listen to this: the boss of the Shanghai railroad says, "At this station the signal box has a very small problem. When the light is supposed to be red it is green." Ha! A small problem? It's so crazy! At least now they have to release the names of the dead. Before they never did that. Because of us they have to. Because of the precedent of Sichuan victims.'

'That's an achievement at least.'

'In China people are learning. People are changing.'

'I'm going to meet Yang Lian tonight, you remember him?'

'You mean Yang Lian? The poet? He writes beautiful poems.'

'Last time I was in his flat in London I noticed a little bronze sculpture hanging in the window. It was a piece of horse tack, part of a bit or something. It had a function; the leather reins passed through it, but it was shaped like a horse as well. It was very old, very beautiful. I said, "Where did you get that?" He said from Ai Dan. I had no idea till then that he knew your brother.'

'I knew him too, in the old days in Beijing. A long time ago. He had to leave. He went into exile.'

'Yes. He's come back to China because his father's ill. He's on his way to Tianjin.'

'Maybe we can all have a drink?'

'I'll try to arrange it. By the way, last night in the youth hostel, I went through all we said yesterday and I kept thinking that it would make a great play one day.'

'Yes,' says Weiwei. 'When I was in there, I sometimes thought that too. The whole situation was so dramatic, it was so full of paradoxes. I was a prisoner of course but so were the guards who had to stand by me day and night, and so were the people watching me from outside, trying to figure out what to do with me. Everyone was stuck. It was a very dramatic situation. And we talked so much about the meaning of art, about politics, about freedom and all the time I tried to answer their questions but at the same time I had to be on my guard because you always have to be very cautious and very careful because you don't know what's really going on. You

only know that you are in absolute danger but at the same time you are desperate to limit the danger and even though you are in absolute danger and cut off from reality, you must still make sure that you don't hurt somebody on the outside or make the problem even bigger by saying the wrong thing. And there was so much confrontation, so much hostility, and the interrogators were not allowed to get to know me or even to say anything that would make me a person. I was just a number. Number 1135. That's my room number. But even this becomes completely dramatic and surreal because the soldiers who are guarding me are young and they have their own past, their own lives, and nobody cares about them at all. They are just soldier A or B or C or D. So confusing. The situation really examines, every second inside examines the very essential questions, the very philosophical questions. How this esoteric society maintains itself and how it will now work and what happens to human nature in those circumstances. It's significant that sooner or later all the soldiers, except one – their leader didn't talk to me – but all of the others all secretly talk to me. But though they all secretly talked to me none of them know that the other ones were also secretly talking to me because of course it's not allowed. They were so bored, wanting to pass the time somehow. They said, "Weiwei, can you tell us a joke?" This was such a crazy situation. How can I tell them a joke? I am in jail; I have no idea what is about to happen to me – I might end up in jail for twenty years. I said, "I'm very sorry. If I had known that I was going to be arrested I would have memorised two hundred jokes!"

'Time passes so slowly, for you and for them, and you try

to memorise everything that happened in your life but after twenty days you have nothing left, it's completely empty! You have remembered every detail, no one has more than that. I remembered every person, every occasion, every meeting, every conversation, from when you are very young right up to that day and then suddenly you are completely empty. It's crazy. Then I try to hold on to something, to think about my son, my wife, my mum. Just to hold on. But then that becomes so painful to think about because they are just as completely innocent as you are and it is unbearable and the outside world also seems like a jail because you can never really communicate to them. So then every time I think of them there were tears pouring down my face and then the soldiers say, "Are you thinking about your wife, your son again? Don't do that. You have to forget about this. You have to forget it all." So I think I really do have to forget about this otherwise I cannot go on. It's so painful, thinking ten years in jail . . . You know, it's just like that . . . So many conflicts about reality, imagination, crime. The whole thing is a paradox. And it continues, even when you leave. It has infected your outside reality. So two of the soldiers were meant to go home by this 25 December. I gave them my number. They already called me.'

'No. Really?'

'Yes. They said, "Are you out?" Because they don't know – they don't have any news in the army. One day they are moved to guard another room and they would never know then what happened in this room. They said, "We were so worried about you, we kept thinking about you, we are so happy you are out . . ." It was so shocking. And after my release the inter-

rogator sometimes comes to see me. It's very strange. I said to him, "Why do you do this, you shouldn't monitor me now."'

'But he is coming to check up on you?'

'Yes. And he says, "Weiwei, just let this one year pass. Come on! You will not die if you don't say a word for one year. Let it pass, then everything will be fine." And I wonder if that's how this nation will change because now there are a lot of individuals who have their own sensibilities and their own judgement. Even after all the kingdoms and dynasties of China, this has never happened before. But now people are beginning to have their own judgement, their own opinion.'

'So this is partly to do with the passage of time. Twenty years ago the individual in those roles would still have had a belief in the ideology. Why is it that nowadays these relatively senior people, even if they are not actually in a revolution, they personally don't want to tarnish their integrity? What is it that's changed?'

'I think that the only reason for the change is because there is so much more information. So much information happens every day and even with such censorship people can still receive a lot of news from the world. Basically I believe a person is a container of all this information, knowledge, judgements. The state of course is still so strong but the Party cannot limit the information any more. There are too many ways round. And with this information people start to form their own view of the world.'

'And that will continue to change.'

'Yes. But the Party is still powerful and of course the struggle to get rich also keeps people busy. But certainly those

people I was talking to inside changed a lot and at the end the main interrogator said, "Weiwei, basically, you are not a bad guy but you did many bad things."'

Weiwei bursts into laughter at the thought.

'How old was the main interrogator in the army camp – the hardcore one?' I say.

'About fifty-one, fifty-two. We're the same generation so we can understand each other. The problem with the younger interrogators was they don't really know what the Cultural Revolution was all about. They had never lived it.'

'So you spoke about the Cultural Revolution with this guy?'

'Yes.'

'Did you get his opinion on it?'

'Not really. First he said, "Why did you become like you are today?" I said, "Well, I've been through the Cultural Revolution, I see how inhuman this state can be." He said, "Come on. Don't joke with me. We all went through that time. Everyone went through that and nobody acts like you do so don't give me that shit."' At this point Weiwei bursts into laughter. 'I said, "Oh God, maybe that's true, maybe there's something else." He just wants to dig it out. To find the real reasons for everything.'

'But your experience of growing up in that place you drew yesterday, underground in the desert. That was an extreme experience, even in the context of the Cultural Revolution.'

'No. Not extreme. You could easily say that my father's position could be considered a soft situation. For so many people it was so much worse. The first interrogator, I told him: "You

people will never really obey the law. Look what you did to your president Liu Shaoqi." He was murdered and nobody knows where or when. The interrogator became very mad and said, "Why do you say *your* president? Was he not *our* president?" I said, "Well, he's your party leader. I'm not part of this party." He became very mad when I said that. He said that I sound like a foreigner. But then he get calm and he said, "Weiwei, you know how he died." Before he died he held the Constitution book in his hand and said, "I'm the Chairman and I'm protected by the Constitution. I cannot be attacked. I am the symbol of the nation. If you attack me you attack the nation." But the red guards just laughed. And of course he was humiliated and put in a camp and died. They even changed his name so nobody could even find out how he died. It's a very sad story. Nobody wants to talk about it now. He was in a higher position than Mao back then. Because at that time China had a policy that the president of the nation is one post and the chairman of the Party is another post. Since then they merged the two. They didn't let it happen again.

'So, you can imagine, I listened to every word that these people said to me. I became so sensitive to everything they said because every sentence becomes so precious, so memorable, when you are completely cut off from outside. You remember every moment, every single word because that's the only thing you have. That's what those kinds of surroundings are designed for; so that they also can examine you very well because of course it's not just the interrogators, there are cameras, people behind the walls, next door, figuring out what to ask next. But you know, from the very first second I realise

even here there is humanity. Even when they put the black hood on me, when the two soldiers were holding me, one soldier grabbed me very tight but the other just pretended to grab me but in fact he held me very loose. So even sitting there, they try to give me more space, not to really hurt me . . .'

'Really?'

'Yes! So then you realise that there are two people sitting here, two other human beings. One obeys the command, the other just tries to use his own judgement and thinks, "I don't see why we have to do this." And that small thing, that tiny sense of humanity, certainly made me much more comfortable in this one-hour road to the secret place. And every time, when they put a handcuff on me, some of them just went *clack*, locked it shut; some of them just did it so carefully, first one tooth, then two teeth, so it's very loose, still comfortable. So loose in fact that you even can take your hand out. And somebody would even very carefully put my shirtsleeve under the handcuff so that the metal would not directly touch my skin. They didn't have to do all those things. It's just a job, why should they care? I didn't even care. But they carefully did that. It shows a lot of humanity, it shows they're different. It shows they think and they decide that they don't believe in this. And some police would always say, "Do you want tea?" They would keep asking. I don't want tea at the start but they keep pouring tea, trying to make me feel good. There was a lot of nice or warm situations there. A lot of humanity.'

*

If only a single conclusion can be taken from Weiwei's tale of eighty-one days inside, I am tempted to say it is this: that more and more, the rank and file are just going through the motions, that they have lost the faith. The gap between what the Party says and what it actually does has finally become too great. Economic growth is slowing; netizens discuss the Party's failings openly online; corruption among officials from village level right up to the politburo is endemic; a new middle class has arrived, with a taste for accountability.

Communism was once a great force in China and once upon a time it really did bind the people together. And many of the founding fathers were – for all their other faults – for the most part, non-venal, non-hypocritical. It is entirely understandable why a downtrodden peasant might admire the story of the Long March, and the early years of the party elders, living frugal lives focused on furthering the revolution of the people.

But that is ancient history and today the Party is pedalling furiously to transfer people's affections from the ideology of communism to the ideology of out-and-out nationalism in its last desperate bid for survival. It is a brazen switch and perhaps the day is not too far off when the people will come to see the Party as part of the problem and not as part of the solution. And when this happens, maybe in a few months time, maybe in a few years, people will gather again in Tiananmen Square to demand their freedoms, only this time those at the top will give their orders but the soldiers and policemen and Party cadres will melt away and the century-old dreams of the 4 May movement will finally be fulfilled.

But perhaps I'm getting carried away. Even the thirty-one-year-old Han Han, the most popular blogger in the world, routinely self-censors his output to avoid being silenced or arrested. His comment on hearing that the imprisoned human rights activist Liu Xiaobao had been awarded the Nobel prize was famously limited to a pair of empty quotation marks. And Chan Koonchung, the Shanghai-born, Hong Kong–raised writer and movie producer whose brilliant dystopian satire, *The Fat Years*, came out in 2010 and was immediately banned in China, is even more pessimistic. I met Chan in the gilded surroundings of a Beijing Kerry Centre café, where he went straight to the heart of the matter: how important is complete freedom, he asked? And is such a thing even possible? And what is wrong with a state that chooses to organise itself so that there is just one party? After all, if a citizen of such a state wanted to participate in the political process, all they would have to do is join that party. Is this really so much worse – or different – from the western, liberal idea of democratic representation? And what criteria should we use to judge which system is preferable: should we base our assessment on how many wars or financial crises each system is responsible for starting? Chan Koonchung continued:

The new normality in China is that people don't care about free speech or universal suffrage. They care about corruption and government accountability and most of all they care about their own prosperity. These really are the Fat Years – here and in the west. No one entertains the idea any more that China will evolve into

a thing like the US or Germany. All they want is for the Party to obey the constitution and its four amendments. They want it to obey the law. That is enough. Remember, China already has a good constitution – it already has law. They made the constitution in 1982. But it sits there like a brand-new kitchen appliance that the Party doesn't want to plug in. There are historical analogies for what China is fast becoming: think of early Italian fascism, with its 'positive' totalitarianism. This is fascism in China today.

In any case, there is too much at stake for power to be transferred peacefully. And secondly, the most probable reason that people didn't torture Ai Weiwei during his spell inside – beyond the inhumane conditions of his illegal detention – was that they had specific orders to treat him very well. Maybe the interrogators pretended to sympathise with him and pretended to be persuaded by him and pretended to treat him with humanity. These are very clever people – you can never tell. But then again, Ai Weiwei is very clever too. He is a prestidigitator, a force of nature. He started life in a hole in the ground and became an internationally acclaimed conceptual artist and activist. He frightened the Politburo into arresting him and then he frightened them into releasing him. It was true he was dazed when he was released – but like a grizzly bear is dazed when it is recovering from the effects of a sleeping dart. Today he pads around his compound like a caged animal, watched by dozens of police and by a government that doesn't quite know how to handle him.

Suddenly, there is a knock on the door and Lu Qing comes in, leading a very old man by the hand. He is so stooped that he can barely walk. Weiwei stands up and shakes the old man's hand and bows and then leads him over to a comfortable arm-chair and asks his assistant to fetch some tea and water. Then Weiwei comes over to me with a grin on his face. He can't suppress his mirth – his joy at what he's just been told.

'You see that old man? He's from my father's village. I met him years ago, when I was young. I only met him twice. He just told me he was concerned about me, so he came all the way to Beijing to check I was all right and do you know what he just said?'

Weiwei is grinning.

'. . . He said, "How long were you in for, Ai Weiwei?" I said, "Eighty-one days." He laughed at me and said, "Ah, that's OK, that's nothing. Don't make a fuss. I was in for years. In the old days everybody was. Forget about it."'

Acknowledgements

My immense gratitude to Julia Lovell and Karen Smith for reading the manuscript so thoroughly and for their crucial and judicious interventions. Any factual errors in the text are my own subsequent additions. Also to JK, Jeremy Page, Hannah Gardner, Leo Lewis, Comino Tamura, Ian Buruma, Tania Branigan, Jon Silver, Avi Shlaim, Bernard Richards, Felix Martin, Eli Zagury, CCD, Rana Mitter, Kate Murray-Browne, Neil Belton, Yang Lian, Chan Koonchung and Liao Yiwu; and all those Chinese citizens who spoke to me, and who must necessarily remain nameless.